brac

1964
Eyes of the
Storm

1964
Eyes of the Storm

PHOTOGRAPHS
AND REFLECTIONS BY

Paul McCartney

INTRODUCTION BY
JILL LEPORE

Liveright Publishing Corporation

A Division of W. W. Norton & Company
Celebrating a Century of Independent Publishing

For information about permission to reproduce
selections from this book, write to Permissions,
Liveright Publishing Corporation, a division of
W. W. Norton & Company, Inc., 500 Fifth Avenue,
New York, NY 10110

For information about special discounts for bulk
purchases, please contact W. W. Norton Special Sales
at specialsales@wwnorton.com or 800-233-4830

This book is printed on paper that has been
harvested from forests that are managed
with an eye to sustainability and social and
environmental responsibility.

Manufacturing by Printer Trento
Book design by Stefi Orazi Studio

ISBN 978-1-324-09306-0

Liveright Publishing Corporation
500 Fifth Avenue, New York, N.Y. 10110
www.wwnorton.com

W. W. Norton & Company Ltd.
15 Carlisle Street, London W1D 3BS

1 2 3 4 5 6 7 8 9 0

Dedicated to my wife, my children, their children
and my glorious family and friends

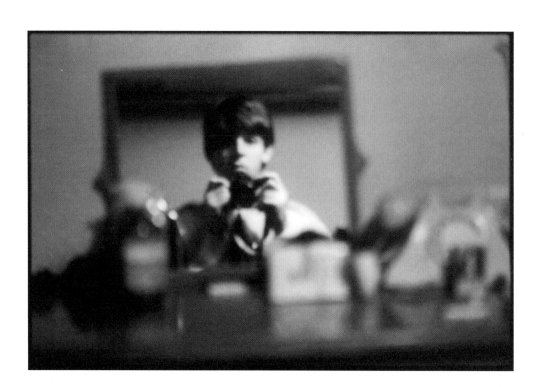

Foreword
Paul McCartney

*To look at the strength, to look at the love and the wonder of what
we went through that's captured in these photographs is the whole thing.
It's what makes life great.*

Somewhere in the back of my mind, I always knew I had taken some pictures in the 1960s. At first, I couldn't pinpoint the year, but I was certain we were quite young, just when The Beatles were really taking off. I never tried to find this collection – consciously, that is – but I kind of thought that it would just surface at the right time. There's often a certain amount of serendipity involved. And while we were preparing for an exhibition of my late wife Linda's photographs in 2020, I mentioned having taken my own, which, I then learned, had been preserved in my MPL archives. So, when I first saw them after so many decades, I was delighted that these images and contact sheets had been lovingly preserved and finally located.

Anyone who rediscovers a personal relic or family treasure is instantly flooded with memories and emotions, which then trigger associations buried in the haze of time. This was exactly my experience in seeing these photos, all taken over an intense three-month period of travel, culminating in February 1964. It was a wonderful sensation because they plunged me right back. Here was my own record of our first huge trip, a photographic journal of The Beatles in six cities, beginning in Liverpool and London, followed by Paris (where John and I had been ordinary hitchhikers just over two years before), and then what we regarded as the big time, our first visit as a group to America – New York, Washington and Miami – to the land where, at least in our minds, music's future was being born.

Now, no one can doubt that these three months were something of a crucible, but at the time we didn't know that a new sound, a new movement was happening. We were strangely at the centre of this global sensation, which had ignited in 1963 in the U.K., with what the press dubbed 'Beatlemania'. It was a period of – what else can you call it? – *pandemonium* that exploded in British concert halls, on television shows and in the charts, where our music was suddenly what all the kids were listening to.

We four guys from Liverpool couldn't possibly realise then the implications of what we were doing. By the end of February 1964, after our visit to America and three appearances on *The Ed Sullivan Show*, we finally had to admit that we would not, as we had originally feared, just fizzle out as many groups do. We were in the vanguard of something more momentous, a revolution in the culture, especially as it affected the youth. This was something we might have felt in some primal, unconscious way, but that is a realm that would be taken up later by rock critics and historians, even well into the twenty-first century, as Jill Lepore describes in her introduction.

The fact that these photographs, most of them mine but a few snapped with my Pentax camera by my bandmates, roadies and managers, have been taken by the National Portrait Gallery, London, for their reopening after a lengthy renovation is humbling yet also astonishing. While I admit

they possess historical value, I have to emphasise that I'm not trying to claim to be a master, only an enthusiastic photographer who happened to be in the right place at the right time. That a senior curator like Rosie Broadley can contextualise what became nearly a thousand photographs, of which 275 are in this book, means a lot to me. I have to add that I have huge respect for all the professional photographers out there who busted their limbs, sadly quite literally at times, to capture the madness of the 1960s. I hope that these photos complement everything they did.

The truth is that I have always been interested in photography, from the time I was very young, when our family owned a little box camera in the 1950s. I used to love the whole process of loading a roll of Kodak film into our Brownie camera. I would ask my brother Mike to take a picture of me outside a hot dog store – an American export to a country that had never previously known hot dogs. And from those early years, we would use the camera to take pictures of each other. This was not just a McCartney family hobby. Every family we knew would take a camera on holiday, as in 'Here we are on holiday in Blackpool' or 'Here I am with Auntie Dilys and Uncle Harry,' as we did when we went to Butlin's holiday camp.

In looking back at these photographs, I have even greater regard for the photographers around The Beatles back then. They would have to frame the picture, guess the lighting and then just go for it – the madness that enveloped us everywhere making their work ever more difficult. Since we were surrounded by journalists, I often took pictures of them, not so much for revenge but because they were an interesting group of people. I would often say to them, 'What's the right lighting?' because they were professionals and would automatically know. Despite the simplicity of the camera, the process, at least to me, was challenging, since with each roll, you had only twenty-four or thirty-six images, which you had to get right, because there wasn't a second chance. This is such a contrast with the process today of taking pictures on your phone. You couldn't be lazy then. You had to take the right picture, actually compose the image in the frame without the safety of knowing you could crop it later. When I watched my wife

Linda work, she was very old-school in that way. She had the discipline to spot the picture and then take it. She understood that she had only one opportunity and she had to get it right.

This kind of traditional photography has more relevance to music and the recording process than you might think. Nowadays, some people will come into the studio without a song, without any idea of what they're going to do – and they'll just jam around until something 'appears'. I often think that this can prove to be a great waste of time, and I advise people to have some idea of what they're going to do before they come in and make a piece of music. But just as with phone pictures, they'll record various pieces of music, mix them and choose later.

Looking at these photos now, decades after they were taken, I find there's a sort of innocence about them. Everything was new to us at this point. But I like to think I wouldn't take them any differently today. Some of them are soft and I could say, 'Well, I wish I'd taken a bit more time to focus them up.' But we didn't have that time. And I'm quite glad of it now. I think of the work of Julia Margaret Cameron; much of her work is soft. Many of her great portraits, they're not sharp at all. So, perhaps I can get away with it too. We were moving at such speed that you just had to grab, grab, grab! It meant some of these shots were not as sharp as others. But I kind of like that, I like the mixture. We've got some very sharp pictures and we've got some more romantic photos with that softness which really captures the time.

Things were happening so wildly that I cannot say that photography was in the forefront of my mind as we toured. Even though we wanted to transform from a little band to a big one, and even though we hoped for international acceptance when we went to France and then the U.S., no one could have predicted what I describe as the 'Eyes of the Storm'. At first, I was tempted to call it the 'Eye of the Storm', because The Beatles certainly were at the centre, or the eye, of a self-generated storm, but when I looked at all these photographs, I realised it really should be in the plural, the '*Eyes* of the Storm', because of all the pictures that others were taking, the photographs I was taking and also the eyes of the fans that greeted us,

the security that looked after us. Who is looking at who? The camera always seems to be shifting, with me photographing them, the press photographing us, and those thousands and thousands of people out there wanting to capture this storm.

The good thing was that our success did not come overnight but developed in a way that I like to describe as a 'staircase to the stars'. As if by design, we had a steady build-up to 1964 and were 'prepared', though who can ever be prepared for fans ripping at your clothes or taking scissors to your hair, as Ringo experienced in, of all places, the British embassy in D.C.? Still, it's true this international phenomenon didn't just come out of nowhere — there was a trajectory — from going to newspaper offices on our own turf, to playing theatres in the U.K., to appearing on radio programmes, before being invited to do TV work, after which we'd be stopped on the street for autographs, especially after a Saturday night show. At first, it was really flattering, and we'd be pleased to stand in line for a little crowd of girls, asking them, 'What's your name, who should I write this out to?' But as the insanity built, we no longer had the time, despite our best intentions, and could no longer be who we really wanted to be.

America was without question the big prize, where most, if not all, of the music we loved came from. This was true for films too, and it was the American movies that attracted not only my generation but my dad's as well. Even the singing stars, long before Elvis, were all American. You may think I'm nostalgic, but you have to remember that this was less than twenty years after the end of the Second World War, and to us, America was 'the land of the free', the land that took in 'your huddled masses' — a phrase I like to remind people of when they start banging on about immigrants. It was, I still like to tell people, a land where immigrants helped to create the American cultural scene, one we loved and then picked up in England.

All the early rock and roll stuff was American. These were the records we loved to hear. When you look back on it, America had a huge advantage because of its Black music — early blues and jazz — which was simply lacking in European culture. The whole thing came from Black people, who were the pioneers of it all, singing in cities, in the kind of clubs where Elvis listened from the outside, hearing songs that he would later take and mould into his own renditions, things like 'That's All Right' and 'Lawdy Miss Clawdy'. That was — and still is to this day — the most popular American music, with things like hip-hop just extending the sensibility into a new century. Anyone who sings in this vein is imitating Black musicians in one form or another. I love to trace where this music came from, much of it from the South, especially Memphis. Anyone who reads the history knows that such music originally emerged out of slavery, from what was sung in the cotton fields, music that was then filtered through gospel into a kind of sound no one had ever heard before. Our fascination with all these forms of music, including our own, was building to a crescendo, as if a star was exploding.

President Kennedy had been murdered only a little over two months before our arrival, and his assassination had ricocheted throughout the world, so we figured the atmosphere in the States might still be subdued. But the minute we landed in New York, we knew instantly that we were not in store for any kind of funereal time. It was a Friday in early February when we touched down, and it felt like thousands, and later, through television and *The Ed Sullivan Show*, millions of eyes were suddenly upon us, creating a picture I will never forget for the rest of my life.

The airport scene that February was bedlam, mass hysteria. Not in Liverpool or London, not in Paris was there anything comparable. But the airport (which had only recently changed its name from Idlewild to Kennedy) was just the start of it, because caravans of folks lined the streets and highways to get a glimpse of us as our car crawled into Manhattan. The journalists and photographers followed us in vehicles and mini-trucks, well-wishers thronging both sides of the road, as if we were some sort of triumphant athletes celebrating a victory lap. The cover photo of this book, which I managed to shoot after escaping through a side entrance at the Plaza where we were staying, communicates both the frenzy of the visit and the power of New York, with all those skyscrapers soaring above the buildings on

West Fifty-Eighth Street. There's something seemingly dire about this need for flight or *escape,* as if we could end up trapped, though if you think about it, it was really *pursuits* like this one that put The Beatles in the middle of the storm. It was a kind of consciousness we were just getting used to.

You might think that all this was terrible, that it was painful, and that we felt like animals in a cage. I can only speak for myself, but I did not feel that way. This was something we had always wanted, so when it actually happened, when the mounted policemen held back the crowds outside the Plaza, I felt like we were the stars at the centre of a very exciting film. And the good thing was that there was never any malice. The people running after us just wanted to see us, just wanted to say hi, just wanted to touch us.

That is not to say that we were unaware of other dangers. When I look back at these photos, I'm surprised that my eye was drawn to so many policemen and their loaded guns. In Oliver Cromwell's day, in the mid-1600s, there might have been a lot of old flintlocks in England, but we're really not a land of guns. Growing up, I don't recall ever having seen a gun, and I was certainly never handed one. I soon learned that America had this Second Amendment tradition, but it was still jarring for me to be in the midst of this land of contrasts: first the glamour, with all those pictures of palm trees in Miami, and then the policeman accompanying us as he pulls up right next to the car, his guns and ammo right next to my camera lens. Particularly in the wake of President Kennedy's killing, I came to realise that this was something that was so American.

Yet other things that were also quintessentially American drew me in. There was an innocence that still remained. You'll see as our group made its way to D.C. and then to Miami that my camera was attracted to this new American universe of common people. Just look at the man with the shovel in front of the Pennsylvanian freight car in Washington, standing raptly watching, or those four aeroplane mechanics clad in white at the Miami airport. These are my people. This is where I'm from. I grew up in a working-class family in Liverpool, so I could never detach myself from people like these. I wanted to be right in the middle of them. My relatives were exactly like these people. You'll find them – the bus driver, the postman, the milkman – not only in my songs but in many of these photos. You might think someone on the street is just some ordinary Liverpool guy, that he's just an ordinary insurance salesman, so what's the big deal? Thinking like this would be a big mistake, as in the case of my cousin Bert, a very intelligent guy with an amazing sense of humour, who actually compiled crosswords, quite cryptic crosswords, for three of the top newspapers in England. Still today, I tell people all the time that there is such great value in the common people.

That America remained a land of contradictions became apparent during the Miami leg of the tour, with all that colour coming after the grey drabness of New York and Washington, where the grounds of the White House and the Capitol Building had been buried in slushy snow. I had yet to pull out the colour film roll, but you can feel the intense excitement as we touched down at the Miami airport, jammed to the roof and the rafters with well-wishers of every sort. There are the mechanics readying the gangplank for us to disembark, while a crowd stands at the ready, as if they want to take part in the new history playing out right in front of them – don't miss those drum majorettes in uniforms. And then comes that explosion of colour as we get the chance to relax and play in the green-blue waters of the Atlantic Ocean, even though we know we still have one more live appearance on *The Ed Sullivan Show* to come. These are some of my favourite photos, and they speak to the luxury of Miami. Coming from Britain, where we didn't get a lot of warm weather, even in summer, it was exciting to be able to take some time off from our punishing routine, to actually sit down, enjoy a day off, and have a drink and a cigarette by the pool. One of my favourite photos in the collection shows George Harrison, his face hidden by sunglasses, being handed a drink – probably a Scotch and Coke – by a girl, and although we don't see her face, we do see her dazzling yellow swimming costume. The composition was deliberate, and I'm glad that I didn't move farther away but kept George as the focus of the image. In looking back on these photos of the

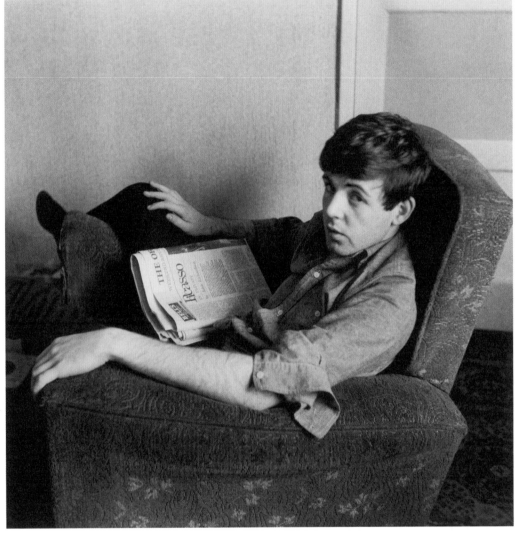

good life, I'm not at all surprised that the colour pictures started happening when we got to Miami, because, suddenly, we were in Wonderland.

Although we had no perspective at the time, we were, like the world, experiencing a sexual awakening. Our parents had fears of sexual diseases and all sorts of things like that, but by the middle of the sixties, we'd realised that we had a freedom that had never been available to their generation. Travel was one thing our parents had never done. They never had money either; you have to appreciate how hard things were both during and after the war. You might be surprised to learn that I was the first person in my branch of the family who ever had a car. People just didn't have them; they depended on public transport, which all of us were used to in Liverpool. Only later did I come to realise that we were in the forefront of these new changes, this abrupt shift in the youth that in hindsight seems to have crystallised in 1964.

You might think from all this that we were political, but traditional politics were far from our minds. Although if you see striving for freedom as some form of being political, you could say that we were indeed at the centre, with a freedom that moved into culture, art and politics. We started witnessing this sea change especially in America. We'd talk to girls at parties, and they'd describe their situation, the fact that they had a boyfriend, a guy with a crew cut who was on the football team, or something that embodied the lack of freedom. Now, I happen to like American football players, but we felt that we had already gone beyond that, and you'd find our aspirations and embrace of freedom in our interviews and, especially, in our songs. It was inevitable that all of this spilled into the political.

When I left home, I didn't go to college. I was living on my own, though I actually had roommates just like the college kids did, these roommates were my fellow Beatles. As with any kids of the 1960s, we discussed the crises of the day, and realised that we didn't like racists or many of the crazy things that were going on in America, particularly that segregation was still in place in many areas. We were offered a chance to go to South Africa, but even though we could have made money there, we turned it down because

of apartheid. And then we refused to play to segregated audiences in America, just because it seemed stupid, at the very least. We couldn't grasp why you'd want one set of people to sit in one place and another group to sit in a different place. It reminded us of medieval civilisations where women had their own place and men, another. It was especially surprising to witness this kind of racial segregation, and also that of Jewish people, who were banned – 'restricted' it was called – from joining country clubs or moving into certain neighbourhoods. It was hard for us to believe that America, which had always been for us 'the land of the free', failed to be free for so many different people.

Rediscovering the photographs I took in my early twenties inevitably makes me reflect on much larger questions. I think it's the same as it would be for anyone, that when you look at pictures of yourself when you were younger – in my case, a lot younger – there are a lot of emotions. On the most basic level, you think, 'Boy, didn't I look good?' but we all look beautiful when we're young, and I'm proud to have been through that and to now have the privilege of revisiting so many of those moments.

I realise that many people get sad when they pore through old family albums, but I don't feel that sense of loss, even though quite a few of the people who are portrayed here have died. When people are grieving, I often tell them to concentrate, just concentrate on the great memories. Yes, it's sad, and how can I not think of my mother, who went much too early, when I was fourteen? Still, the truth is that nobody gets out of this alive. And as banal as it might sound to some, that is the reality of this thing called life. I'm aware of how hard it can be, but we shouldn't spend too much time worrying about death, because it's inevitable.

It's not so much a feeling of loss but a joy in the past. When I look back and think, I have to say '*Wow*' – we did all that, and we were just kids from Liverpool. And here it is in the photographs. Boy, how great does John look? How handsome is George and how cool is Ringo, wearing that funny French hat? In fact, every picture brings back

memories for me, and I can try to place where they were and what we were doing on either side of the picture. I'm also drawn to the pictures of the photographers, who were never our enemy. They bring back memories of what it was like being in New York for the first time, being taken down to Central Park, with all those hard-bitten cameramen shouting out, 'Hey Beatle, hey Beatle, hey Beatle.' And we'd look at them and they'd take the picture, and then one more, always just one more.

I'm reminded of so many things: of an England that was more my parents' generation than my own (just look at those almost formal photos of George's parents, Harry, a bus driver, and Louise, who were much younger than you might think, but they'd gone through a world war and then rationing and we're seeing them from our modern viewpoint); of the early concerts and those original fans; of 'Beatlemania', a true English invention, which launched us so well; and of a London that in 1963 spoke of promise and ambition and everything new to four young men from the North.

And I'm reminded of an America that I know still exists, somewhere. I remember all those stories, some of them real, others imagined, from looking out of the train window, seeing American freight trains, American railway yards. I like American trains to this day. I like to think that I can hear 'that lonesome whistle blow.' It's the majesty of all those beautiful old blues songs, and I begin to wonder how all those people hitched rides across the country in the old days. Even then, as you hear in my songs, I was always imagining the lives of people I did not know, like that man, 'the Pennsylvanian', I'll call him, in front of the train yard, whose story I will never know, but I can still ask: 'What was he like when he went home that night? Did he mention having seen The Beatles at the dinner table?'

These people, some famous and others, like the fans, totally anonymous, now bring back so many stories, a flood of special memories, which is one of the many reasons I love them all, and know that they will always fire my imagination. To look at the strength, to look at the love and the *wonder* of what we went through that's captured in these photographs is the whole thing. It's what makes life great.

Preface
Nicholas Cullinan

We all know what Beatlemania looked and sounded like from the outside, but what did it look and feel like for the four pairs of eyes that lived and witnessed it first-hand? *1964: Eyes of the Storm* follows The Beatles' extraordinary journey through Paul McCartney's lens, city by city, from touring regional music venues in Liverpool and London, to performing in Paris for eighteen days and, finally, travelling to the United States to visit New York City, Washington, D.C. and Miami. McCartney's photographs document three pivotal months – December 1963 through February 1964 – and bring a crucial new perspective to this period. In Paul's own words, his pictures are the 'Eyes of the Storm': looking out at the cultural maelstrom caused by four incredibly gifted young men, all hailing from Liverpool, who had worked so hard for their success. As Paul says, 'This international phenomenon didn't just come out of nowhere – there was a trajectory.'

Over more than half a century, we have become familiar with press photographs showing the smiling band members and their screaming fans. Paul McCartney's photographs, in contrast, have more in common with a family album, capturing the band members, their families and girlfriends, the managers and the entourage. The people you see here are caught in moments of relaxation, laughing and chatting, swimming in the sea and hanging out by the pool. At the same time, these images reveal the intensity of touring, of long days spent in rehearsal, in hotels and travelling by planes, trains and automobiles.

McCartney has likened their personal, episodic quality to a diary: 'creating a picture I will never forget for the rest of my life.'

The majority of the photographs are portraits, the type we might take of friends: playful and affectionate. The group of friends represented here, however, happens to be John Lennon, George Harrison and Ringo Starr, who together helped change the very nature of popular culture with their music, album covers, films and style. The informality and intimacy of these portraits is what makes them so unique. Paul shows John playing the guitar in a hotel suite in Paris. An exhausted George is pictured sleeping on the plane to New York. Fresh off the beach, Ringo, wearing only his swimming trunks, rehearses for their second *Ed Sullivan Show* broadcast. Capturing The Beatles at the beginning of a life-changing journey, these arresting and startlingly simple pictures could only have been taken by someone who was sharing these experiences and was innately curious about the rapidly changing world around them.

The archive from which these photographs were drawn has been preserved for nearly sixty years as part of Paul McCartney's personal collection. Because these images were stored as negatives and contact sheets and only recently rediscovered, few of them had ever been printed or shared beyond his immediate circle of family and friends. Realising their significance, Paul has been instrumental in curating the photographs. In making his

selection, Paul spent hours poring over these images, which, in turn, sparked a flood of memories, now recollected in this book. For the exhibitions, modern prints have been made from the original negatives; in the case of the contact sheets, new scans of images were created where negatives did not exist. As each image was reproduced at a larger scale, new and delightful details emerged: the faces of people in crowds waiting at New York's Central Park and the airport workers in Miami who have their fingers in their ears to cut out the sound of thousands of fans.

The Beatles' story of these three months occurred during a period of remarkable social and political ferment, within both the United States and the United Kingdom — a story that is explored in the following essay by historian Jill Lepore. Paul, with his Pentax camera in hand, had the opportunity to record what was happening around them and to document their remarkable journey as a band. Many of the photographs are in black and white, well suited to the grainy backstage environments of venues in post-war Britain. They capture the mood of 1960s Paris and the wintry scenes of a bleak day in Washington. By contrast, the glorious colour photographs of The Beatles relaxing in Miami provide an almost surreal picture of American prosperity and glamour, one that would have been largely unfamiliar to people in the United Kingdom. It is evident that Paul's keen eye and his burgeoning interest in photography inform the many portraits and photographs; this is explored alongside the changing styles and technology of photography in the essay by the National Portrait Gallery's senior curator Rosie Broadley.

We will always be honoured that Paul McCartney approached the National Portrait Gallery to share his significant archive, which records such a pivotal moment in history. The Gallery explores the unfolding story of British culture and identity, through portraits of some of the most important and iconic figures in British history. The Gallery's own collection contains an extensive and wide-ranging selection of photographs of Paul McCartney and The Beatles throughout the 1960s by many leading photographers of the time. Paul's images add a much more immediate aspect to those well-known depictions — looking at the world, rather than just being looked at by it.

The Gallery reopened its doors in 2023 after a complete refurbishment, during which, for the first time in its history, its collection has been entirely redisplayed. Our photographic collections, long one of our hidden strengths, now possess a new prominence, and are threaded through the displays and galleries, as we continue to champion the work of photographers through our exhibitions programme. It is then surely fitting that we have opened with an exhibition of Paul McCartney's photographs, sixty years after they were first taken. What is so pleasing about this anniversary is that we can celebrate a vibrant and still-performing living legend, whose contribution to British cultural life is exceptional. Equally exciting for North American audiences is the sixtieth anniversary of The Beatles' first appearance on *The Ed Sullivan Show*, in 1964, when the group reached seventy-three million Americans.

We are grateful to all those involved in making this exhibition and publication possible. I would like to thank the team and our partners at MPL, in particular Sarah Brown, who worked so closely with the Gallery to transform an archive of negatives and contact sheets into these wonderful photographs, and her colleagues, for their skilled contributions and support. At the Gallery, my thanks go to Rosie Broadley for her hard work, dedication and continued oversight and development of this project. Our greatest gratitude must, of course, go to Paul McCartney, not only for offering us the opportunity to present this unseen archive but also for his generosity, invaluable selection and guidance. It has been a privilege to work with him, and we are also delighted that the exhibition will tour internationally, so that a global audience will be able to appreciate his photographs. We can't think of a better way to begin such an exciting new chapter for the National Portrait Gallery.

Dr Nicholas Cullinan, Director
National Portrait Gallery, London

Introduction
Beatleland: The World in 1964
Jill Lepore

If you want to know about the Sixties,
play the music of The Beatles.

Aaron Copland

On 4 November 1963, The Beatles played before members of the royal family at the Prince of Wales Theatre in London, exuberant, exhausted and defiant. 'For our last number I'd like to ask your help,' John Lennon cried out to the crowd. 'Would the people in the cheaper seats clap your hands? And the rest of you, if you'd just rattle your jewellery.' Two weeks later, The Beatles made their first appearance on American television, on NBC's *Huntley-Brinkley Report*. 'The hottest musical group in Great Britain today is The Beatles,' said reporter Edwin Newman. 'That's not a collection of insects, but a quartet of young men with pudding-bowl haircuts.'[1] And four days after that, on 22 November, the day their new album, *With The Beatles*, went on sale in the United Kingdom, *CBS Morning News* with Mike Wallace broadcast a five-minute report from 'Beatleland', by London correspondent Alexander Kendrick. 'Besides being merely the latest objects of adolescent adulation and culturally the modern manifestation of compulsive tribal singing and dancing,' Kendrick reported, 'The Beatles are said by sociologists to have a deeper meaning. Some say they are the authentic voice of the proletariat.'[2] Everyone searched for that deeper meaning. The Beatles found it hard to take the search seriously.

'What has occurred to you as to why you've
 succeeded?' Kendrick asked Paul McCartney.
'Oh, I dunno,' he answered. 'The haircuts?'[3]

Kendrick's report had been set to air again that night, on the *CBS Evening News with Walter Cronkite*. The rebroadcast was cancelled. The 1960s started in 1964, historians like to say, and 1964 started on that day, 22 November 1963, at 1:40 p.m. Eastern Standard Time, when Cronkite broke into the television network's daytime soap opera *As the World Turns*.[4] 'In Dallas, Texas, three shots were fired at President Kennedy's motorcade,' Cronkite said, his voice grave and urgent. 'The first reports say that President Kennedy has been seriously wounded by this shooting.' You couldn't see Cronkite; the news had just come in on the wire service; the cameras would still have been warming up: all you could see was a slide that read, 'CBS NEWS BULLETIN.' Minutes later, with the cameras finally on, the screen, black and white, showed Cronkite in the newsroom, in shirtsleeves, spruce but shaken. 'If you can zoom in with that camera, we can get a closer look at this picture,' he told a cameraman as he held up a photograph of the motorcade taken moments before the shooting. Then, at 2:38 p.m., Cronkite looked up at the clock, tried to gather himself, took off his black-framed glasses, and announced that the president had died.[5]

'Time seemed to stand still,' BBC reporter Peter Watson wrote in his notes on the day. He'd been in New York, reporting from the United Nations, but rushed to the airport to catch a plane to Dallas. 'President Kennedy was shot at 12:35 local time from the fifth floor of a state book warehouse as he drove by on his tour of

Dallas,' Watson wrote in his first report. 'The murder weapon, a 6.5mm Italian rifle with a telescopic sight was found under a staircase in the building.'[6] News travelled across the Atlantic by satellite. On BBC television, newscaster John Roberts said, 'We regret to announce that President Kennedy is dead.' He bowed his head, and kept it down, and then, for nineteen minutes, there was nothing on the screen but the BBC's logo, in black and white: a spinning globe.[7]

'We were backstage somewhere on a little tour in England when we heard the news,' Paul McCartney told me.[8] That night, The Beatles were getting ready to play in the northern town of Stockton-on-Tees.[9] You could tell, even in that minute, that the world was turning. It was as if you could feel it, rotating, and moving through its orbit. It was something, maybe, that you could try to catch on film. Two days later, Jack Ruby shot Kennedy's killer, Lee Harvey Oswald, on live television. 'We have seen everything now,' Anthony Burgess wrote in the BBC's magazine, *The Listener*. 'That impartial eye has looked on murder; from now on there will always be the stain of a corpse on the living-room hearthrug.'[10] You could hold your camera up to the world, in 1964. But what madness would you capture, what beauty, what joy, what fury?

THE NEW MADNESS

In 1964, The Beatles became the first truly global mass culture phenomenon: they'd been shaped by a wide, wide world, and their music reached that world, bounced by satellite and flown by air freight and shipped by container ship. They wore Italian suits and Cuban boots and had German haircuts and played 1920s British music-hall music and rockabilly and rhythm and blues and Black roots music from the banks of the Mississippi and the streets of Detroit and the Blue Ridge Mountains.[11] It's even in the name. 'Nothing really affected me until I heard Elvis,' Lennon once said. But then came Buddy Holly and Chuck Berry. 'The Beatles' is a mashup of the name of Holly's band, The Crickets, and the Beat poets, a label that came from Black slang, where 'beat' meant beaten down.[12]

Beatles records played on radio stations from Tokyo to Johannesburg. By the time Beatlemania broke out, the sun had set on the British Empire. But the age of globalisation had begun. And something more, too, was just catching fire: an unsettling, an upheaval, revolutionary. *Time* magazine, writing about The Beatles, called it 'The New Madness'.[13]

Partly, it was the magnificent irreverence, the affectionate cheekiness, the surprisingly soft sexiness.

> Reporter: Who came up with the name Beatles, and what does it really mean?
> Lennon: It means Beatles, doesn't it? But that's just a name, you know, like shoe.
> McCartney: The Shoes, you see? We could have been called The Shoes for all you know.[14]

It came out in every interview; the interviews themselves became a signature, four very, very clever young men batting back reporters' endlessly idiotic questions, a patter only barely fictionalised in the 1964 film *A Hard Day's Night* (called, by the *Village Voice*, 'the Citizen Kane of juke-box musicals'):[15]

> Reporter: Tell me, how did you find America?
> Lennon: Turn left at Greenland.
> Reporter: Has success changed your life?
> McCartney: No.
> Reporter: What would you call that hairstyle you're wearing?
> Harrison: Arthur.

'We're constantly being asked all sorts of very profound questions,' McCartney once said, 'but we're not very profound people.'[16] They were profound musicians. Asked, preposterously, to explain their own significance, or the forces behind the generational change, cultural revolutions and political transformations in which they were caught up, they demurred, and dodged, and made fun of the question. Still, McCartney tried to capture some of that New Madness, what he could see of it, through the lens of a camera. Each of The Beatles acquired a Pentax in 1963,

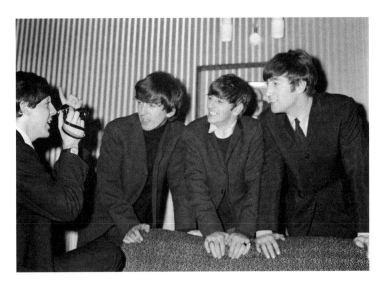

Paul photographing his fellow Beatles, December 1963.

which maybe helped them cope with the stress of being photographed constantly, unendingly, and with the worry that they were about to travel to a country where they expected, like Kennedy himself, to be greeted by frenzied crowds and hordes of photographers and – a worry never admitted – exposed to possible gunmen. McCartney shot dozens of rolls of film from the end of 1963 to early in 1964, as the band travelled from Liverpool to London to Paris and then to New York, Washington, D.C. and Miami. Somehow, hundreds of McCartney's photographs – negatives, prints, contact sheets – were saved, and rediscovered in 2020, a gallery of Beatleland from the inside, looking out.

> And then while I'm away
> I'll write home every day
> And I'll send all my loving to you

This book's selection of those photographs show what McCartney saw, eyes into the storm, sending home loving.

The Beatles brought the North of England to the rest of England, and then brought it to the world. The New Madness started in Liverpool. Lennon and McCartney had been playing together since 1957, but still, to some people, they seemed to have come out of nowhere. 'We were from the North of England, which was nowhere to a lot of

people,' McCartney says. That nowhere, the dark and gritty, war-wearied, smokestack-fired, working-class North, had lately become the subject of a certain fascination. *Coronation Street*, set in Manchester, had debuted on television in 1960. In 1962, the Scotsman Sean Connery was on the billboard at every corner cinema, starring as James Bond, bringing a different British sexiness to the big screen. But The Beatles became the embodiment of the North, the sound of it. It wasn't just their music, or their accents, but their wit. A little Flanders and Swann. A little *Goon Show*. And a lot of Liverpool.

> Reporter: Why do you wear all those rings on
> your fingers?
> Starr: Because I can't get them through my nose.[17]

'The most important thing about the Beatles is that they come from Liverpool,' Frederick Lewis wrote in the *New York Times* in December, reporting on a development in the United Kingdom that by 1963 had been dubbed 'Beatlemania': the seeming insanity of writhing crowds of young people screaming, shrieking, shuddering, collapsing; bursting, blooming, wilting, like fields of flowers. 'By comparison, Elvis Presley is an Edwardian tenor of considerable diffidence,' Lewis wrote. The Beatles, he explained, had emerged 'as spokesmen for the new, noisy, anti-Establishment generation which is becoming a force in British life.'[18]

What was that force? It really was generational, but by no means was it exclusively British. The Beatles had been born during the long, hard, rationed and air-raid-sheltered years of the war, under the ever-present threat of a German invasion: Lennon and Starr in 1940, McCartney in 1942, Harrison in 1943. Very early on, as The Quarry Men, they wore drainpipe trousers and bootlace ties and greased their hair, like Marlon Brando, or like other swaggering British boys who joined gangs or pretended to be thugs and called themselves Teddy Boys or, later, 'Mods' and 'Rockers'. In 1960, they shed that look when they left Liverpool for Hamburg, another port city – 'the naughtiest city in the world,' said Harrison[19] – where they hung out with students and artists and writers from all over the

world, everyone groping for the latest ideas, the newest thing, the moment, the moment, the moment. Even in dingy basement pubs, they played for what was, essentially, an international audience. 'It was handy them being foreign,' Lennon said. 'We had to try even harder, put our heart and soul into it, to get ourselves over.' They played till they dropped, and when they dropped they soaked it all up: art student chic, beret-wearing existentialism, red light district bawdyism, German pub rowdyism. 'I was born in Liverpool, but I grew up in Hamburg,' Lennon said. 'We were forced grown, like rhubarb,' said Harrison.[20] They were cultivated in the soil of a postwar, transnational youth movement, aching, yearning, angry.[21] They took all that seriously. But they also didn't take any of it seriously.

Reporter: Are you a Mod or a Rocker?
Starr: No, I'm a Mocker.

By 1962, back in England, they weren't teenagers anymore, except Harrison. But their fans were. The Beatles first appeared on the radio that year on a BBC show called *Teenagers Turn – Here We Go*.[22] Teenagers were tamer in Britain than in America, less anguished, and less adversarial. 'America had teenagers but everywhere else just had people,' Lennon pointed out, not inaccurately.[23] British teens, including The Beatles themselves, were far more likely than American teens to go to work after high school (only Lennon had gone to college; he attended the Liverpool College of Art). They were the first generation not obligated to military service: with the decline of the British Empire, conscription had ended in 1960. When a reporter asked, 'If there had been National Service in England, would the Beatles have existed?' Starr answered no: 'Cuz we would have been in the army.'[24] Asked other times, they were less serious.

Reporter: Where do you gentlemen stand as far
 as the draft is concerned in England?
Lennon: About five eleven.
Starr: It comes from the door over there.[25]

Freed from the duty of fighting for the empire, they fought against the establishment, and on behalf of a sexual awakening. In 1960, Penguin had published the long-banned D. H. Lawrence novel *Lady Chatterley's Lover*; in a trial held that year, the courts had declared that the book was not obscene. The Pill was sold in the United Kingdom starting in 1961; two years later, The Beatles released the single 'Please Please Me', as well as the eponymous album, events celebrated by Philip Larkin in his poem 'Annus Mirabilis':

> Sexual intercourse began
> In nineteen sixty-three
> (which was rather late for me) –
> Between the end of the 'Chatterley' ban
> And the Beatles' first LP.[26]

'Please please me / Whoa yeah like I please you,' they sang. And the girls, imagining that pleasure, keeled over.
Nineteen sixty-three is the year Beatlemania seized England. 'In one meteoritic year,' the BBC announced, 'they've led the way from the cellars of Liverpool to the national limelight.'[27] By June, they had their own radio show, *Pop Go The Beatles*.[28]

Reporter: How difficult is it to keep up the zest?
Lennon: Oh, we do the zest we can.[29]

They were iconic, inescapable, the very carefully promoted good, clean lads, the Fab Four, ushered, on a tour of the United Kingdom, from car to hotel to stage to hotel to car, a fleet of photographers in tow. 'We don't have a private life anymore,' Harrison was already beginning to complain. 'We're public property now.'[30]
You can see the walls closing in on them in McCartney's photographs from London and Liverpool. Rooftops, car windows, hotel rooms. But not everything was closing, shutters latched. In London, McCartney told me, 'the world opened up', especially at the Establishment Club, an anti-establishment comedy club founded by Peter Cook in 1961 in Soho, at the site of a former strip club.[31] Novelists, painters, poets. You could sit down with

directors from the National Theatre and hear about the next play they were putting on. Lifetime members were presented with a portrait of Harold Macmillan, the Conservative Party prime minister, the embodiment of the Establishment, of Victorianism and of Toryism.

Macmillan, sixty-seven, waistcoat and walrus moustache, was the last prime minister born during the reign of Queen Victoria, and the last to have served in the Great War, desperately wounded, damaged, hobbled, every bit as much a relic as *Doctor Who*'s doctor, the science-fiction character who made his debut on BBC television in 1963, in a fantasy of Britain as the world's policeman, lord of the universe, lord of time itself.[32] Macmillan's ministry marked the end of an era. 'Altogether, we are at a low ebb,' Macmillan wrote in his diary in January 1963. 'All my policies at home and abroad are in ruins,' he lamented, despairing. 'We have lost everything, except our courage and determination.'[33] Only months later, his administration was much tarnished by a scandal involving his minister of war, John Profumo, who had been having an affair with Christine Keeler, a very young and very highly paid escort who was also sleeping with a Russian naval attaché.

> Reporter: What do you think of the Christine Keeler Profumo affair?
> Harrison: (dryly): It's great, yeah.
> (Beatles laugh)
> Reporter: (laughing): Good publicity![34]

After Profumo stepped down, a rocker named Screaming Lord Sutch, twenty-three, ran for his seat in Parliament; he advocated lowering the voting age to eighteen and presented himself as a candidate (and essentially the only member) of the National Teenage Party.[35] Macmillan eventually resigned. The *Daily Mirror* shrieked on its front page, 'WHAT THE HELL IS GOING ON IN THIS COUNTRY?'[36]

LES BEATLES

Whatever was going on was going on all over the place. In November 1963, The Beatles released their first album in France, LES BEATLES. On 10 December 1963, Walter Cronkite decided to go ahead and broadcast Alexander Kendrick's report from Beatleland, originally scheduled for 22 November, on the *CBS Evening News*.[37]

> Reporter: Have you ever heard of Walter Cronkite?
> McCartney: Nope.
> Harrison: Yeah. News.
> Lennon: Good old Walter! NBC News, isn't he?
> Yeah, we know him. See? You don't catch me![38]

American Beatlemania began. The Beatles had released three singles in the United States; none had broken out. But on 26 December, their fourth, 'I Want To Hold Your Hand' blasted off like an Apollo rocket.

> Reporter: What was the first million seller in England that you had, and when was it?
> Lennon: It was 'She Loves You', I think. (to the others) Was it?

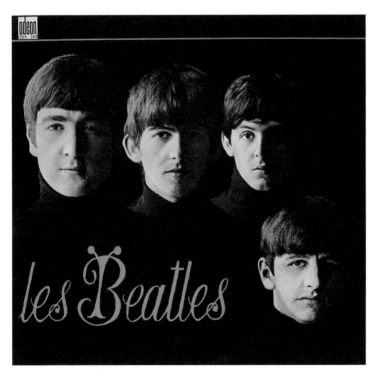

Les Beatles, their debut album in France.

McCartney: Yes.
Reporter: And the second was . . .
Lennon: 'I Want To Hold Your Nose.'[39]

Bob Dylan heard 'I Want To Hold Your Hand' on the radio while driving in California in January. He nearly drove off the road. 'Fuck!' he said. 'Man, that was fuckin' great. Oh man – fuck!'[40]

The Beatles spent much of January in Paris, performing at the Olympia theatre. 'LES BEATLES' read the marquee, captured in a photograph by McCartney. Lennon and McCartney had been to France before, in 1961, to celebrate Lennon's twenty-first birthday.

> Reporter: Paul, you're going to have a birthday
> shortly – but you don't expect to get any presents
> from the boys, I hear. . . .
> Lennon: Paul got me a wimpy and a Coke for my 21st.
> McCartney: Mind you, that was back in '39![41]

They'd gone to the Eiffel Tower and the Louvre and to the Olympia theatre to see the French singer Johnny Hallyday. They got 'the cheapest seats in le theatre,' McCartney wrote in a letter home. 'Everybody went wild, and many was the stamping + cheering in the aisles, and dancing, too. But the man said sit down, and so we had to.' Hallyday, whose real name was Jean-Philippe Léo Smet, was, at the time, more or less an Elvis impersonator who desperately wanted to be mistaken for an American: born and raised in Paris, he pretended that he had an American father and had grown up in Texas. After seeing him in Paris in 1961, Lennon, apparently less impressed than McCartney, had written home that France had 'no "Rock." (Well, a bit of crappy French Rock.)' Hallyday was learning to ride a horse and talk like a Texan. Lennon and McCartney were going in the other direction: it was on that trip that they'd gotten their artsy European haircuts, courtesy of Jürgen Vollmer, a friend from Hamburg, a German fashion-school student and photographer. They were making themselves European, not American.

Lennon would later say, of the 1960s, 'Everyone dressed up but nothing changed.'[42] But if that applied to the counter-culture, it didn't apply to national politics, especially the relationship between the United States and Europe and the rest of the world. Even as Johnny Hallyday was offering Parisian teenagers a French imitation of a white American southerner's adaptation of Black American music, civil rights activists were fighting to dismantle segregation and independence movements were shifting the balance of power between the global north and the global south. In France, Charles de Gaulle, elected president in 1958, fought for a 'Free Europe', independent of either American or Soviet influence. In 1963 de Gaulle had blocked Britain from entering the European Economy Community – this, as much as the Profumo affair, had contributed to the decline of Macmillan's ministry. Like Britain, France in the early 1960s was reckoning with the legacy of its long century of imperial rule. 'The final hour of colonialism has struck,' Che Guevara would declare in a speech to the United Nations in 1964. 'And millions of inhabitants of Africa, Asia and Latin America rise to meet a new life and demand their unrestricted right to self-determination.'[43] Millions who rose up were struck down, killed in fighting, crowded into camps and slaughtered.

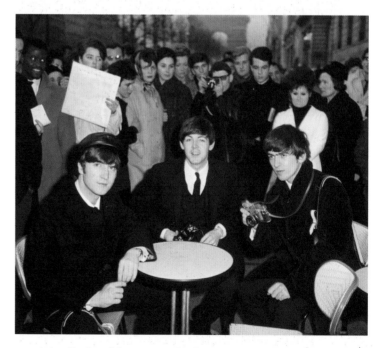

John, Paul and George on the Avenue des Champs-Élysées in Paris, France, January 1964.

Nelson Mandela and nine other leaders of the African National Congress were put on trial in South Africa in July 1963, charged with sabotage. 'During my lifetime I have dedicated myself to this struggle of the African people,' Mandela declared in a three-hour speech delivered from the defendants' dock in April 1964. 'I have cherished the ideal of a democratic and free society in which all persons live together in harmony and with equal opportunities. It is an ideal which I hope to live for and to achieve. But if needs be, it is an ideal for which I am prepared to die.'[44] He was sentenced to life in prison.

France had withdrawn from Vietnam in 1954, and beginning in 1958, de Gaulle had seemed to offer support for Algerian independence. '*Je vous ai compris,*' he declared during a visit. Even as the United States began waging a counter-insurgency war in Vietnam and Britain continued its staggeringly brutal campaign to suppress the Mau Mau independence movement in Kenya, de Gaulle agreed to Algerian independence in July 1962. The next month, an assassin tried to kill him. On 11 March 1963, the day the would-be assassin was executed by a firing squad, The Beatles were taping a radio show. The next day, in Texas, Lee Harvey Oswald ordered a rifle.[45]

Even as The Beatles were being hailed as the instigators of the New Madness, symbols of everything from mass bohemianism and student activism to sexual liberation and women's emancipation and the stirrings of a counter-cultural revolution, they were mainly busy writing, performing and recording music.[46] In Paris in those early weeks of 1964, McCartney took a series of mirrored photographs of himself, holding the camera tight against his chest. He shot photographers shooting back at him; Ringo in a Napoleon hat; everyone mugging with plaster busts of themselves, for bronze sculptures made by David Wynne; a headless woman in a coat; a gendarme, caught through the back window of a limousine, directing traffic, as if he, too, were forever posing for a camera. The Beatles kept one eye on their audience and one eye on America. A fistfight between photographers and the management disrupted one early performance; the Olympia had to be ringed by gendarmes. During those three weeks in Paris, they performed twice and sometimes three times a day. They went into a studio and recorded German-language editions of some of their hits – 'Komm, Gib Mir Deine Hand' ('I Want To Hold Your Hand') and 'Sie Liebt Dich' ('She Loves You') – and recorded a song McCartney had written in their hotel room: 'Can't Buy Me Love'. They ran into Johnny Hallyday in the studio: McCartney shot him thrumming. In spare moments, they listened, rapt, to Dylan's second album, *The Freewheelin' Bob Dylan.*

> Yes, 'n' how many deaths will it take till he knows
> That too many people have died?

They were writers and composers, musicians and recording artists, and if there was political upheaval all around them, it barely touched them.[47] But the music always reached them.

> The answer, my friend, is blowin' in the wind
> The answer is blowin' in the wind.

Back at their hotel, the night after their first show in France, they got a telegram telling them that 'I Want To Hold Your Hand' had reached the top of the *Cash Box* chart in America (it topped the *Billboard* chart the next week). The news was both a thrill and a relief. 'I'd been very fussy about America,' McCartney said not long afterwards. 'I'd said, "We can't go to America, and come back, having failed. If we ever get number one there, then we can really go in there and, you know, we'll be kings."'[48]

In the United States, Capitol Records printed five million posters featuring a drawing of four sets of Beatles hair – faceless – and the promise 'The BEATLES Are Coming!'[49] They came on 7 February, flying into an airport newly named after the dead American president.[50]

THE BRITISH INVASION

'The British invasion this time goes by the code name Beatlemania,' Walter Cronkite announced.[51] Flying into JFK airport in New York, Ringo Starr would later say, was

like flying into an octopus, the tentacles reaching up to the plane. Thousands of teenagers showed up, in a swarm. After The Beatles' Pan Am flight landed, and the Fab Four gathered on a stage for a press conference, the screaming was so loud that some reporters assumed it was the screech of a jet engine.[52] 'What do you think your music does for these people?' one perplexed reporter asked.

> Starr: I don't know. It pleases them, I think.
> Well, it must do, 'cuz they're buying it.
> Reporter: Why does it excite them so much?
> McCartney: We don't know. Really.
> Lennon: If we knew, we'd form another group and
> be managers.
> Reporter: What about all this talk that you
> represent some kind of social rebellion?
> Lennon: It's a dirty lie. It's a dirty lie.

What did they represent? everyone asked. Rebellion? Or maybe something closer to the opposite? 'The Beatles want to hold your hand,' wrote Tom Wolfe. 'But the Stones want to burn down your town.'[53]

> Reporter: Are you concerned about the rumour
> that's going around that the Rolling Stones are
> more important than the Beatles?
> Lennon: Is it worrying us? No.
> Starr: No.
> McCartney: It doesn't worry us, 'cuz you get . . .
> Lennon: We manage our grief.[54]

They rode to their hotel, the Plaza, in a motorcade, under police escort. McCartney called up a radio station and requested Marvin Gaye. 'ELVIS IS DEAD, LONG LIVE THE BEATLES,' read a poster carried by a girl in the crowd of four thousand that had gathered outside the hotel. 'We want the Beatles!' they chanted, in scarfs and mittens, against the cold. 'So this is America,' Starr said to himself. 'They all seem out of their minds.'[55]

McCartney pulled out his camera and took pictures from the plane and from the motorcade: jet engines, skyscrapers, girls in crowds, police in double-breasted

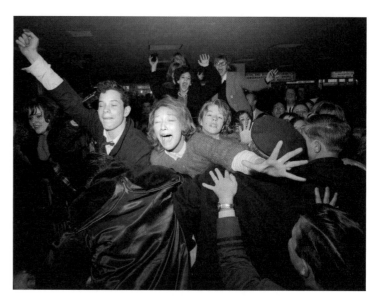

Police at JFK Airport restrain Beatles fans.

dress blues, police on horseback, police in riot helmets, police, police, police. You could 'find 200 or 300 of them . . . protecting the Beatles,' a witness later testified, during hearings on race riots, 'whereas up in some of the denser areas of the West Side and Harlem, you can't find a policeman at any time of day.'[56]

They were surrounded, almost always. And they were almost always together, their own defence. 'It was a brotherhood,' George Martin said. 'It was like a fort, really, with four corners, that was impregnable.'[57] By the time they got to New York, they well knew the particular experience of touring foreign lands. Lennon, asked whether he liked Sweden, after performing there in October 1963, said, 'Yes, very much. It was a car and a room and a room and a car and we had cheese sandwiches sent up to the hotel.'[58]

> Reporter: Have you been out since you've
> been here?
> McCartney: I dunno, with the police hanging
> around all the time.[59]

One reporter called them 'prisoners with room service'.[60] Outside, the girls kept screaming and shrieking and fainting. Weren't they the real prisoners? 'What did it

mean that young women were willing to violate police barricades, ignore police authority completely so that they could try to touch Ringo's hair?' asked the feminist critic Susan Douglas. 'It was kind of a collective jailbreak.'[61]

A *Life* magazine reporter, looking back, said The Beatles were 'the great can opener of the twentieth century'. It was the height of the Cold War. *Dr. Strangelove or: How I Learned to Stop Worrying and Love the Bomb* opened in theatres at the end of January; originally scheduled for release on 22 November 1963, its opening, like the CBS News report on The Beatles, had been delayed because of the Kennedy assassination.

> Reporter: It's been said that the Beatles are a threat
> to public safety. Could you give me your reaction
> to that, any one of you?
> Lennon: Well, we're no worse than bombs, are we?[62]

If The Beatles were a can opener, what did they open up? What, at bottom, did they represent, and who? 'They sort of represent the teenage people,' one teenager told a reporter.[63] 'The feminine side of society was represented by them in some way,' Yoko Ono remarked in 1969.[64] She was hardly alone. Plenty of people have argued that The Beatles represented feminism or, in any case, advanced it, by their own femininity – their androgynous appearance, their tenderness, their songs' endless lyrics about pleasing women, loving women, learning from women, the sympathy, the compassion.

> Eleanor Rigby
> Picks up the rice in the church where a wedding
> has been
> Lives in a dream
> Waits at the window
> Wearing the face that she keeps in a jar by the door
> Who is it for?

Whether it came from Lennon and McCartney's relationships with their mothers or their wives or from Brian Epstein, who was gay and had his own sense of the fluidity of gender and sexuality, this feminine quality of

The Beatles' would only grow, sometimes appearing as a throaty neediness,

> Half of what I say is meaningless
> But I say it just to reach you, Julia

sometimes a solemn, wistful longing.

> When I find myself in times of trouble
> Mother Mary comes to me
> Speaking words of wisdom
> Let it be

There was the joy and sadness to the music, the brilliance of it all, and then there was the ecstasy of listening to it, the sexual release – 'Close your eyes and I'll kiss you/Tomorrow I'll miss you' – or, for the very lucky and very dedicated, the almost unbearable excitement of getting a glimpse of The Beatles themselves, each ecstasy taken as still another symptom of the newest madness.[65] 'The cause of this malady is obscure,' insisted David Dempsey, a critic for the *New York Times*, in an article titled 'Why the Girls Scream, Weep, Flip'. He suggested, on the one hand, that these particular girls were desperate: 'membership in the screaming and jumping societies includes a high proportion of the homely, and of those who are lonesome, or ill at ease in social situations.' Also, he argued – not the first or the last to see The Beatles, as well as their fans, as somehow threateningly, mysteriously Black – the screaming and writhing was, at bottom, an expression of primitivism, the music full of 'jungle rhythms', the dancing 'instinctively aboriginal'.[66]

Meanwhile, on a planet more closely tied together than ever before, outbreaks of the madness in other parts of the world were attributed to the corroding influence of the West. Between 1962 and 1964, when Beatlemania was spreading from Liverpool and London to Paris and New York, dozens of teenage girls in a rural boarding school in Tanganyika, East Africa, began laughing and crying, uncontrollably, and for no apparent reason, and could not stop. Unable to study, they were sent home, but that only seemed to spread the affliction. The outbreak affected

thousands of people and occasioned months of investigation. After another outbreak in Uganda in 1964, experts offered the diagnosis of 'mass hysteria', possibly caused by the strain of modernity itself.[67]

> Reporter: What do you think about all the
> psychologists that are giving . . .
> Harrison: Oh . . . rubbish.
> Reporter: . . . all these heavy, heavy definitions of
> what it all means?
> Harrison: A load of rubbish.
> Lennon: They've got nothing else to do, them fellas.[68]

Mass hysteria: you might see it in schoolgirls, 'after a rock 'n roll concert,' one doctor wrote, analysing the outbreaks in Tanganyika and Uganda in the light of Beatlemania. But, in general, 'Societies in flux in which people continue to practice the old in the face of the new seem particularly prone to have hysteria epidemics.'[69] Whatever way you looked, in 1964, teenage girls were getting unruly.

> Hold your head up, you silly girl
> Look what you've done
> When you find yourself in the thick of it
> Help yourself to a bit of what is all around you.

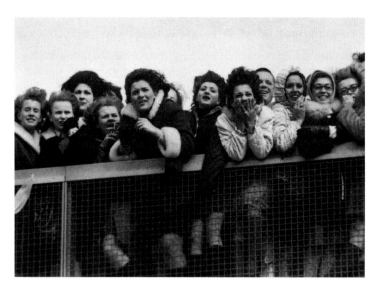

Excited fans watching The Beatles arrive at JFK Airport, 7 February 1964.

I asked McCartney why the girls screamed. He leaned back in his chair, winding up an answer he must have given hundreds of times before. Thousands. He smiled. That smile. 'Can you blame them?'

On 9 February, the day The Beatles went on *The Ed Sullivan Show*, 'I Want To Hold Your Hand' was the nation's number-one single, but its number-one album was *The Singing Nun*, a collection of religious songs by Jeannine Deckers, a Dominican nun from Belgium who accompanied herself on acoustic guitar.[70] (Deckers appeared on *Ed Sullivan* in 1964, too; Sullivan visited her in the monastery.)[71] Johnny Hallyday had appeared on the show in 1962 – in an episode taped at the Moulin Rouge.[72] But The Beatles, spruce in suits and ties, made television history: seventy-three million people tuned in, the largest audience in television history.

They knew they'd brought something new, but they also knew they'd brought something old, something American, back to America. 'We used to laugh at America except for its music,' Lennon said. 'It was black music we dug,' he added, but 'the whites only listened to Jan and Dean.' The point, he said, was to get people to 'listen to this music.'[73] They listened. For the first three months of 1964, Beatles records accounted for 60 percent of all record sales in the United States.[74]

That first night on *The Ed Sullivan Show*, The Beatles played two short, mind-blowing sets. And then Sullivan, very much the older gent, hair slicked back, looking something like a vampire, thanked the New York Police Department for handling the unprecedented crowds outside the theatre and for closing Broadway at Fifty-Third. It had been a near riot. A jailbreak.

THE RACE

'It's like I'm running for president, innit?' McCartney said two days later, on 11 February, as passengers on a train from New York to Washington asked him for his autograph.[75]

In the United States, 1964 was an election year. Arizona senator Barry Goldwater, a conservative who opposed the Civil Rights Bill, entered the race for the

Republican presidential nomination. 'There is a stir in the land,' Goldwater would declare. 'There is a mood of uneasiness. We feel adrift in an uncharted and stormy sea. We feel we have lost our way.'[76] The Texan Lyndon B. Johnson, who'd replaced Kennedy, was running as the Democratic nominee.

> Reporter: What do you think of President Johnson?
> Starr and Lennon: Never met him.
> Lennon: (comically, to Starr) Oh, we're thinking alike!
> McCartney: We haven't met him.
> Starr: We don't know. We've never met the man . . . (pause) Does he buy our records?[77]

In November 1963, after Kennedy's assassination, Johnson had pledged to pass a proposed civil rights bill. 'No memorial oration or eulogy could more eloquently honour President Kennedy's memory than the earliest possible passage of the civil rights bill for which he fought so long,' the new president told a joint session of Congress. In his State of the Union address in January, Johnson had declared a 'war on poverty' and renewed his dedication to the Civil Rights Bill, pledging to open every opportunity 'to Americans of every colour'. On 10 February, the day after The Beatles appeared on *The Ed Sullivan Show* from New York, the bill finally passed the House. Before the end of the month, it would reach the floor of the Senate. Johnson got to work, senator by senator. As Johnson's biographer Robert Caro has explained, 'If the senator said, "You know, that's gonna kill me with my constituency," he would refute, he would cajole you, or threaten you, or bribe you. Anything he had to do to get your vote.' Richard Russell, a Georgia senator and the leader of the South, said he could have beaten Jack Kennedy on civil rights, but he couldn't beat Lyndon Johnson. 'He'll tear your arm off at the shoulder and beat you over the head with it,' Russell said. 'He will get this passed.'[78]

The Beatles had planned to fly to Washington, but a snowstorm led them to take the train instead. On board, everyone took photographs, including each of The Beatles. Starr, a natural Buster Keaton, the underdog in an oversized overcoat, clowned around with the cameramen

Paul greets waiting journalists and photographers in Washington, D.C.

and did his imitation of a photographer, carrying a half dozen camera bags and crying out, 'Exclusive!' McCartney took some of his best photographs of the trip on that train ride. One image, from a Pennsylvania train station, shows two Black men taking a break from shovelling snow; in another, a Black worker strokes his chin on a station platform, a cargo car hulking behind him. At some point on the ride, a reporter cornered McCartney.

> Reporter: What place do you think this story of the Beatles is going to have in the history of Western culture?
> McCartney: You must be kidding.[79]

Still, they were taking it all in. In England, McCartney said, he'd seen scenes of civil rights protests, the footage at Little Rock, 'the two black girls going into the school and the baying mob and sort of police and dogs and it was like God, that is so scary. And we didn't think America was like that. So this was the thing, it was a gradual finding out about America because we'd bought the dream, give me your huddled masses, America's the land of the free and safety from the Holocaust and wow, you know, it's going to be much better now.' But the more the four men saw of America, the more they saw of segregation. A great disillusionment. 'It was like,' McCartney added, 'God, is that really true?'

In Washington, he took pictures of the Capitol and the White House and the marquee at the Coliseum, where The Beatles performed their first U.S. concert. At a nearby playhouse, he shot another marquee: 'CHRISTINE KEELER GOES NUDIST' – the Christine Keeler whose affair with John Profumo had brought down Britain's prime minister.

While The Beatles were in Washington, southerners in the Senate were plotting a filibuster. It began a few weeks later. 'We will resist to the bitter end any measure or any movement which would tend to bring about social equality and intermingling and amalgamation of the races in our states,' Russell declared. The filibuster would last fifty-four days. Both Martin Luther King Jr and Malcolm X travelled to Washington to watch. It was the only time the two men met. 'I'm for freedom, justice, and equality for Black people in this country,' Malcolm X told a reporter. 'And since the liberal element of whites claim that they are for civil rights legislation, I have come down today to see, are they really for it, or is this just some more political chicanery that they're using to trick the Negroes into voting for them when the election rolls around this year.'[80]

Brian Epstein had warned The Beatles never to discuss politics in public; it would narrow their appeal.[81] But there was no real way to avoid the questions of race, segregation and racial justice. It came at them again and again. 'The Beatles made it all right to be white,' *Time* magazine announced, in a cover story from 1965.[82] 'We don't have to wait for The Beatles to legitimise our culture,' Stokely Carmichael fumed.[83] Still, The Beatles had legions of Black fans. 'They were so fresh and irreverent,' said Julian Bond, who, in 1960, while a student at Morehouse College, helped found SNCC, the Student Nonviolent Coordinating Committee. The Beatles, Bond said, were 'what we imagined ourselves to be – contemptuous of adult forms and not willing to conform to the standard way of dressing or thinking.' *Time* magazine might have thought of The Beatles as somehow reclaiming whiteness, but civil rights leaders embraced The Beatles as champions of the cause. SNCC once sent out a memo about how a New York fundraiser would be much more successful if 'James Brown or the Beatles could be added' to the bill, acts indistinguishable to SNCC organisers.[84]

In the spring of 1964, as the filibuster in the Senate wore on, Johnson announced a new agenda. His administration would not only wage a War on Poverty and secure passage of the Civil Rights Act but would work to produce a Great Society. 'The Great Society rests on abundance and liberty for all. It demands an end to poverty and racial injustice, to which we are totally committed in our time. But that is just the beginning,' he said during a speech in Michigan. 'It is a place where the city of man serves not only the needs of the body and the demands of commerce but the desire for beauty and the hunger for community.'

> You know I work all day
> To get you money to buy you things
> And it's worth it just to hear you say
> You're gonna give me everything
> So why on earth should I moan?
> 'Cause when I get you alone
> You know I feel okay

The desire for beauty and the hunger for community after a hard day's night. How mad was that?

THE GREATEST

On 13 February 1964, The Beatles flew to Miami; the captain of their airplane wore a Beatles wig.[85] They spent a week in Miami Beach, more free time than they'd had in months. They went swimming. They went fishing. They went boating. They went water-skiing. They drank cocktails by the pool. McCartney shot in colour: seagulls and surf, girls in bikinis, Harrison shirtless, Starr in sunglasses, an advertising sign dragged along by a single-engine plane cutting through a cloudless blue sky: 'THERE IS ONLY ONE MISTER PANTS.'

On 16 February, The Beatles appeared again on *The Ed Sullivan Show*, broadcast, live, from their Miami Beach hotel. 'Here are four of the nicest youngsters we've ever had on our stage,' Sullivan said, waving them on.

I've got arms that long to hold you
And keep you by my side
I've got lips that long to kiss you
And keep you satisfied

And the girls screamed and swooned and clutched at their hair.

Meanwhile, Miami Beach was bracing for one of the greatest sports events of all time, the first boxing match between heavyweight champion of the world Sonny Liston and rising star Cassius Clay, scheduled for 25 February. On 18 February, as part of their publicity tour, The Beatles were driven in a limousine to be photographed with Liston, who was widely expected to win. Robert Lipsyte, a twenty-six-year-old sportswriter, was in Florida to cover the fight. Liston, he said, 'took one look at these four little boys and he said, "I ain't posing with them sissies."' Then they went to see Clay. Lipsyte got to the gym where Clay was training and asked the clutch of reporters what all the hubbub was about. 'Some group, you know, singers for, for girls,' someone told him.

And Cassius Clay has not arrived. The Beatles turn around, 'cuz they're not gonna wait for some Cassius Clay, but the guards push them right up. And like – in those days you could push the Beatles. They pushed them right up the stairs and they push all five of us into an empty dressing room and lock the door. The Beatles were raging, and they were banging and cursing. And then suddenly, the door bursts open, and there is the most beautiful creature any of us have ever seen. You, you forget how big Cassius Clay was 'cuz he was so perfect. He was laughing and he said, 'Come on, Beatles, let's go make some money!' And they followed him out, like, like kindergarten kids.

In a series of famous photographs, Ali, in boxing shorts and gloves, punches a row of Beatles, who fall like dominoes, then stands over them, lying in a row in the ring, while he beats his chest. Lipsyte:

And afterwards the Beatles leave. Cassius Clay goes back into that dressing room to get his rubdown. He, he beckons me over and he said, 'So who were those little sissies?'[86]

A week later, Clay would defeat Liston in seven rounds. After the fight, he'd publicly avow his conversion to the Nation of Islam and take the name Muhammad Ali. They fought a rematch the next year. Ali knocked Liston out in the first round.

Reporter: How long will you be in America?
Lennon: Till we go.[87]

The Beatles would never look back. They flew to London on 21 February, their first American tour come to an end. But their rise had only just begun. They recorded more singles and released another album in 1964, and made their first film. By 4 April, Beatles songs occupied the first five spots on the *Billboard* singles chart: 'Can't Buy Me Love', 'Twist And Shout', 'She Loves You', 'I Want To Hold Your Hand' and 'Please Please Me'. The music industry would never be the same.

'We were all on this ship in the sixties, not just The Beatles, but our movement, our generation,' Lennon later said. 'And of course we went somewhere.'[88] Quite where is harder to say.

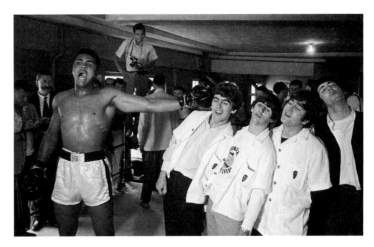

The Beatles with American heavyweight boxer Cassius Clay (later Muhammad Ali).

In June, The Beatles set out again, on their first 'world tour.' It would take them from Denmark to Hong Kong and Australia. Back in the United States, Democratic Senator Hubert Humphrey made a speech in the Senate, in an attempt to end the filibuster on the Civil Rights Bill. 'I say to my colleagues of the Senate that perhaps in your lives you will be able to tell your children's children that you were here for America to make the year 1964 your freedom year. I urge my colleagues to make that dream of full freedom, full justice, and full citizenship for every American a reality by their votes on this day, and it will be remembered until the ending of the world.'[89] The bill finally passed on 19 June. Two days later, three civil rights workers – James Chaney, Andrew Goodman and Michael Schwerner – were killed by Klansmen in Mississippi. They'd been trying to register Black voters, part of a campaign called Freedom Summer. But that summer would become, too, the first of four 'long, hot summers' of racial justice uprisings, each following another grisly instance of police brutality, the first starting in Harlem in July, only weeks after Johnson signed the Civil Rights Act.

Early in July, the Republican National Convention met in the Cow Palace, in San Francisco. Barry Goldwater had accepted the nomination, denouncing moderation and inaugurating a new era in American politics: the rise of extreme conservatism.[90] But outside the Cow Palace, Beatles fans staged 'Ringo for President' rallies.

Reporter: Who do you like for President?
McCartney: Ringo – and Johnson's second choice.[91]

Fans at Ringo for President rallies wore buttons that read, 'IF I WERE 21, I'D VOTE FOR RINGO.' At the time, young Americans, like young Britons, were fighting to lower the voting age to eighteen, on the grounds that if they could be drafted to risk their lives in Vietnam, they ought to be able to vote. In the United States, after years of a student-run antiwar movement, the voting age would be lowered in 1971 with the ratification of the Twenty-Sixth Amendment.[92]

On 18 August, The Beatles headed out on a second American tour – thirty-two shows in twenty-four cities in thirty-four days. It started with a press conference in Los Angeles.

Reporter: Ringo, how do you feel about the 'Ringo for President' campaign?
Starr: Well, it's rather . . . It's marvellous!
Reporter: Assuming you were President of the United States, would you make any political promises?
Starr: I don't know, you know. I'm not sort of politically minded.
Lennon: Aren't you?
Starr: No, John. Believe me.

It was the same old question: What do The Beatles represent? And, as ever, the press conference got very *Goon Show*.

Reporter: Ringo, would you nominate the others as part of your cabinet?
Starr: Well, I'd have to . . . wouldn't I?
Harrison: I could be the door.
Starr: I'd have George as treasurer.
Lennon: I could be the cupboard!

The next night, The Beatles opened their tour in San Francisco, where they played at the Cow Palace, amid the shadows of Goldwater.

Reporter: I want to ask the Beatles what they think of Barry Goldwater.
McCartney: Boo! (shows thumbs down)
(the crowd cheers)
McCartney: (through the crowd noise): I don't like him . . . I don't like him . . . unquote![93]

The Beatles were playing in Vancouver on 22 August when the Credentials Committee of the Democratic National Convention met in Atlantic City and Fannie Lou Hamer, speaking from the floor, exposed the travesty of the convention. Mississippi, like other 'Jim Crow', or racially segregated, states (parts of the former Confederacy), had sent an all-white delegation. In protest, Hamer had

Congress of Racial Equality (CORE) civil rights protesters at the Republican National Convention at the Cow Palace, San Francisco, July 1964.

answering the phone by hollering, 'This is Beatlemania here!'[95]

The New Madness kept spreading. On 14 September, when what became the Free Speech Movement began at the University of California at Berkeley, The Beatles were playing in Pittsburgh. 'You've got to put your bodies upon the gears and upon the wheels, upon the levers, upon all the apparatus, and you've got to make it stop,' Berkeley student Mario Savio declared, in a mass protest that began after the university tried to prevent students who'd worked for Freedom Summer from rallying for support on campus.[96]

The Beatles, meanwhile, were hitting up against the limits of their own speech. If they had deftly evaded reporters' political questions since that first press conference at the Pan Am lounge in Kennedy airport in February –

> Reporter: What about all this talk that you represent some kind of social rebellion?
> Lennon: It's a dirty lie. It's a dirty lie.[97]

– they flew right into them that August. They were scheduled to play their first concert in the Jim Crow South, in Jacksonville, Florida, on 11 September. On 26 August, at a press conference in Denver, before their concert there that night, they were asked about the hotel they were slated to stay in when they got to Jacksonville, the George Washington.

> Reporter: George, I understand that from here you're going, later on next month, down south. I understand you're pretty against the segregation down there and we understood there were some problems about the hotel you might stay in in Jacksonville.
> Harrison: We don't know about our accommodations at all. We don't arrange that. But, you know, we don't appear anywhere where there is.[98]

The press kept bringing it up. On 6 September, at a press conference in Montreal, they were asked whether they

co-founded the Mississippi Freedom Democratic Party, which sent its own delegation. She told the story of the beatings and arrests she'd endured, trying to register Black voters. She told the story of the murder of the three civil rights workers, and the assassination of the civil rights leader Medgar Evers. And then she asked, 'All of this is on account we want to register, to become first-class citizens, and if the Freedom Democratic Party is not seated now, I question America, is this America, the land of the free and the home of the brave where we have to sleep with our telephones off of the hooks because our lives be threatened daily because we want to live as decent human beings, in America?'[94]

Johnson accepted the Democratic nomination on 27 August. The next day, in New York, The Beatles finally met Bob Dylan, in a room at the Delmonico hotel, an encounter mostly remembered for being their first introduction to marijuana. Dylan got so high he kept

would perform in a segregated venue. Lennon said, 'We will not appear unless Negroes are allowed to sit anywhere they like.' All their contracts, at this point, included a non-segregation clause. Technically, any segregated concert would have violated the new Civil Rights Act.[99] 'Segregation is a lot of rubbish,' Starr said, not long after. McCartney continued to be shocked by America. 'Off in the woods somewhere there would be these Nazis and you'd go, "Oh fucking hell, they're loonies these Americans,"' he told me. 'You knew about Ku Klux Klan, you'd heard all that history and lynchings and stuff. But you thought it was all over, you thought it was all better.' And then you found out it wasn't all better.

They played in Jacksonville, at the Gator Bowl, and then the next day headed north, to play in Boston Garden, and ended their North American tour on 20 September, in New York. They were touring the United Kingdom in the fall, when the elections were held in October. The night before the election, Brian Epstein sent a telegram to the Labour Party leader Harold Wilson: 'Hope your group is as much a success as mine.'[100]

On election day, The Beatles sat for an interview in Stockton-on-Tees, the very town where they'd been performing in on 22 November 1963, the day Kennedy was killed.

> Reporter: I think Paul has aspirations to become
> Prime Minister. Have you still got those ideas?
> McCartney: No.[101]

The Labour Party won, and Wilson became the new prime minister – 'Thus pudding the Laboring Partly back into powell after a large abcess,' as Lennon wrote, in his Jabberwockyish orthography.[102] Wilson, forty-eight, promised to create a 'New Britain'.[103] The next month, on 3 November, Americans voted, in a landslide, for Johnson and his Great Society. 'The nationwide triumph of political liberalism that occurred on November 3, 1964, was the last,' the historian Jon Margolis has written. 'Within it lay the seeds of the conservative ascendency.'[104]

But you couldn't see that, at the end of 1964. You could see, instead – or, at least, you can find in the archives

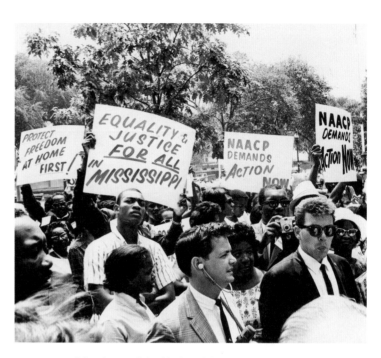

Members of the National Association for the Advancement of Colored People (NAACP) protesting against the disappearance of three civil rights activists from Mississippi, Washington, D.C., U.S., 24 June 1964.

– memos from the leaders of SNCC, hoping to raise money to get Stokely Carmichael out of jail by convincing The Beatles to stage a benefit concert. James Forman sent a telegram to Joan Baez, asking for help in getting a message to them. Then his staff followed up. 'For some time there has been a rumor floating around that the Beatles might be willing to do something for SNCC,' he wrote in 1965. 'It has now become urgent as the Beatles are expected in the U.S. shortly.'[105] That benefit concert never came off. The next year, in a series of interviews for a London newspaper, Lennon said The Beatles had gotten so big, and Christianity seemed to be in such decline, that it was as if The Beatles were 'bigger than Jesus', and McCartney, asked about the United States, denounced its racism. Southern Baptists started burning Beatles records and damning their music as Satanic. Robert Shelton, grand dragon of the KKK, setting Beatles record bonfires in Memphis, declared, 'I couldn't identify them as whether they're actually white or black.'[106] And that, of course, had been one part of the point.

REVOLUTION

Maybe the most powerful photograph Paul McCartney
took in 1964, and certainly the saddest, is a close-up of a
policeman in Miami, on a motorcycle, a revolver and six
bullets at his hip. Malcolm X was shot to death in America
the next year, then, in 1968, Martin Luther King Jr.
McCartney, in 1968, wrote 'Blackbird', he says, about
that civil rights struggle, a quiet anthem.

> Blackbird singing in the dead of night
> Take these broken wings and learn to fly
> All your life, you were only waiting
> For this moment to arise

A great upheaval, a new madness, a counter-culture,
a revolution.

> You say you want a revolution
> Well, you know
> We all want to change the world

The Beatles changed the world in 1964, and the world
changed them, and it spun and unravelled and ravelled,
and the music thrummed and stirred hearts and awakened
souls and rockets flew to space and the oceans began to
rise and the protestors marched and cried and the girls
screamed and screamed and screamed. Everyone dressed
up. In Cuban boots and Italian suits. And everything
changed. Then came a counter-revolution, and a descent
into political violence.

> Don't you know it's gonna be
> All right?
> Don't you know it's gonna be (all right)
> Don't you know it's gonna be (all right)

Maybe it is. Maybe it was. Maybe it will be, holding on to
the ecstasy, forsaking the fury.

Photographs

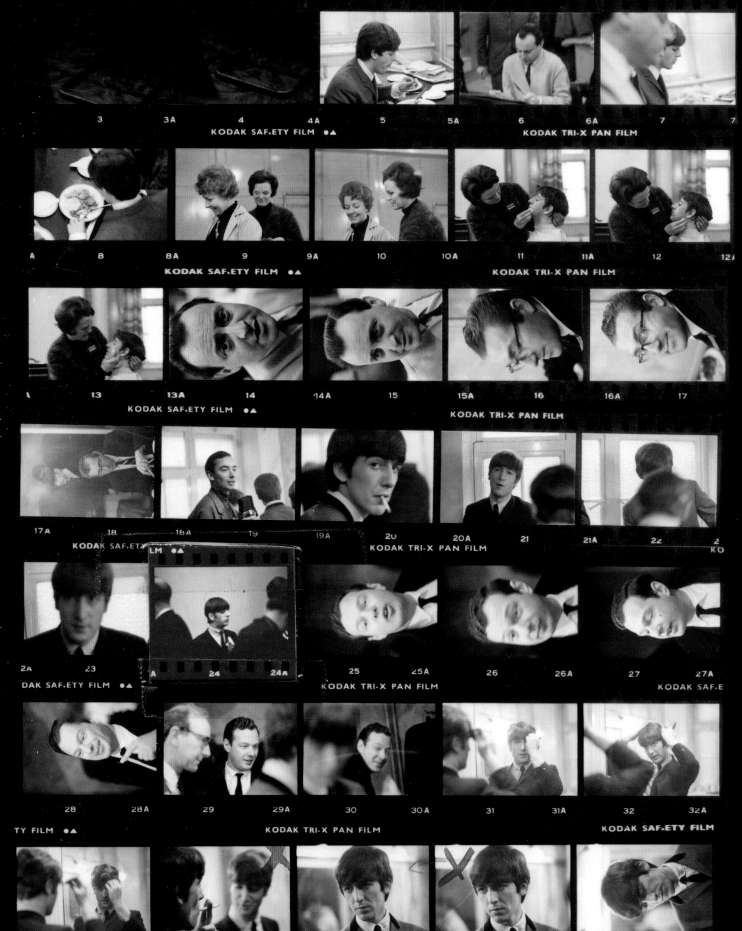

Liverpool

London

Paris

New York

Washington, D.C.

Miami

LIVERPOOL

7th & 22nd December 1963

In late 1963 I was still learning to use my camera and practised by taking portraits of those close by. As a kid I had always been interested in art and what I saw in the world around me, and having a camera let me explore my artistic 'eye' in a new way. As a high school student, I'd won an art prize for a painting I did of a church, so I think some kind of visual sensibility was there from a young age. And after winning a prize in a national essay competition, I spent the book-token on a book of modern art, which opened my eyes to the current art scene. This was the first time I started to form opinions about which artists I liked and which I didn't. By the time I was taking photos I was on the road with The Beatles and had developed a pretty good understanding of composition, framing and patterns in art which I was subconsciously applying. Being on the road also meant I had a host of new subjects to try to capture in the quickly evolving medium of photography.

In the early 1960s we were starting to see the kind of stuff our parents had never seen because of new inventions such as television, portable cameras, colour film. We didn't grow up with coffee table books (or even proper coffee), so I wasn't taking photos with the goal of them ending up anywhere. It was simply another avenue to explore in art and the photographs were just for me, though I'd show them to a few friends and family and maybe make a print for somebody. Publishing the photographs here has added a new dimension to how I look at them now.

I think the following photos show me trying to encapsulate the madness that ensued in late 1963 though early 1964. As someone who came from a working-class estate in Liverpool, I'm proud to say that the craziness we saw as musicians was first experienced in our hometown. I've taken photos of those most familiar to us, so you'll see a number of Liverpool faces and a lot of northern people here.

The photographs also feature John, George, Ringo and, when you include me, the four of us Beatles. As a band, we got a lot of things from Liverpool, without question, but something that really came across and, I think, made us stand out was our sense of humour. People from Liverpool are funny. We're from that tradition. A lot of that humour is evident in these photos and in how we spent our time together. This is one of the things I love about The Beatles. We messed around. It kept us sane. And, looking back, I think it was a great unintended plan – we were using *play* as a tool.

We were curious too, and our horizons were always expanding. We were interested in everything. We began discovering photographers like Henri Cartier-Bresson and Richard Avedon, who we worked with a few years later. In those early days we were working with people like Dezo Hoffman and Norman Parkinson. Parkinson used to line us up and get us to 'pull eyes'. You can see how wide

our eyes are on some of his portraits of us. Robert Freeman was another that we simply spent a lot of time with, and who photographed some of our album covers.

We were learning from all the photographers we met. In Hamburg we met Astrid Kirchherr, who was a great photographer, and became good friends with her. I remember being inspired by seeing what Astrid saw and how she worked. In general, we were with photographers so often we learnt their tricks along the way. I enjoyed watching them work and how they would carry a little black bag with them and without looking they'd dive their camera right into it, just to change the film. Then they'd come out with a newly loaded camera, ready to go again. I appreciated the skill involved in that.

When we were taking pictures ourselves, we would ask the photographers, 'What should the light setting be?' But, of course, sometimes they didn't want to reveal their secrets, or they'd deliberately tell us something wrong, like 'F8 at a fortnight'. I don't think they wanted the other photographers to listen in and give their secrets away to the competition.

Some of the photographs were taken in Liverpool when the four of us were on a music panel show called *Juke Box Jury* and the BBC broke with tradition by coming out of London and up to Liverpool to film it at the Empire Theatre. There is a shot of the host David Jacobs here. After *Juke Box Jury* they brought in a new audience – I think both had been made up of our fan club members – and we taped a special for the BBC called *It's The Beatles*. It was a pretty wild show and had a huge audience when it aired that night. Something like twenty-two million, which was close to half the country at that time.

The photographs I took in Liverpool show a slice of what it was like to be backstage in late 1963: the waiting, the fun, and the ever-present Scouse humour. They show how we were often around other people and musicians, meaning our senses were constantly stimulated. Something which provided inspiration not only in our music, but also in what caught the attention of my camera.

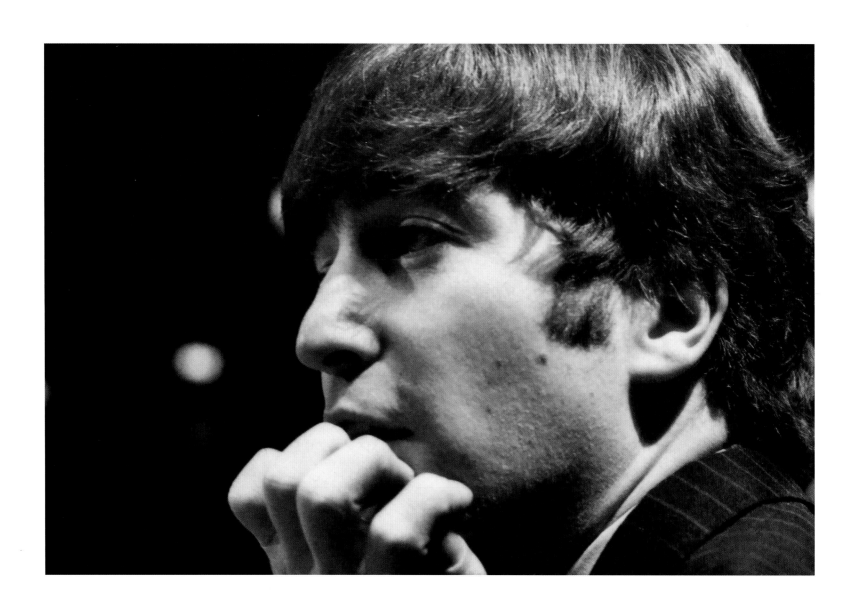

42 John and George.

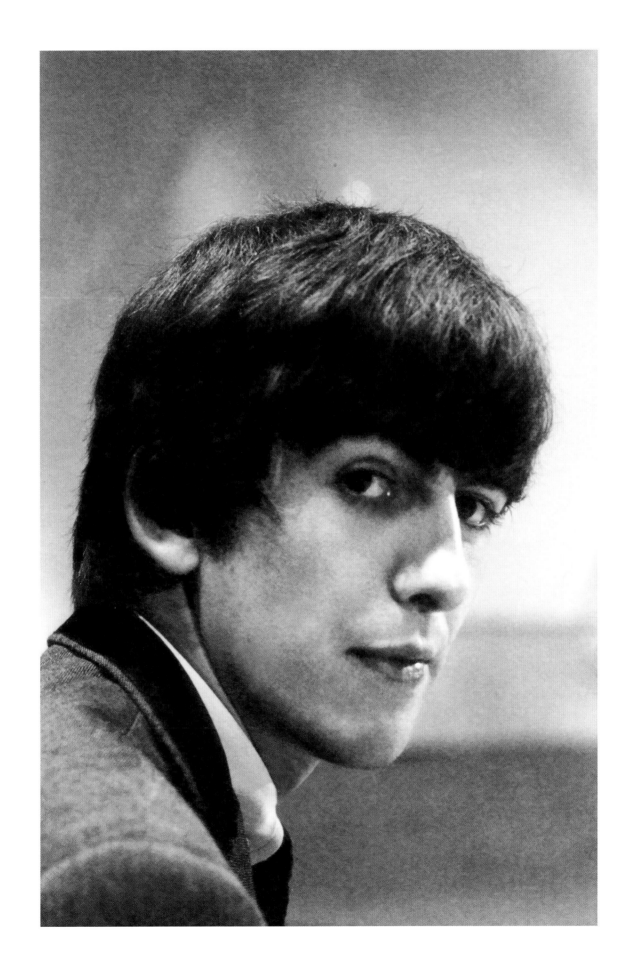

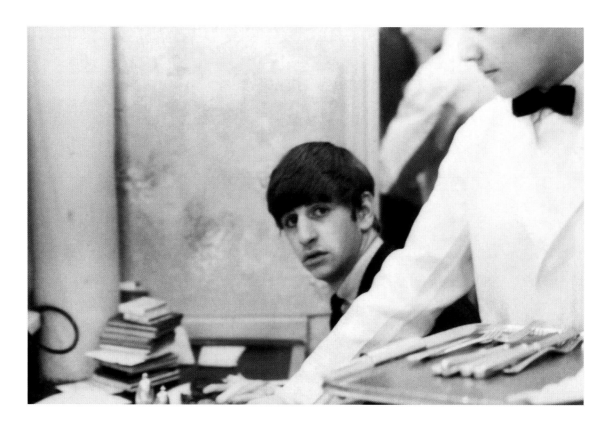

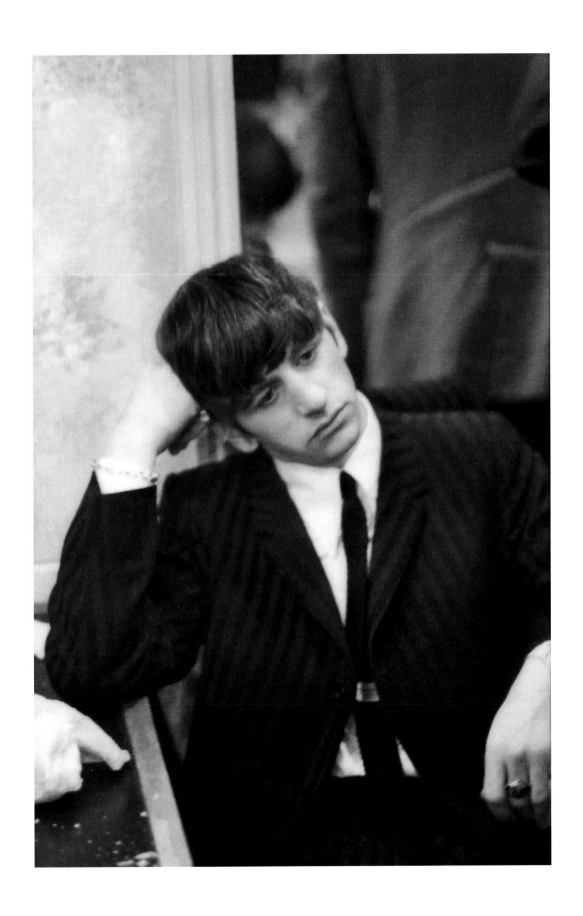

At this point, Ringo had been in the band for a year and a half, but I still remember the first time we played with him. John, George and I looked at each other and knew: this is it!

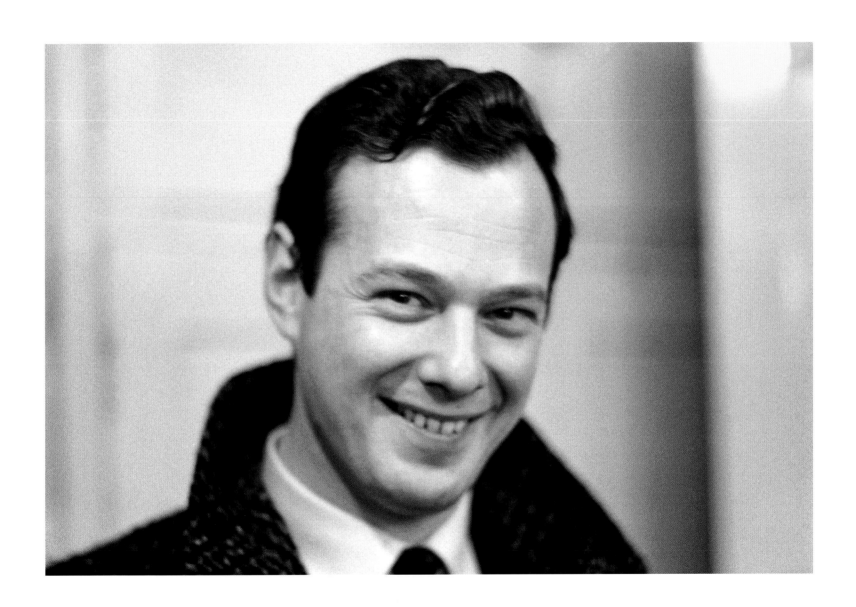

Our manager, Brian Epstein. We called him Mr Epstein and he was the one person who could keep us in line.

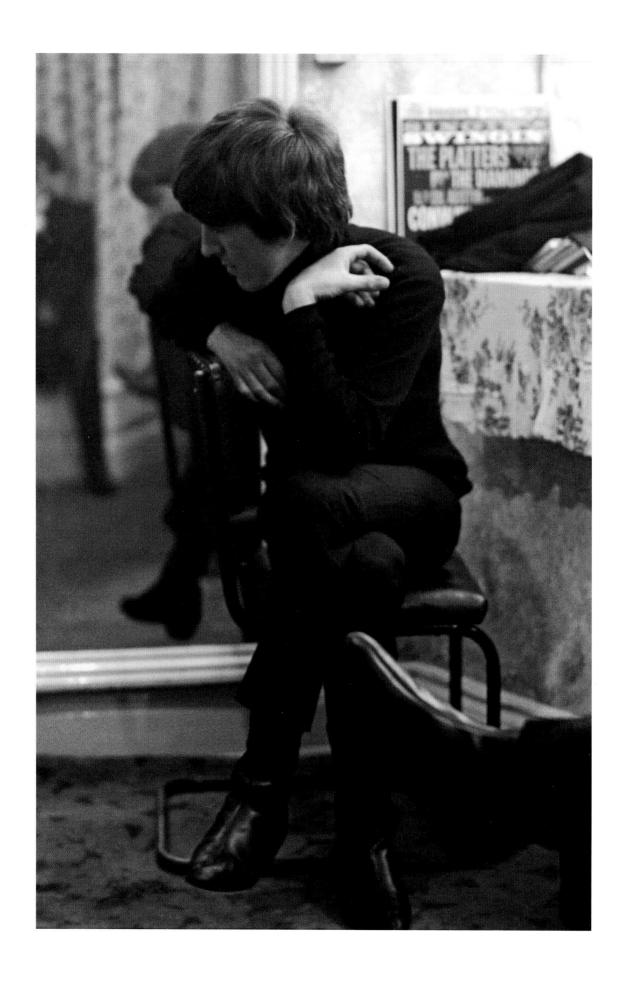

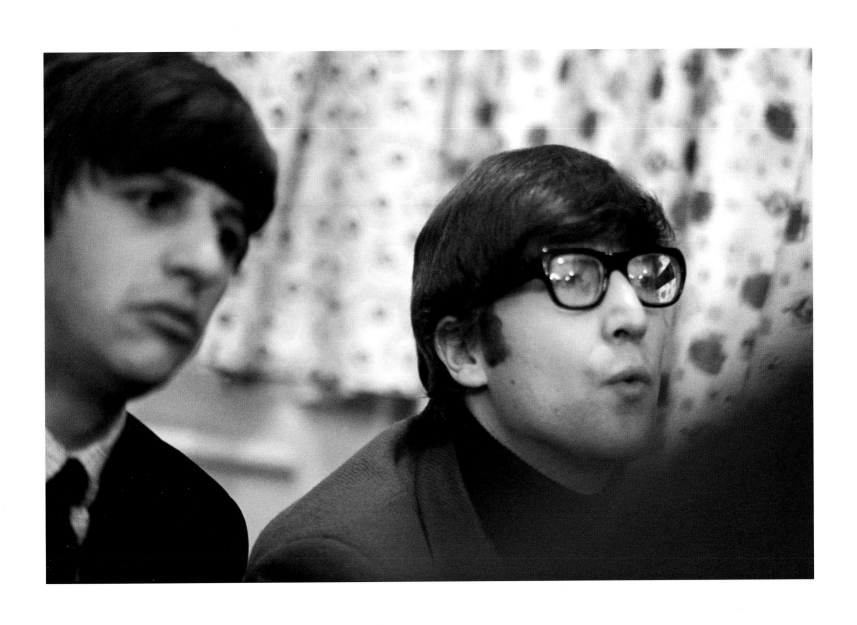

A rare picture of John in his glasses.

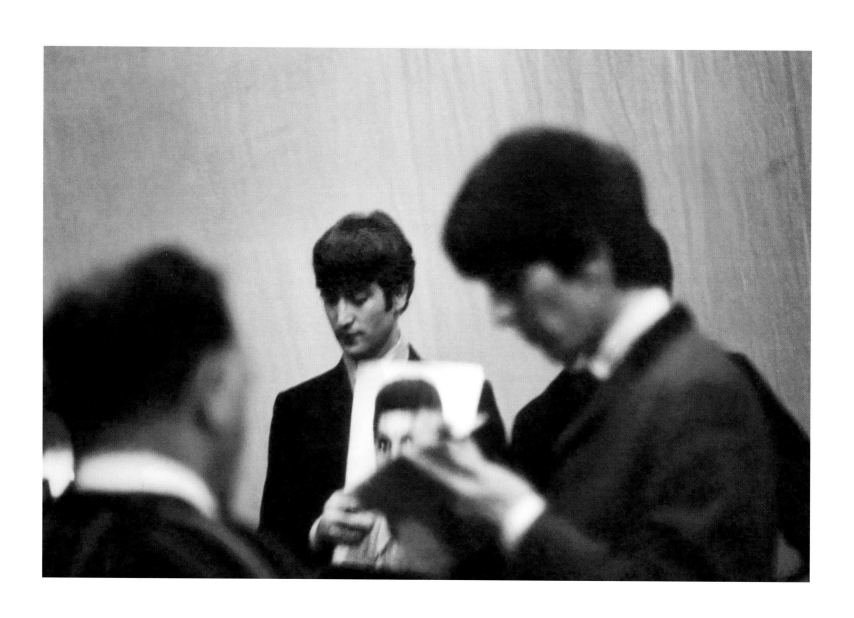

Freda Kelly, who ran our fan club.

Well known to British TV audiences at the time, David Jacobs, the presenter of *Juke Box Jury*.

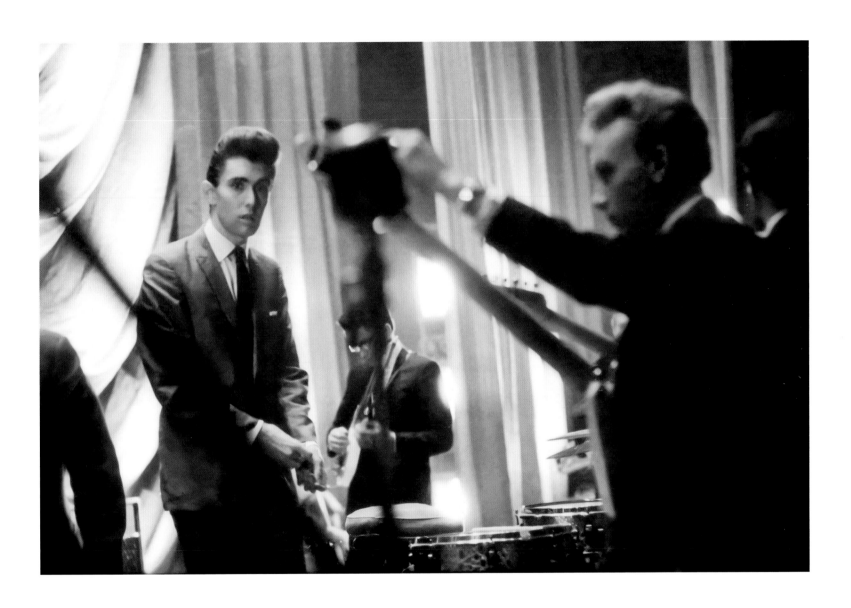

Peter Jay and The Jaywalkers rehearsing.

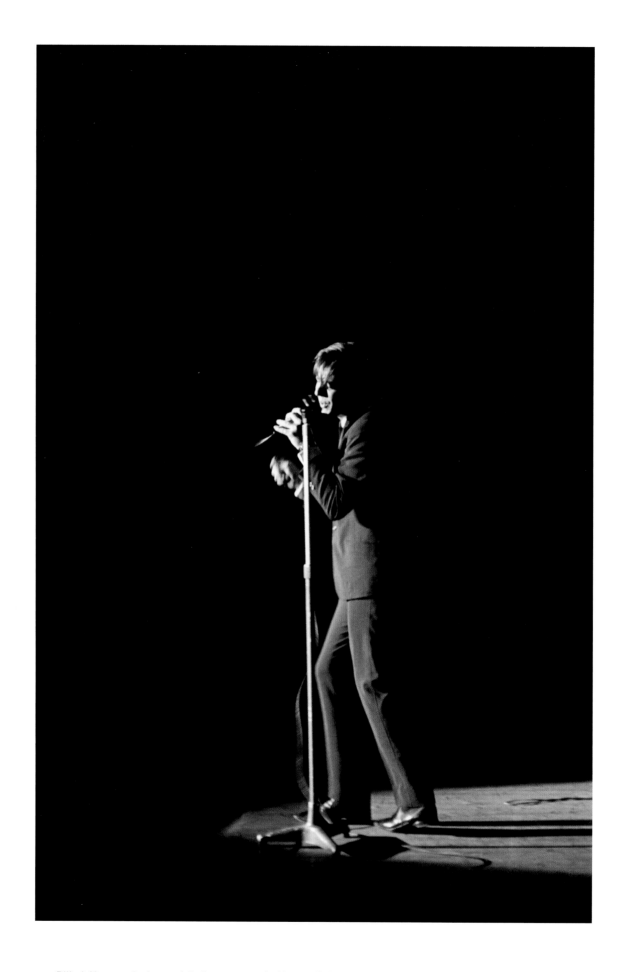

Billy J. Kramer during a plaintive moment in his set, lit by a solo spotlight creating a sense of intimacy.

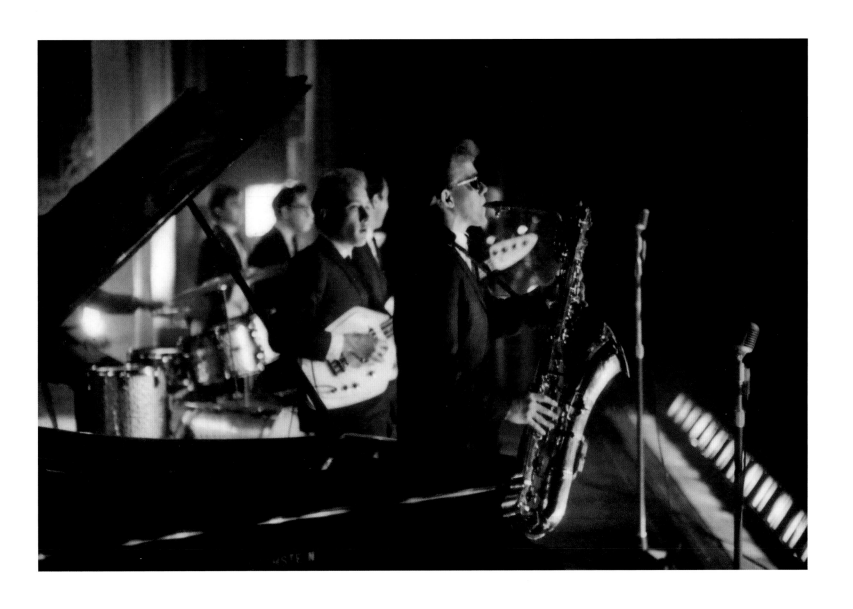

Peter Jay and The Jaywalkers onstage.

Cilla Black's great spirit and distinctive voice took her from the cloakroom
of The Cavern Club onto the national stage. Her real name was Priscilla White.

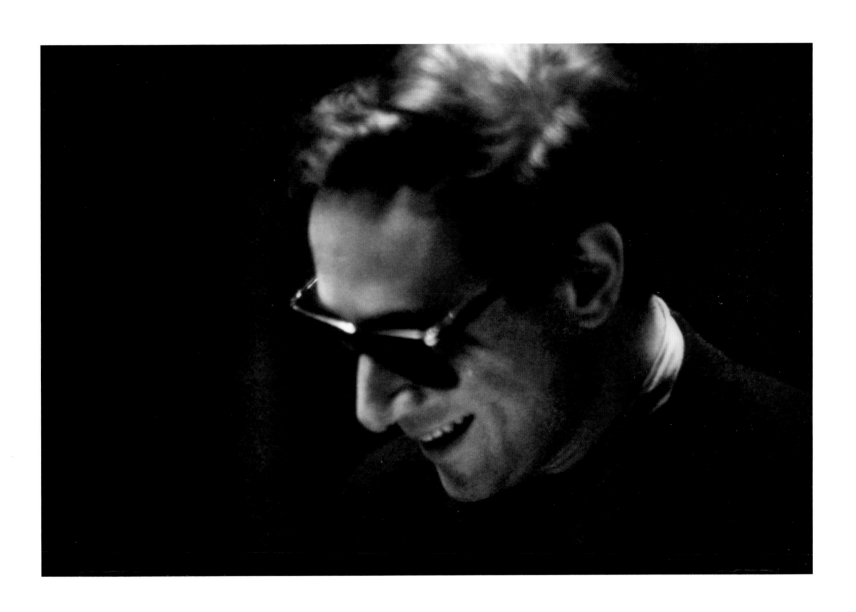

Michael Braun shadowed us in England, France and the U.S. to write his book, *Love Me Do! The Beatles' Progress.*

Our roadie, assistant and friend Mal Evans.

Our publicist Tony Barrow, who coined the term 'Fab Four' and wrote the liner notes for our first album releases. He was the smoker of all smokers!

The X on this photo shows it's been taken from a contact sheet, and the mark —
made by me — indicates it was a favourite.

And all I had asked him to do was 'act naturally'.

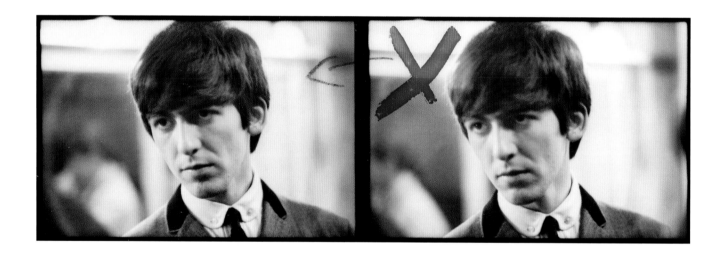

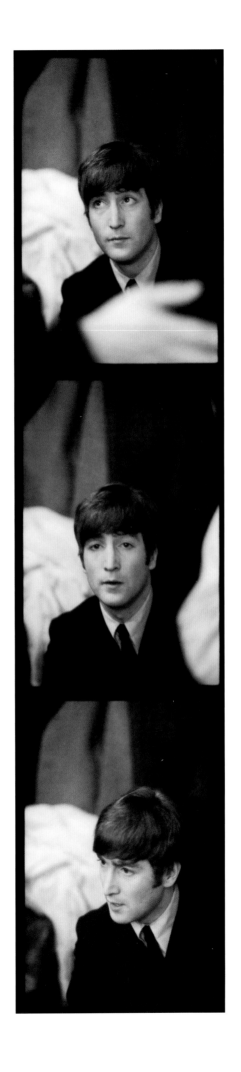

Liverpool

London

Paris

New York

Washington, D.C.

Miami

LONDON.

24th December — 12th January 1964

It was the big city. It was *London,* and I loved it.

I didn't know my way around. But there were paper maps, which you could fold out and read, or you could use that great old street atlas the *London A–Z.* If I needed to go somewhere like Fleet Street, I had to look it up. Just learning to find my way around was exciting and all part of the thrill. London gave me so many new experiences, and some of them inevitably found their way into my photos and songs. I was soaking up everything at that age, especially as it was all so different from where I'd grown up.

Looking back, I can see that photography was becoming more important and present in my life, and my first camera suddenly gave me a way to explore the medium. One of the kids in my office recently pointed out that in meetings I'll start framing things that interest me with my fingers. Forming a frame, looking for a good shot. And as I've been reviewing all these photographs, I only thought of cropping in on a couple of them. If you're confident at composing a shot within the camera's viewfinder, you won't need to crop later. You have to be looking for that good shot, though. If you're sitting around a table with a group of people, it might be difficult, because everyone is too far apart. But if you move a little you can find something that is framed much better. I think you need to know that instinctively, as you don't have long before the moment has gone.

In the early days, we'd often find ourselves needing photos for a promotional handout, so we'd visit these society photographers because music photography was still a new thing. (They didn't come to us yet!) The sessions we attended in London were a bit more professional than we had previously experienced back home. Besides Dezo Hoffman, there was Philip Gotlop, who I remember being based in Kensington. We would make our way over to his studio and do any setups he suggested.

In 1963 I moved into apartment L at 57 Green Street with John, George and Ringo. It's in Mayfair, near Park Lane, which was pretty upper-class even then. The apartment was just bare rooms, though. No chairs, nothing on the walls. It didn't feel like a home, and I got stuck with the smallest room. So, soon afterwards, I was invited to live with my girlfriend Jane Asher and her family. They put me up in a garret flat on the top floor, and I think the self-portrait in the mirror was taken in that room. Not only did the Ashers give me a home away from home, but it was full of interesting people and conversations, and also a very good place to write. I had a small Knight piano in my bedroom, and there was another piano downstairs that Mrs Asher used with her students. She was a teacher at the Guildhall School of Music and Drama, and one of her students had been a young gentleman named George Martin, who some years later became The Beatles' producer.

Our first year in London was a really big one, and these photos show the people I was surrounded by at that time. They show me at home with the Ashers or backstage and side of stage, capturing the other musicians. It was around October 1963 that the press started using the term 'Beatlemania'. The screaming fans chasing after us is more prevalent in the photos I took in the U.S., but it had been happening throughout the year with the British fans. However, despite learning things like that 40 percent of the U.K. population had watched one of our TV performances, or having two singles go to No. 1, it all still felt a little precarious to me. Like George Martin later said in our *Anthology* TV series, it was difficult to believe in 1963 that The Beatles would last forever. I think the photos I took back then acknowledge that uncertainty. They show my excitement of being around other budding musicians. It was all worth capturing, as you didn't know how long it would last.

We finished the year with *The Beatles Christmas Show*, where many of these photos were taken. It was a lot of fun. Three or so weeks all sold out, mostly with two shows a day. The shows were at what was then known as the Finsbury Park Astoria. We often played in cinemas like that, as what we think of as concert venues today didn't really exist yet.

The bill included The Barron Knights featuring Duke D'Mond, and artists signed with our manager, Brian Epstein, like Tommy Quickly, The Fourmost, Billy J. Kramer with The Dakotas and Cilla Black, many of whom are captured in this book. Sadly, some of the musicians from this time don't tend to be remembered much now unless you go looking for them. So, it's nice that many of them turn up in the photos.

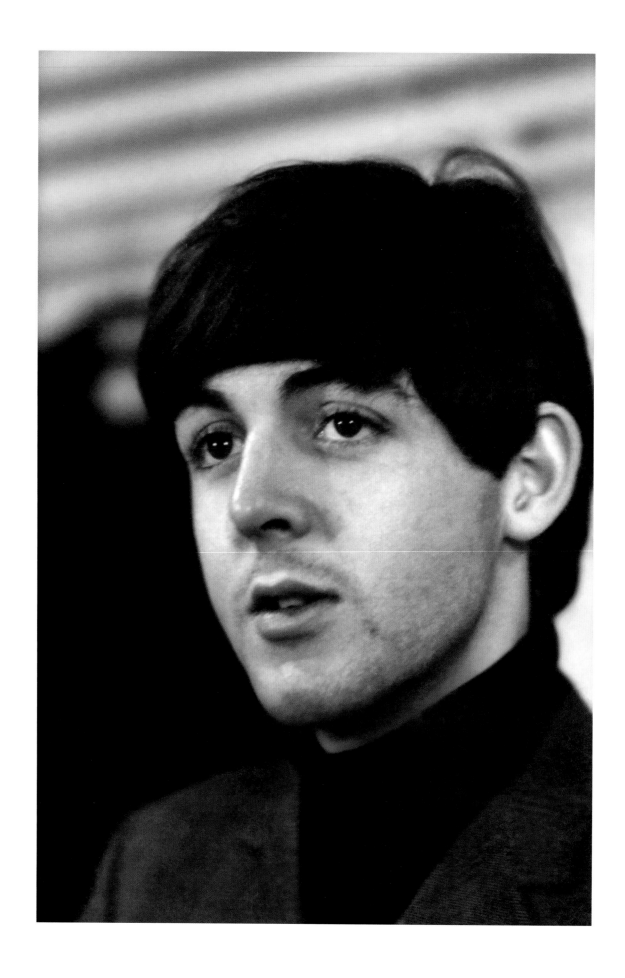

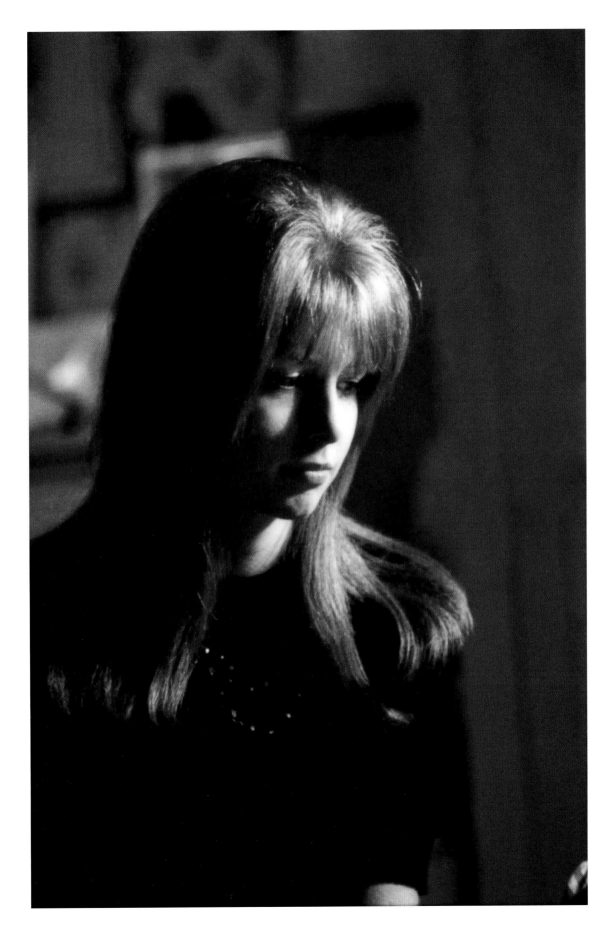

I met Jane Asher at the *Swinging Sound '63* show at the Royal Albert Hall and moved in with her family at the end of the year. I often took her portrait while we were together.

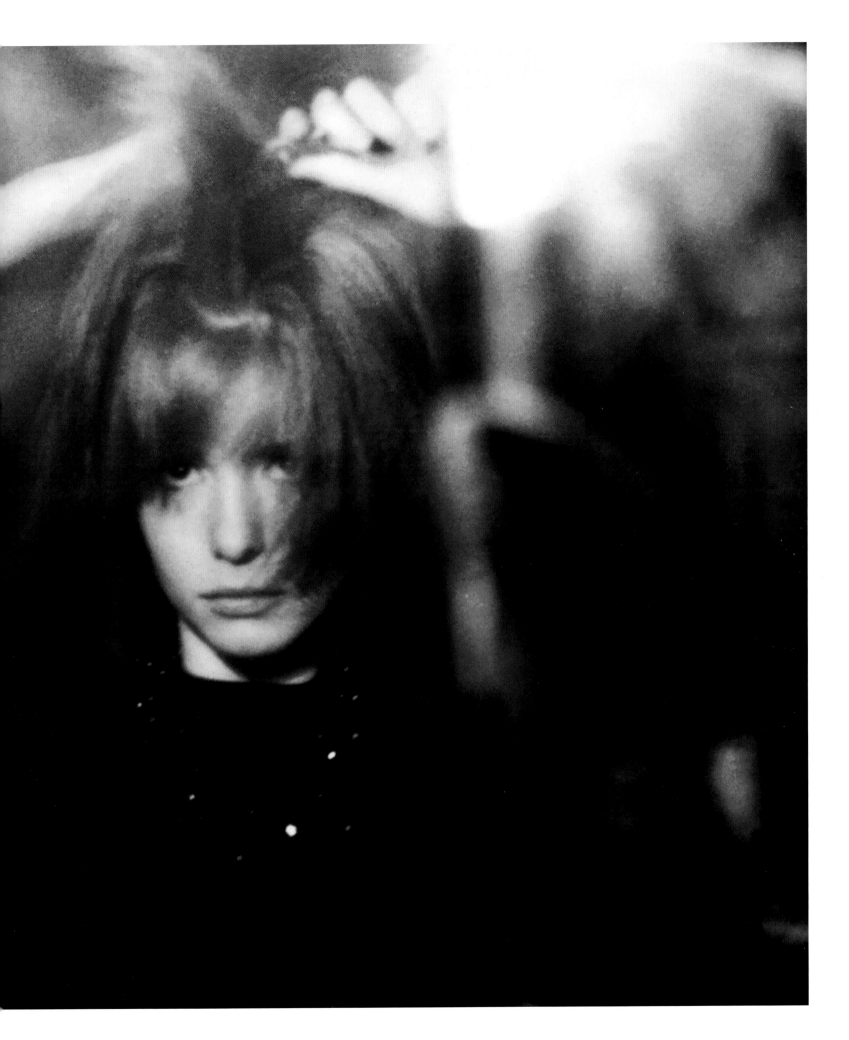

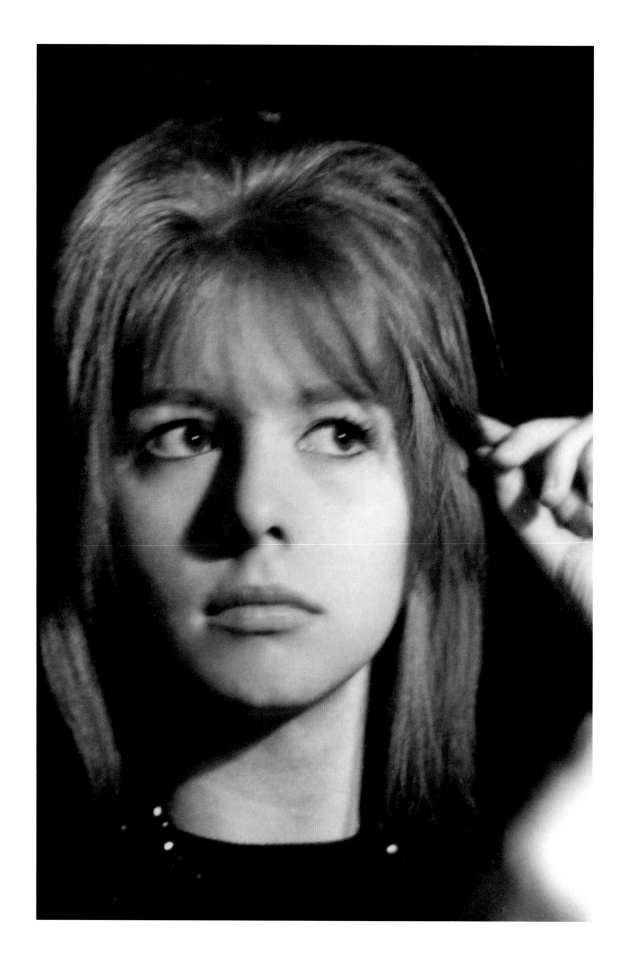

The intimate black-and-white shot doesn't do justice to Jane's striking copper-coloured hair.

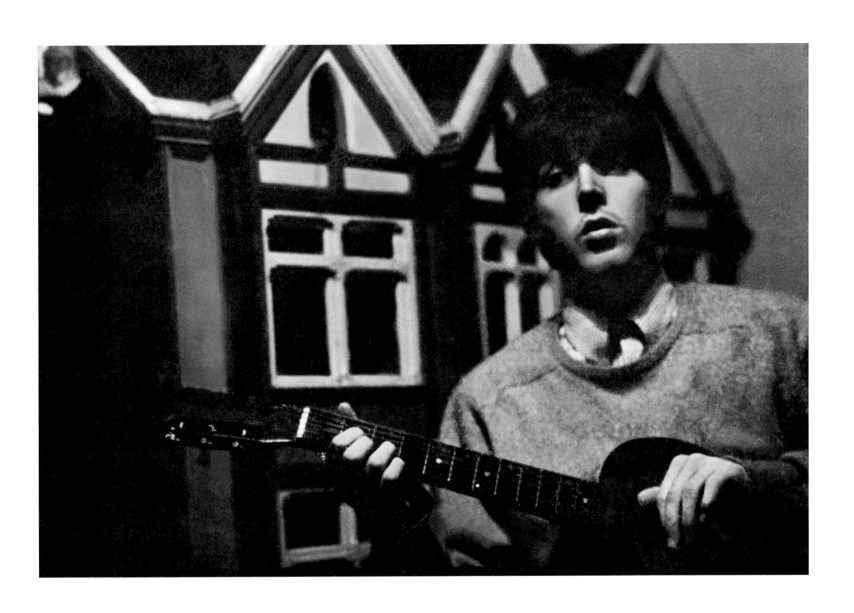

Peter Asher, Jane's brother. Around this time I wrote 'A World Without Love' for him and Gordon Waller. It replaced 'Can't Buy Me Love' at No.1 in the U.K. chart.

The view from the back of the Ashers' house in Wimpole Street.

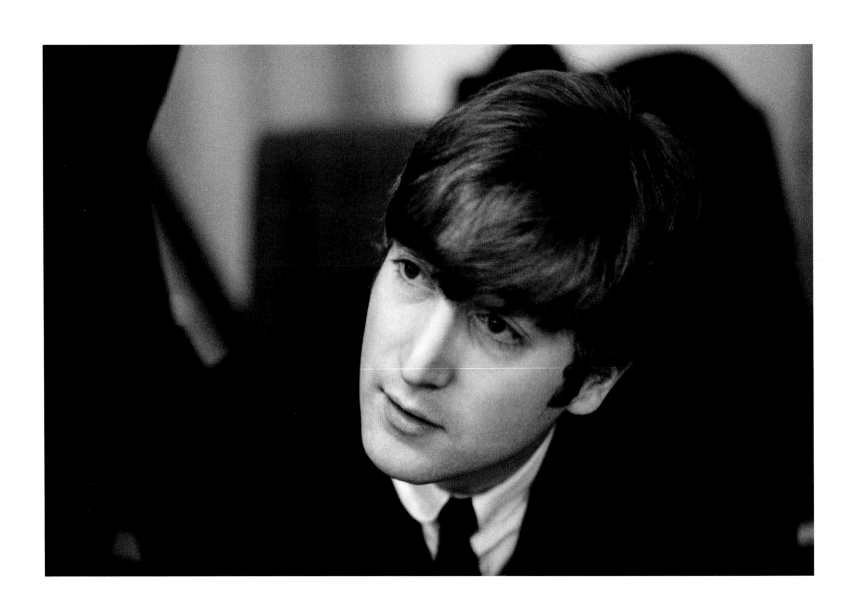

John and George backstage at the Finsbury Park Astoria for one of our Christmas shows.

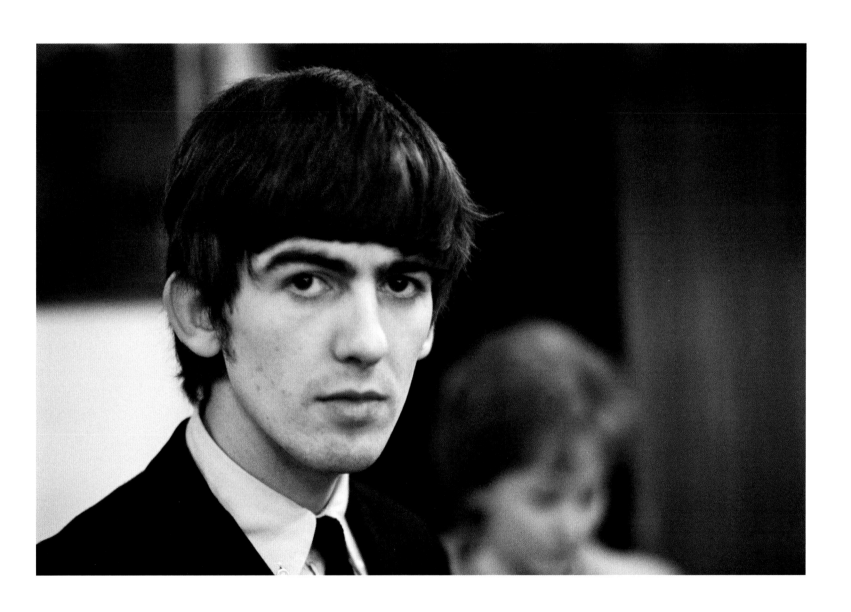

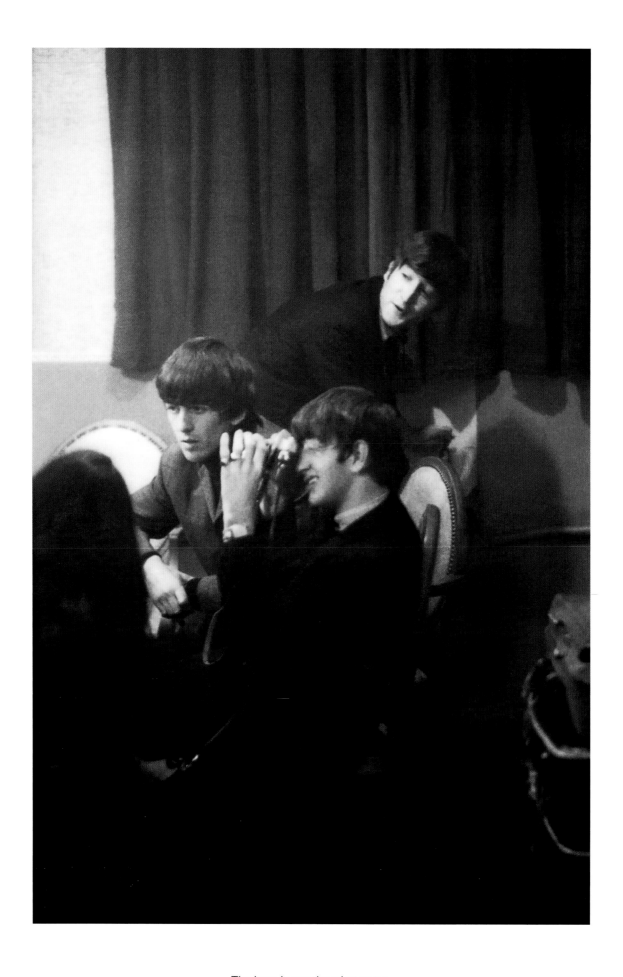

The boys in our dressing room.

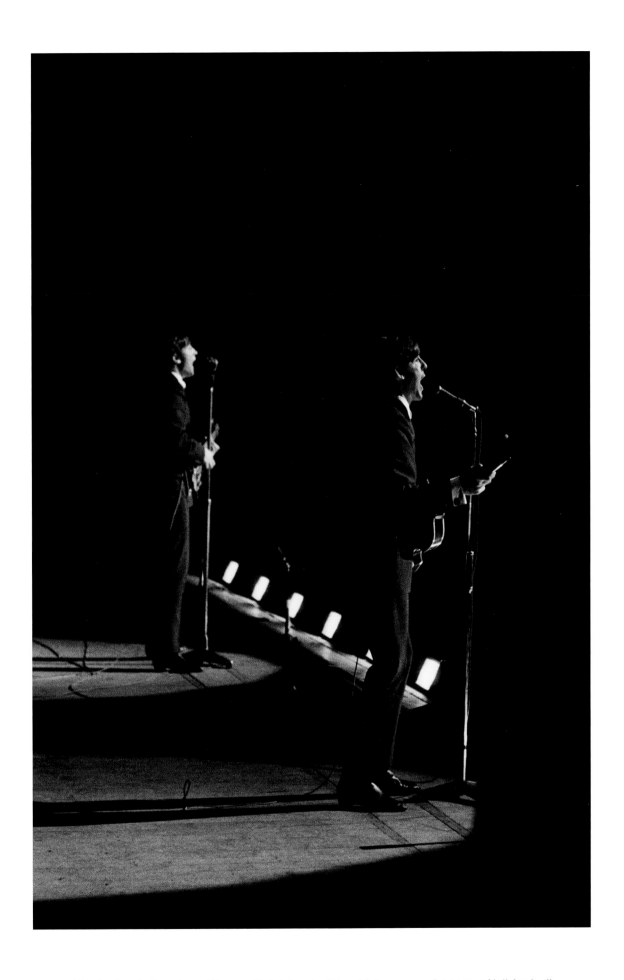

With the band all onstage, this was likely taken by Brian, Mal or our road manager Neil Aspinall.

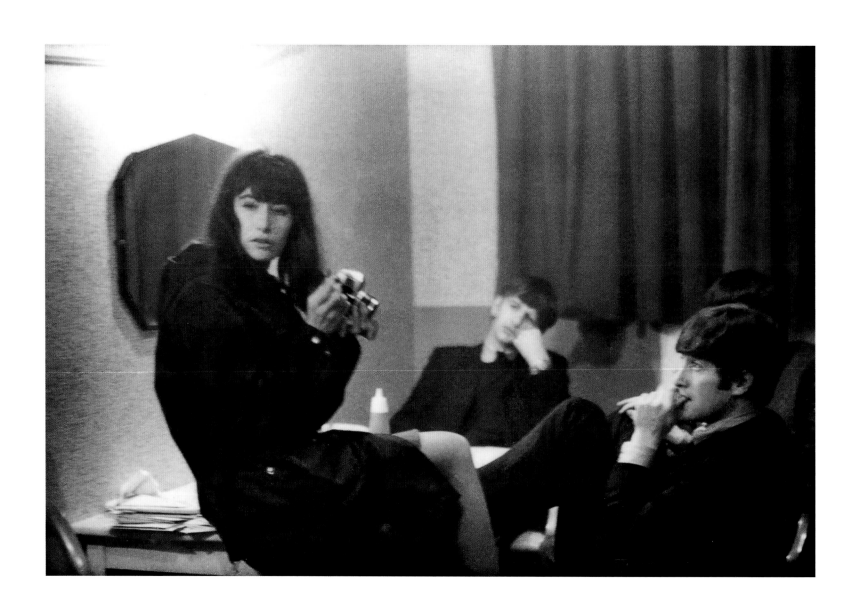

88 Sometimes fans would be allowed in our dressing room.

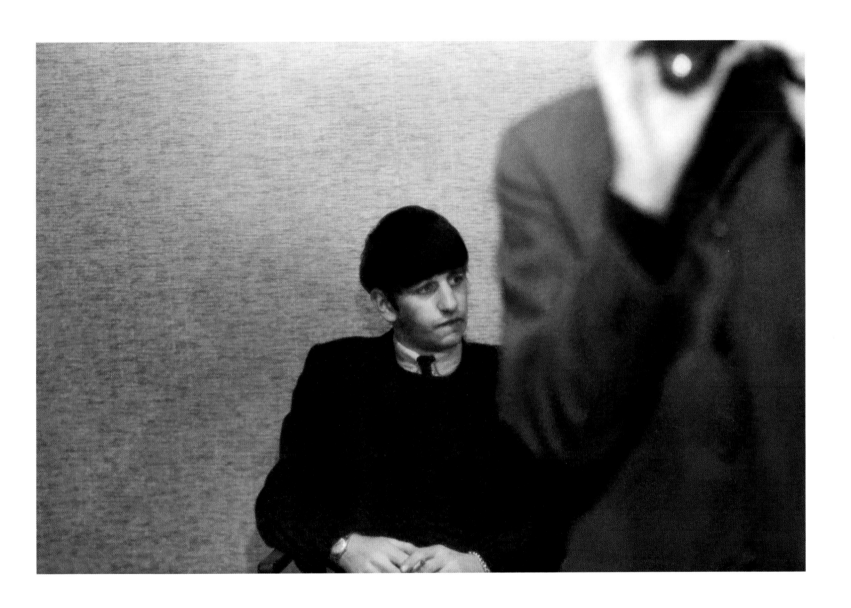

Using the mirror backstage to capture a pensive Ringo off guard.

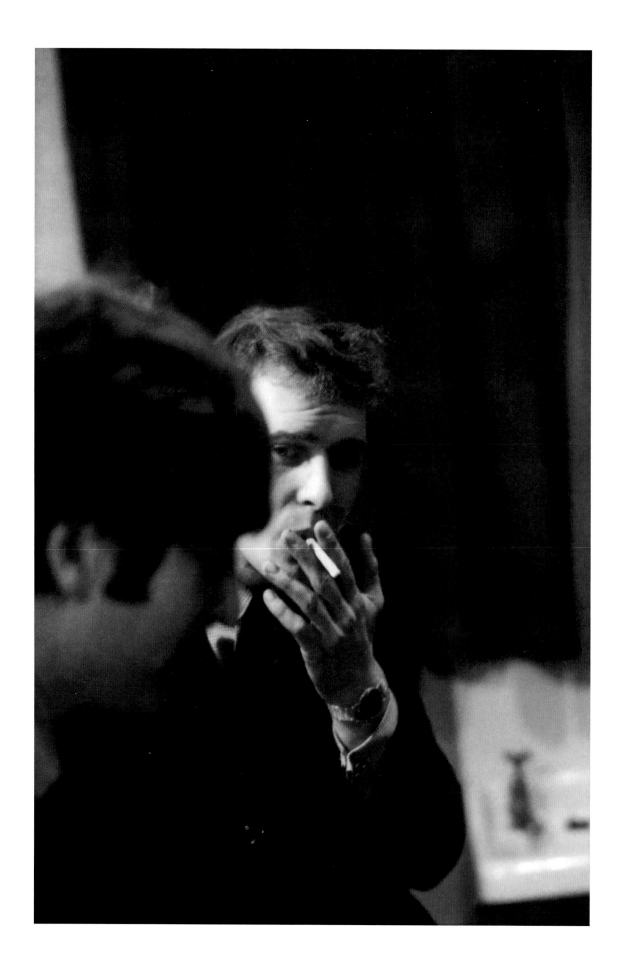

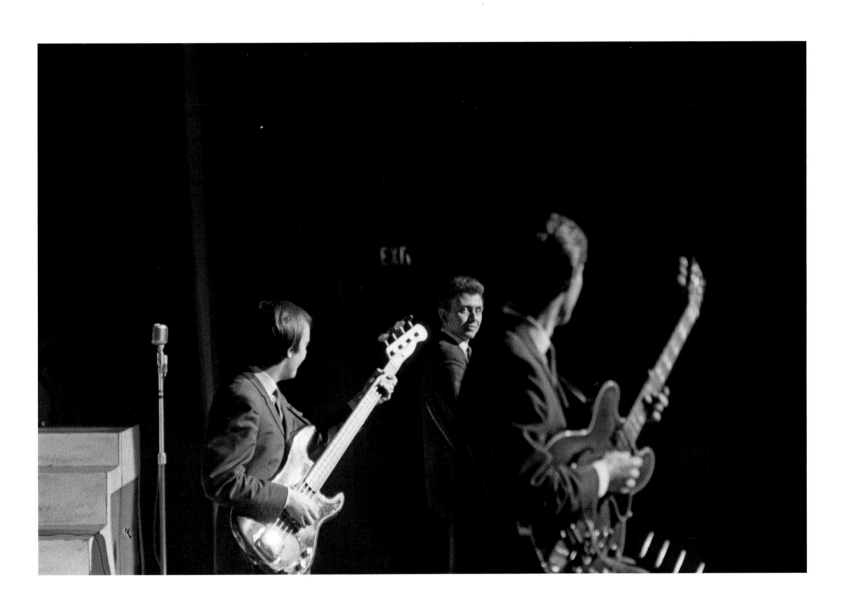

Left: Our road manager Neil used to drive us in our fan-graffitied Commer van across the U.K. The equipment went in the back, we would be in the front. George and I had also recently passed our driving test, so would sometimes vie for the keys.

Above: The Fourmost onstage during *The Beatles Christmas Show* at the Finsbury Park Astoria.

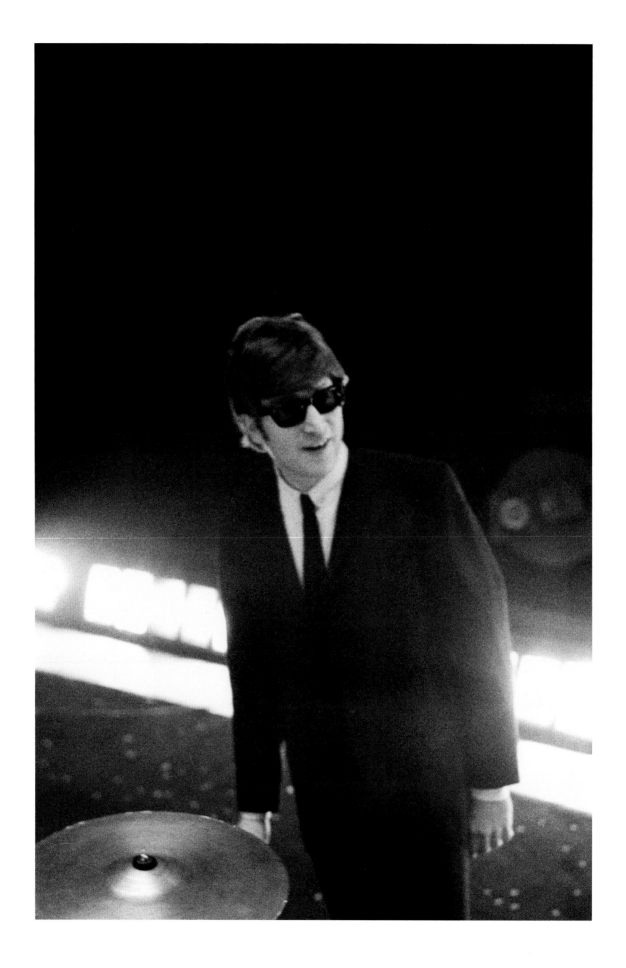

John looking very cool during rehearsals for *The Beatles Christmas Show*.

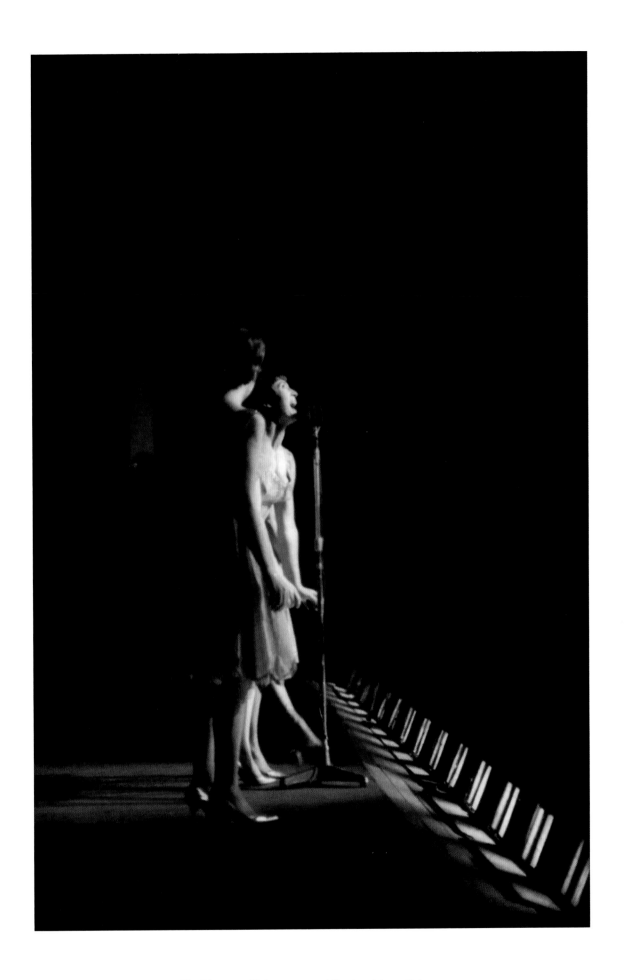

The Vernons Girls onstage at the Lewisham Odeon.

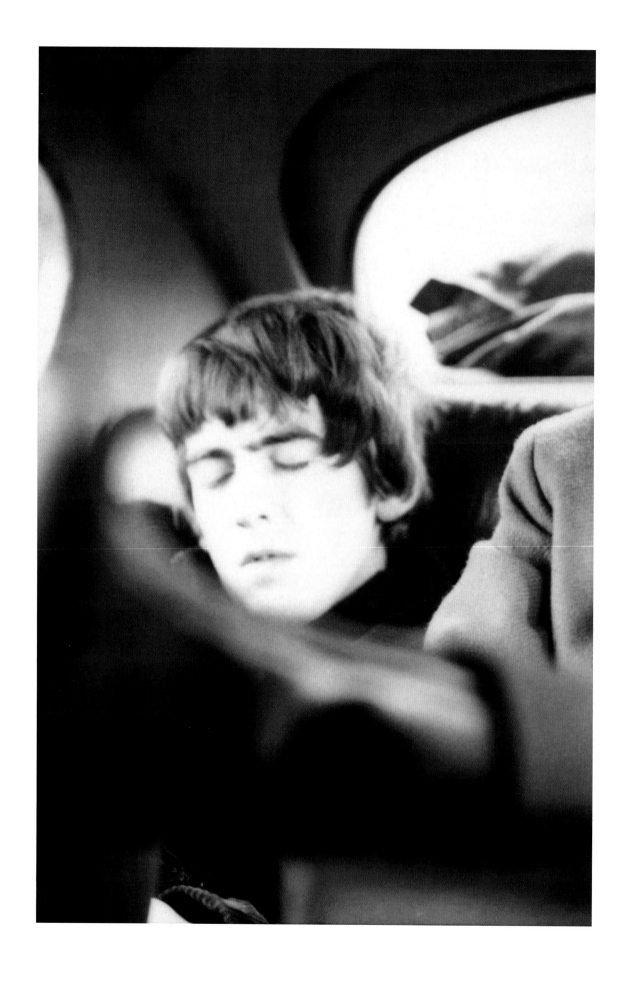

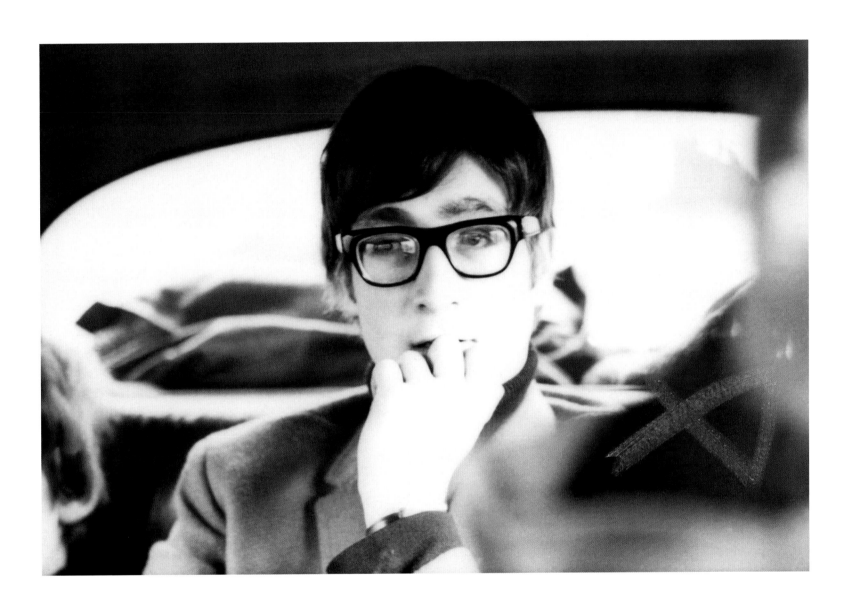

I love the intimacy of these shots. We were a tight-knit group, so only one of us
would have been able to get these kinds of photographs.

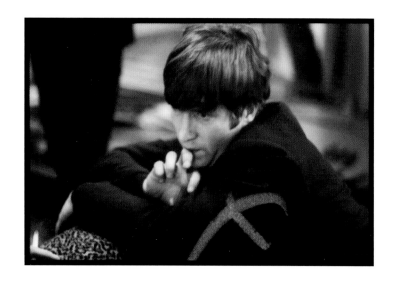

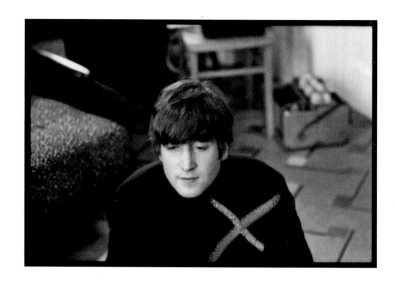

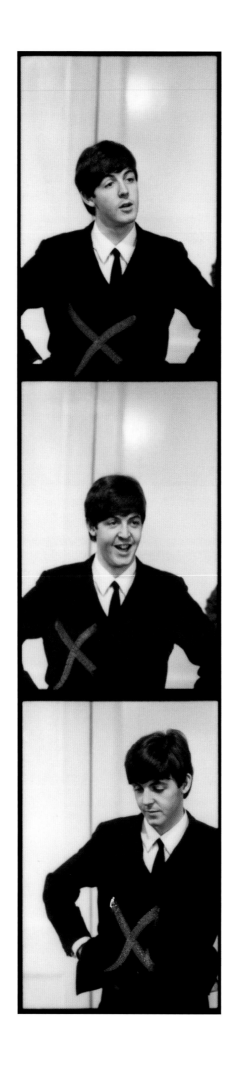

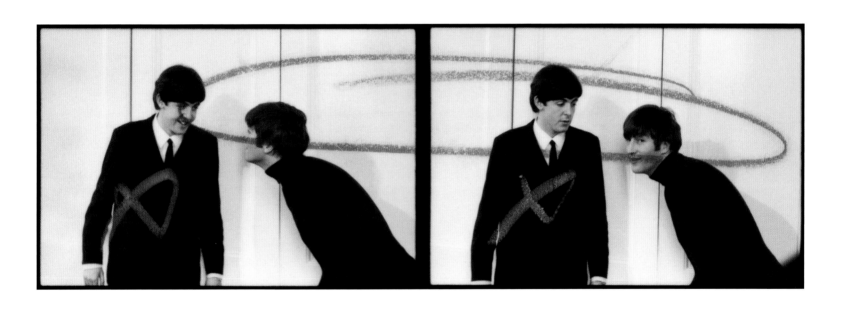

Playing about during a photo session in The Clarence Tavern in Finsbury Park.

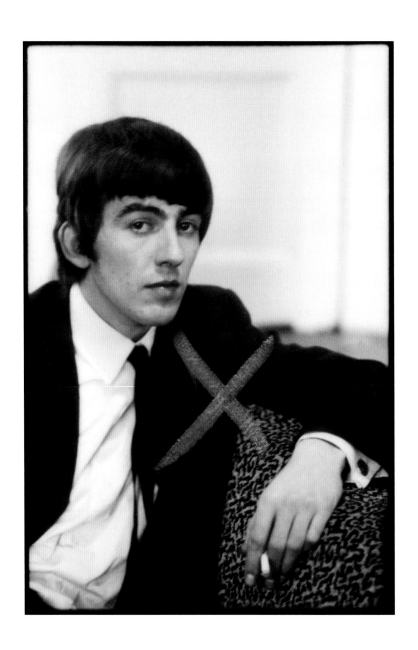

Favourite shots were sometimes marked with a chinagraph pencil.

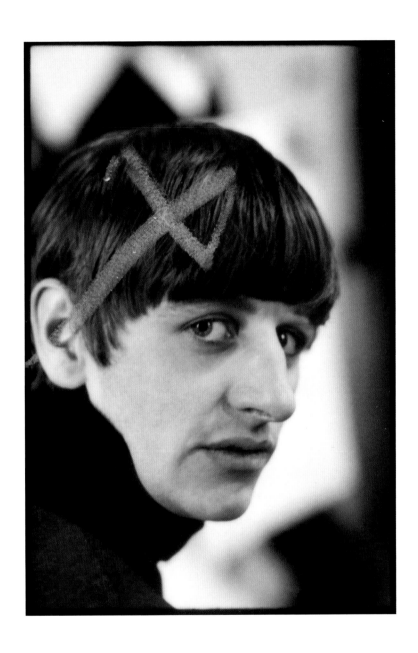

Bill Corbett, our driver and a good laugh.

Nice to see Mal taking a break.

The director Peter Yolland, who, with Brian Epstein, helped create *The Beatles Christmas Show*.

Judy Lockhart-Smith, who worked at Parlophone Records and went on to marry George Martin in 1966.

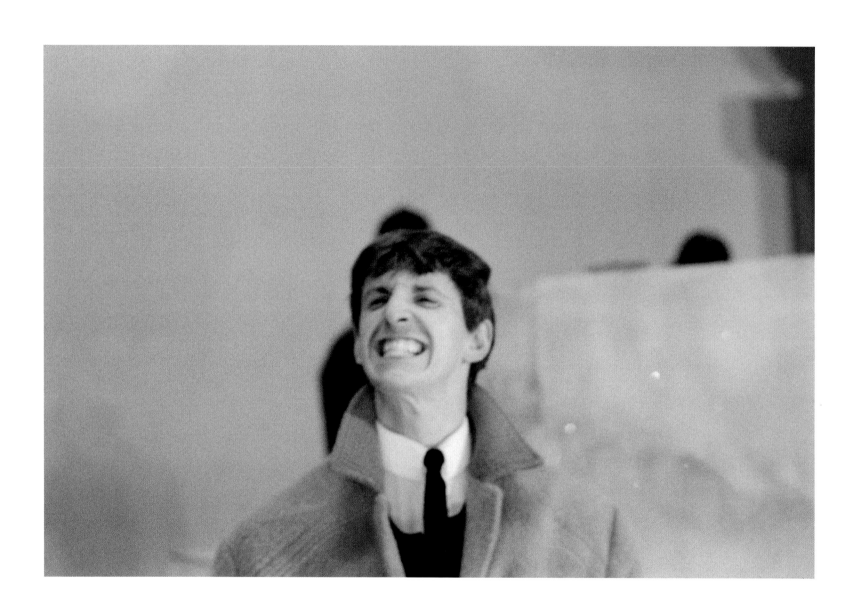

Billy Hatton, bassist and singer from The Fourmost.

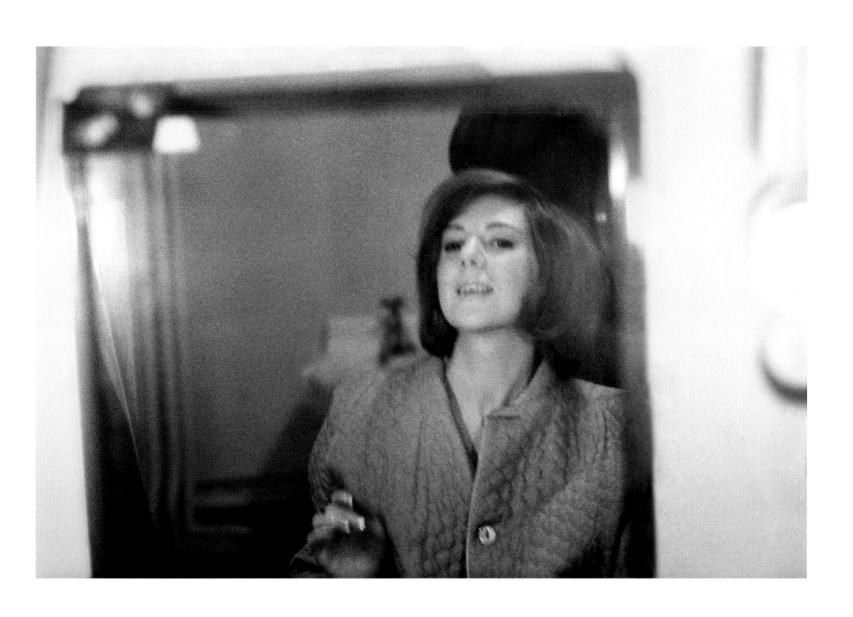

Cilla backstage at *The Beatles Christmas Show.*

Following page: Photographer Robert Freeman and John caught in profile.
They lived in the same apartment block in London for a while.

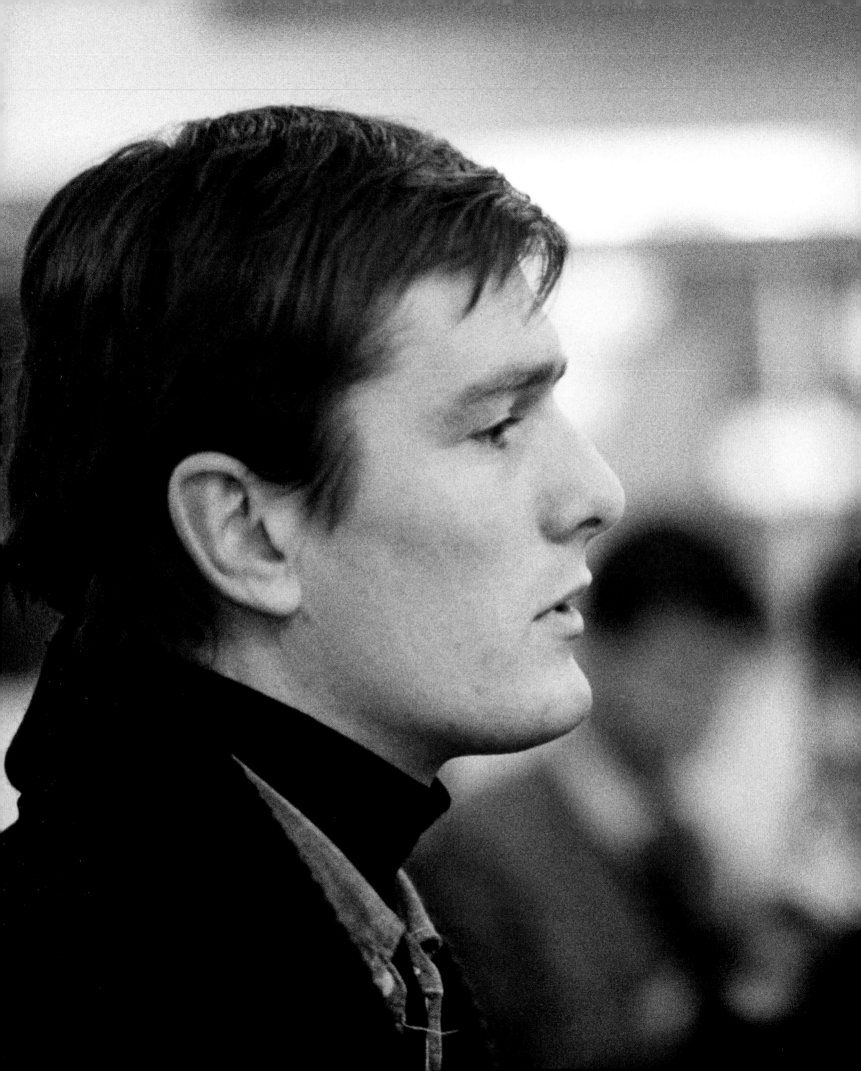

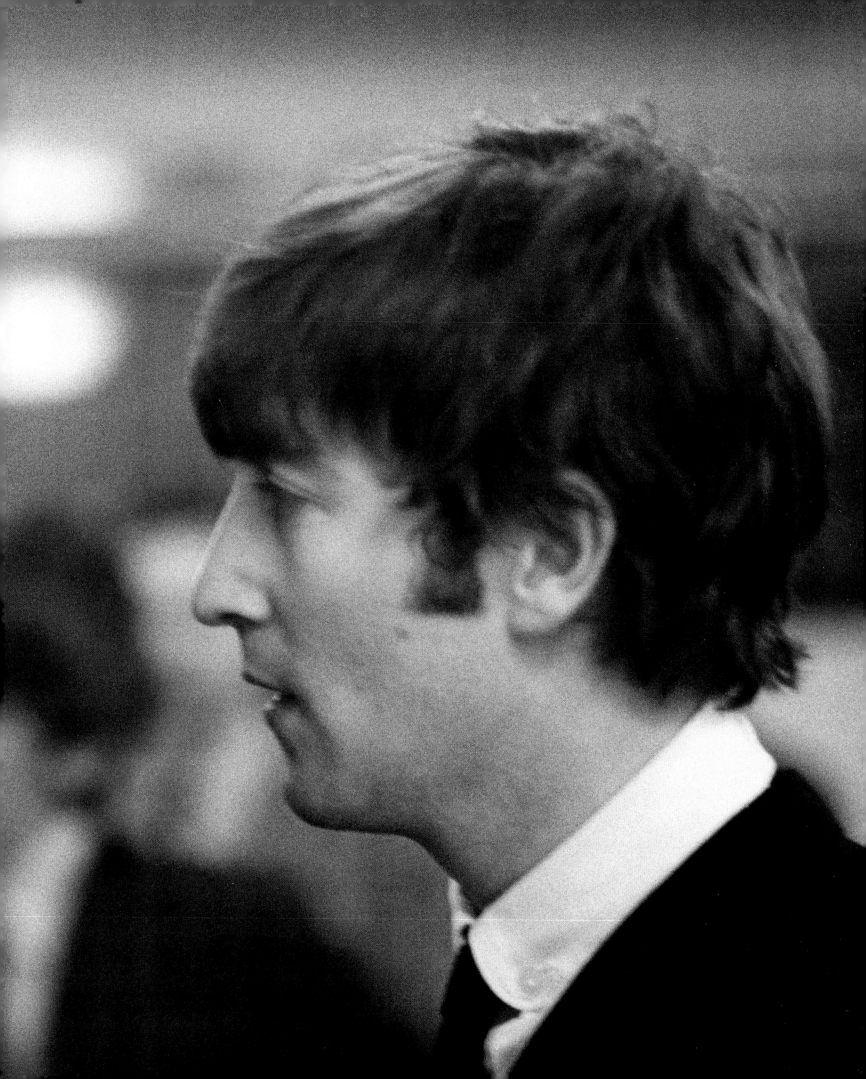

George's loving and supportive parents, Louise and Harry.

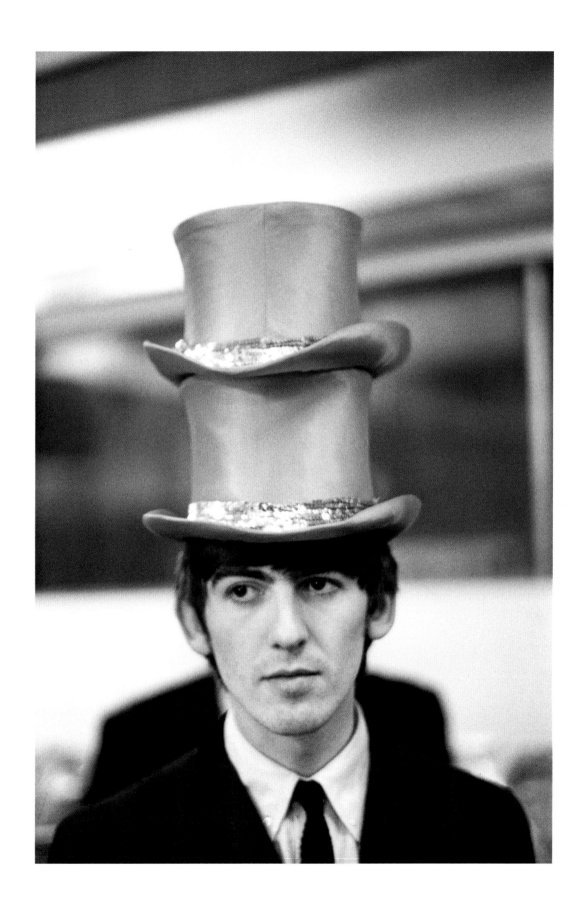

George with two hats.

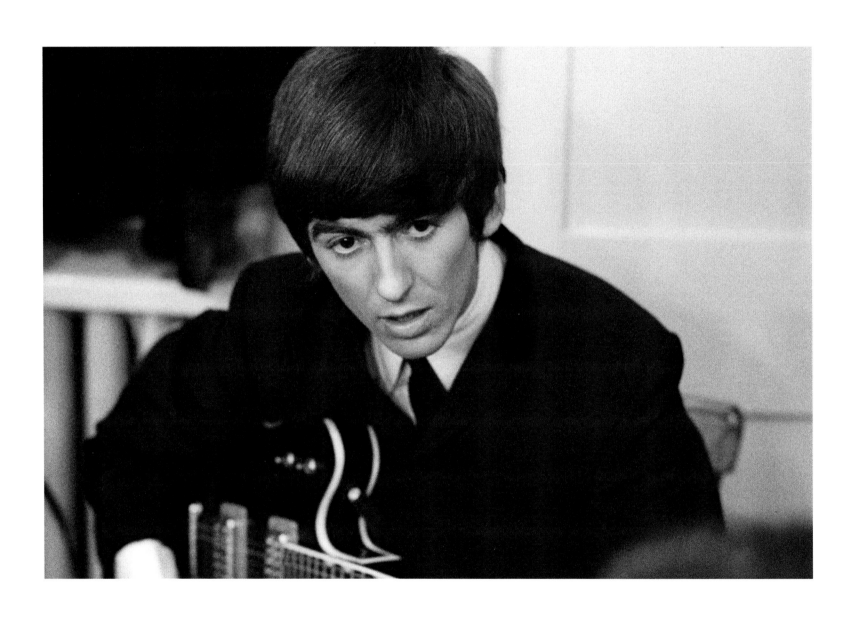

Billy J. Kramer descending the steps of the stage-set helicopter.

Spotlight and shadow create a dramatic image of Billy.

We learned all sorts of things from the photographers we worked with. For instance, we were often asked to pose for shots where we would be four heads stacked vertically on top of each other. It turned out this was for a single column in a newspaper as the editors didn't always have the room for a wider image.

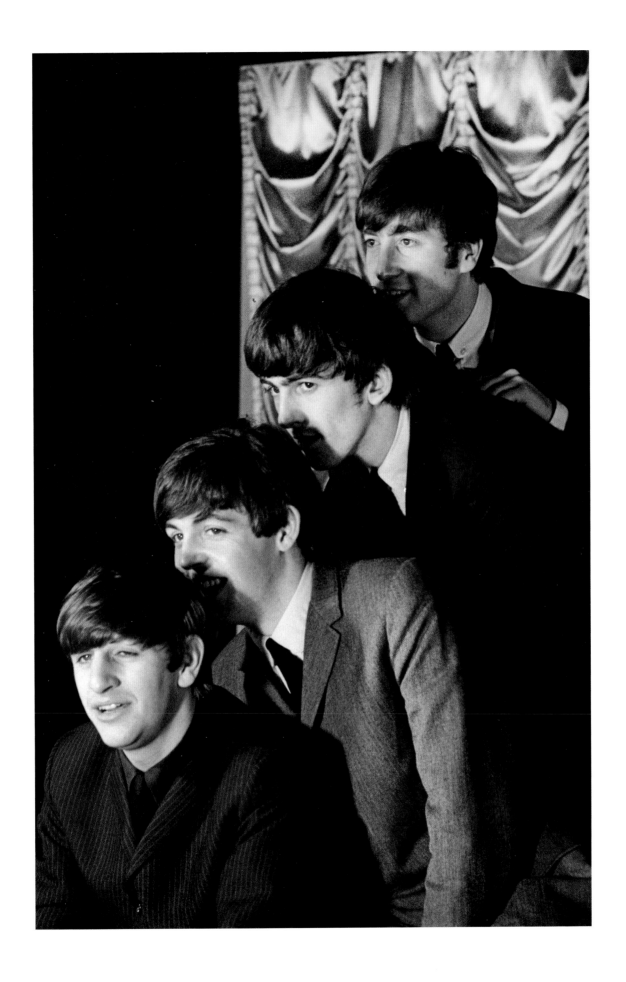

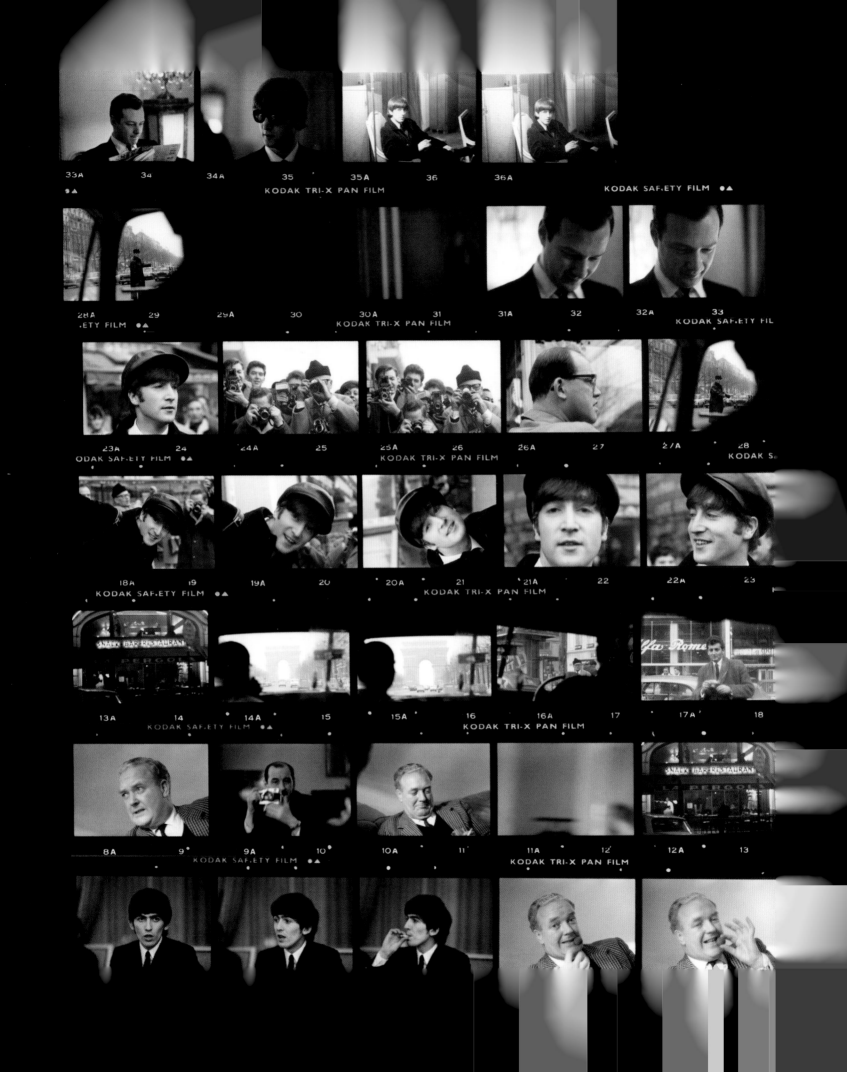

Liverpool
London
Paris
New York
Washington, D.C.
Miami

PARIS
14th January – 5th February 1964

When we arrived in Paris in January 1964, we were seduced by the charm and sensibility of the city. As I look at these photographs, it's the first thing I notice – the free spirit and the spontaneity.

When we got to Paris we were tourists, and that's reflected in some of my photos. We were driven around to get to photo shoots or to the theatre and, on our way, I might see a crowd in the street that looked *very* French. There would only be a few seconds to decide whether something like that might make an interesting photo, often based on the lighting or the situation. So here, instead of just standing in front of the Arc de Triomphe and taking a picture, I've caught it in the mist through a car window. It's more of an emotional, intuitive response to the scene, rather than something posed or planned. The photographs taken in our hotel suite feel like family snapshots because they remind me what it was like to sit around with the guys and our guitars. That's how John and I worked, and so it's special to look back and to have captured him exactly the way I remember. Later on, we chose to use some shots from my Paris contact sheets in Richard Hamilton's poster for The Beatles' 'White Album'.

As a teenager I was interested in looking at photographs. I think that had been awoken by the *Observer* newspaper, as they always had good pictures, particularly in the sports section. When they'd report on a rugby match,

the images wouldn't just be of a team posing with a rugby ball. It would be mud and muck and scrums and sweat and really good action shots. I loved that. It was more artistic and more real.

People sometimes forget that things we take for granted now had to be invented. Rock and roll didn't used to exist. Then in the fifties, when we were teenagers, it suddenly arrived. It changed our lives. It's the same with photography. All the styles that you see today, from photo apps and fashion magazines to billboard adverts – all those archetypes had to be invented, too. For years people had photographed us as The Beatles, and suddenly we could photograph them back, and so there is an element of playful revenge in some of these shots. I also admired the cinematic style of French New Wave films like François Truffaut's *Jules et Jim*, which had been a big hit with us, so perhaps I was trying to incorporate that aesthetic into the photos I was taking.

There were so many photos taken of us as a band in Paris. I joked at the time that it felt like twenty thousand. We were photographed cancanning, with flower sellers, jumping in front of the Champs-Élysées. All taken before the light faded because it was January, and we weren't the earliest of risers. We were booked to do two shows a day for several weeks at l'Olympia, a Paris theatre where John and I had been before. But that had been a completely

different kind of experience. In 1961, the two of us tried to hitchhike our way down to Spain because for John's twenty-first birthday he had been given a hundred pounds by his rich dentist uncle from Scotland. We thought that was a king's ransom. We only got as far as Paris though and stayed for a week because we loved the city so much. We saw Johnny Hallyday play a show at l'Olympia, and the crowd went pretty wild for him. We met him during our 1964 trip because he was engaged to Sylvie Vartan, who we were sharing the billing with, and so I got to photograph Sylvie performing and Johnny waiting for her.

John and I were just sponging up experiences on that first trip. Visiting Montmartre to see where all the painters had lived. Drinking *vin ordinaire*, which we hated – we thought it tasted like vinegar. By chance our friend from Hamburg, Jürgen Vollmer, was also in town. I think he was working as an assistant to the photographer William Klein at that point. John and I had come to Paris sporting a hairstyle known as the D.A. – the duck's arse, as it's affectionately known back in Liverpool. Jürgen had his hair combed forward and John and I had always liked his sense of style. So we persuaded him to cut our hair like his and that's how the Beatle hairstyle came into being. It's funny that terms like 'mop top' and The Beatles wigs all came from that one holiday. John and I had millions of fabulous little experiences in Paris.

But when 'Les Beatles' got to Paris in 1964, we were now professionals – we were older and more mature, and we'd had some success with the band. The flight to Paris was certainly the biggest trip we'd done as a band, and there were several thousand fans at London Airport to see us off. When we landed, though, it felt like there were more journalists waiting to greet us than fans, so we knew we'd have our work cut out there, but we eventually managed to win the French over.

After one of the Paris shows, we were at the George V Hotel when a telegram arrived from Capitol Records in America. 'Attention: The Beatles. Congratulations boys. Number one in the US. "I Want To Hold Your Hand".' We ran around the hotel room and screamed and danced. I remember leaping on Mal Evans, our roadie, who was a big guy. I jumped on his back, and we had a lot of fun celebrating that night. I'd always said to Brian Epstein and the guys: 'I don't think we should go to America until we've got a number one hit.' I thought it would be a great idea to come in on a wave of success. If you've got a number one, the success is undeniable. So, in Paris we found out that my little plan had worked. Now we could go to America. We got our visas, we got our stuff and a few days later I was landing in the U.S. for the first time, camera in tow.

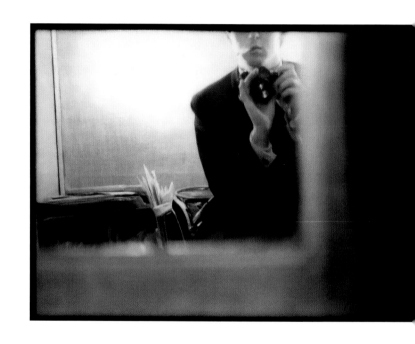

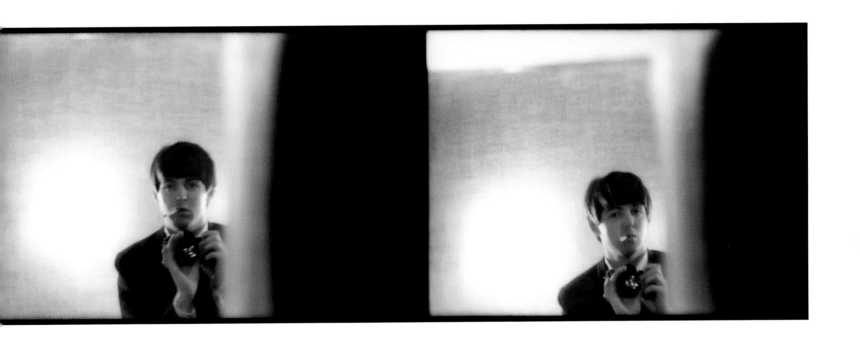

Self-portraits in a mirror.

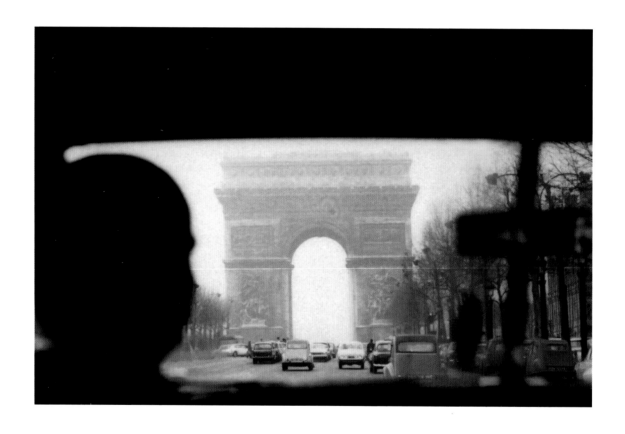

Paris from the back of our black Austin Princess, driven by our chauffeur Bill.
He told us he could speak French. He couldn't. 'Can I park ici?'

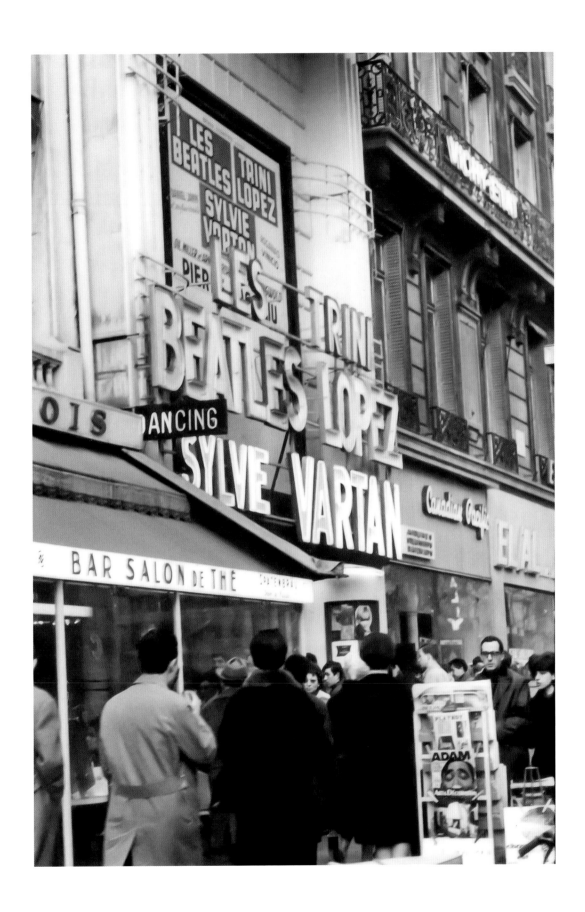

It was a thrill seeing our name up in lights at l'Olympia theatre.

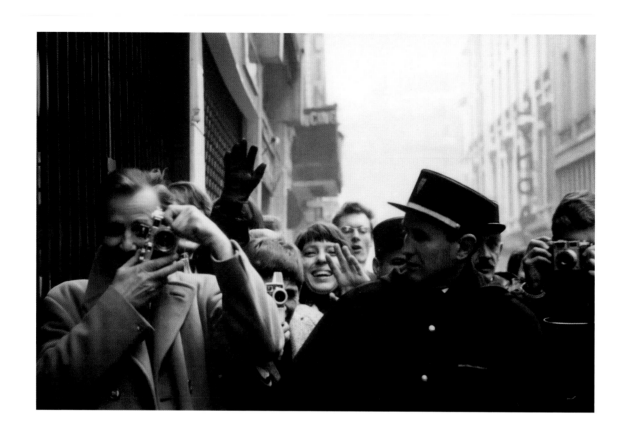

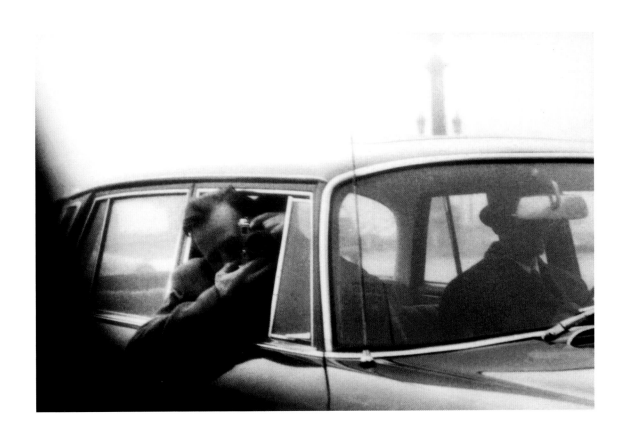

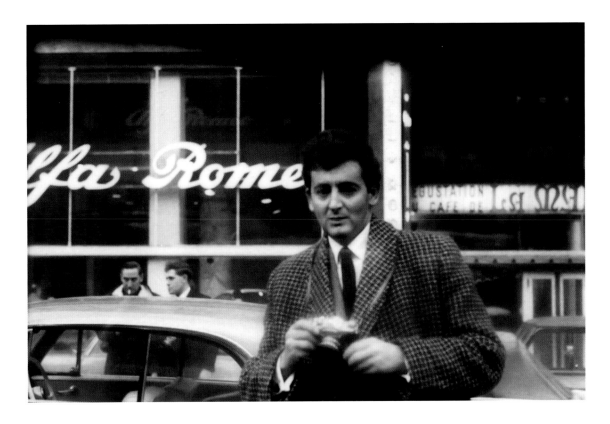

Bottom: Photographer Harry Benson, who sometimes travelled with us.

Following page: The man in the hat is Dezo Hoffmann, who became a friend.

131

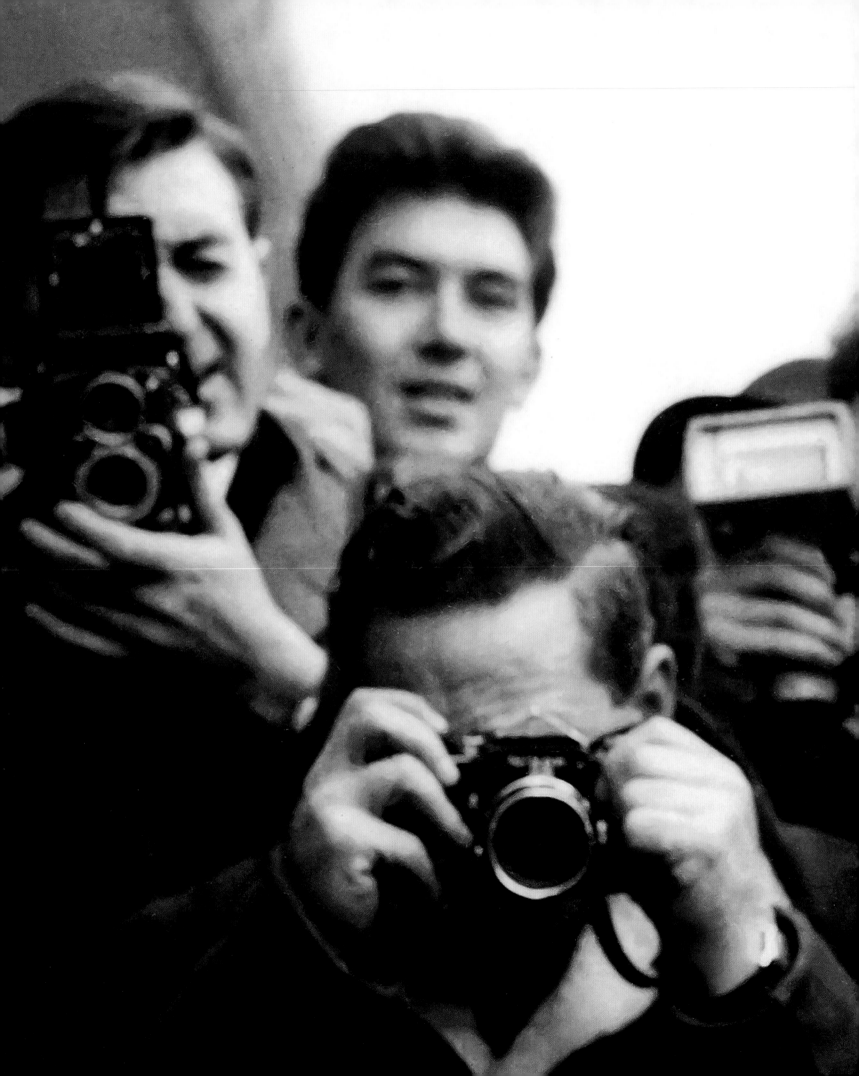

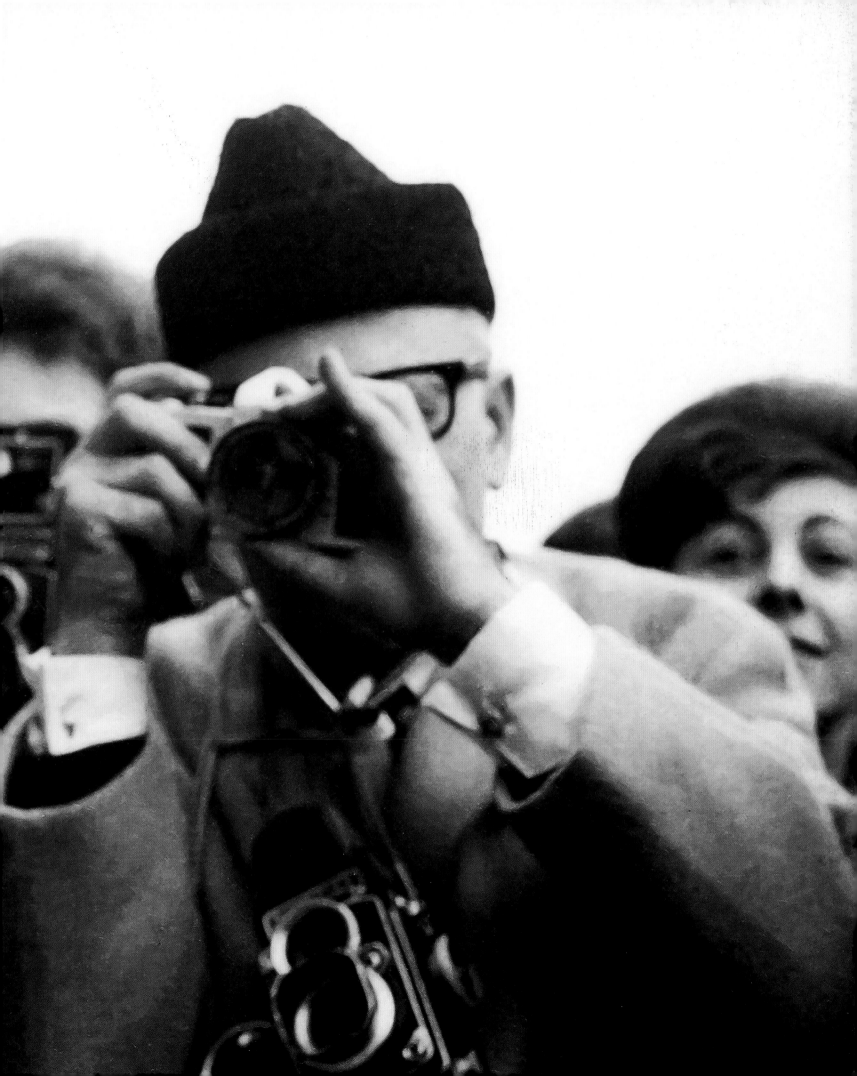

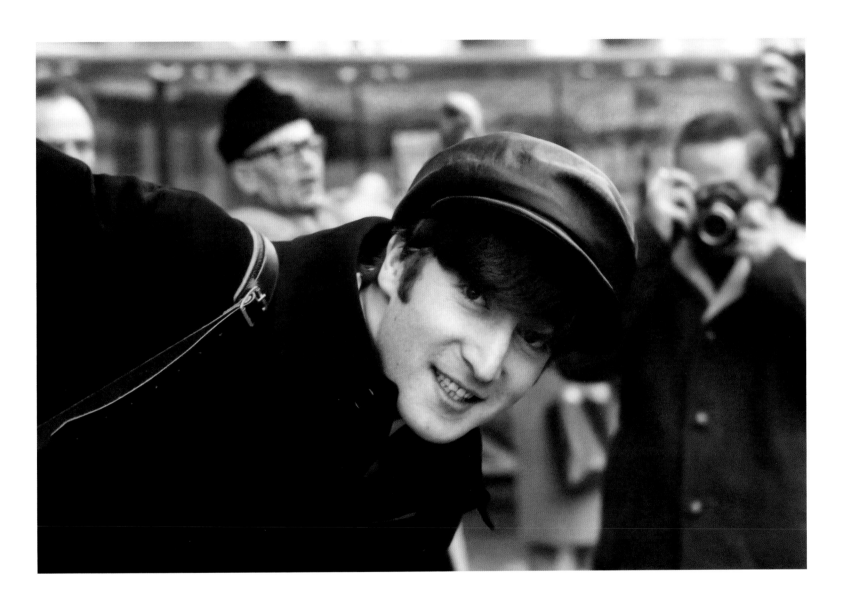

135

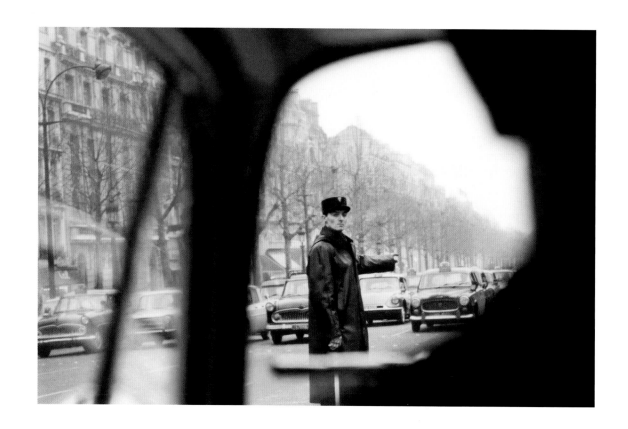

I was captivated by *parisienne* street life.

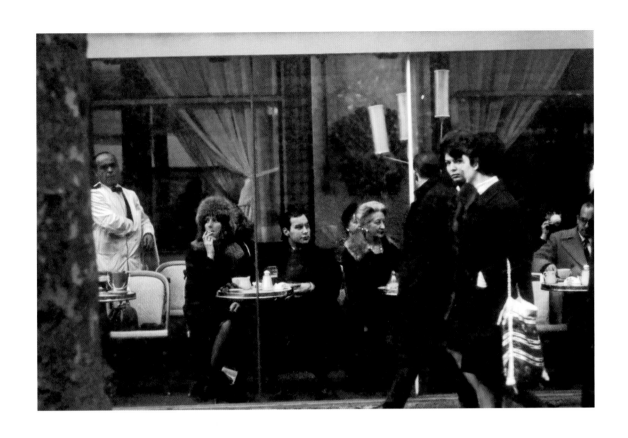

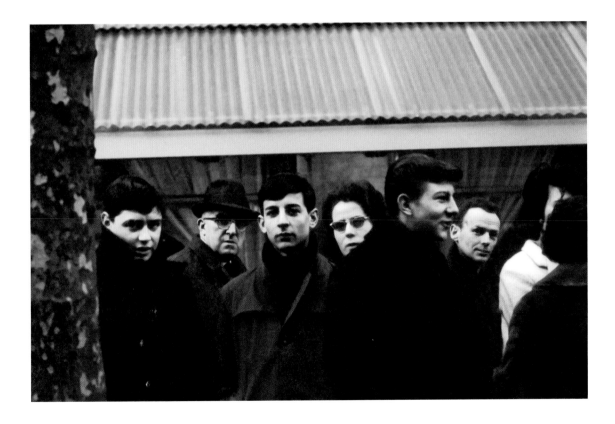

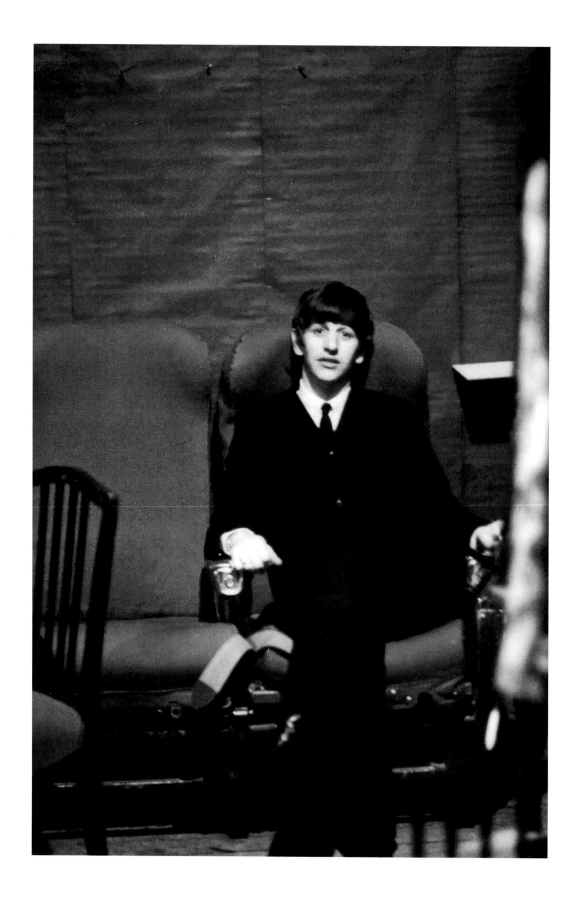

Ringo backstage at l'Olympia.

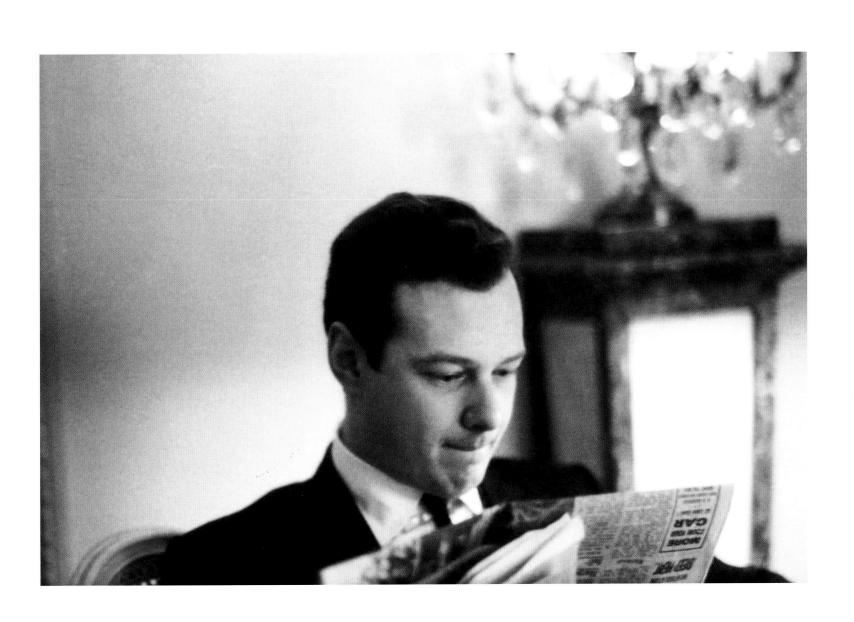

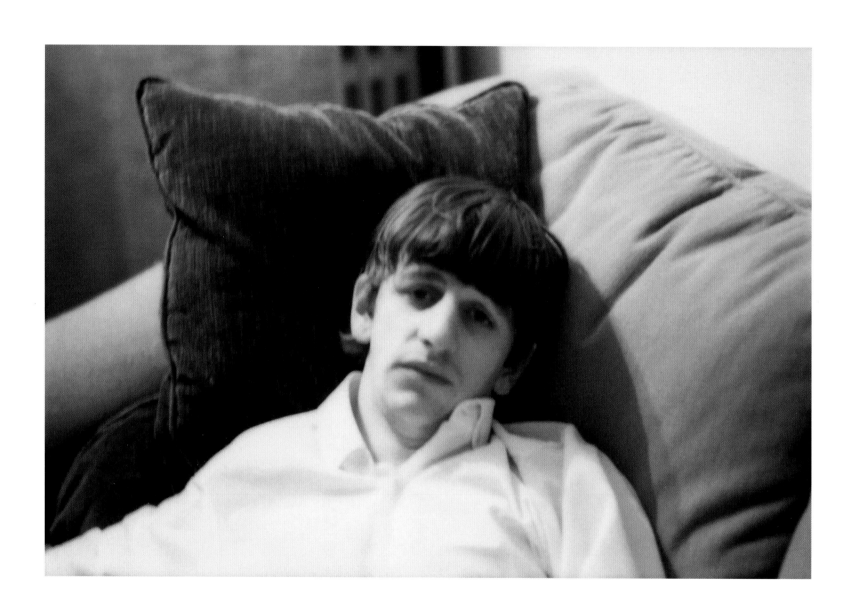

We weren't known to be the earliest of risers, but then we never got an early night, either.

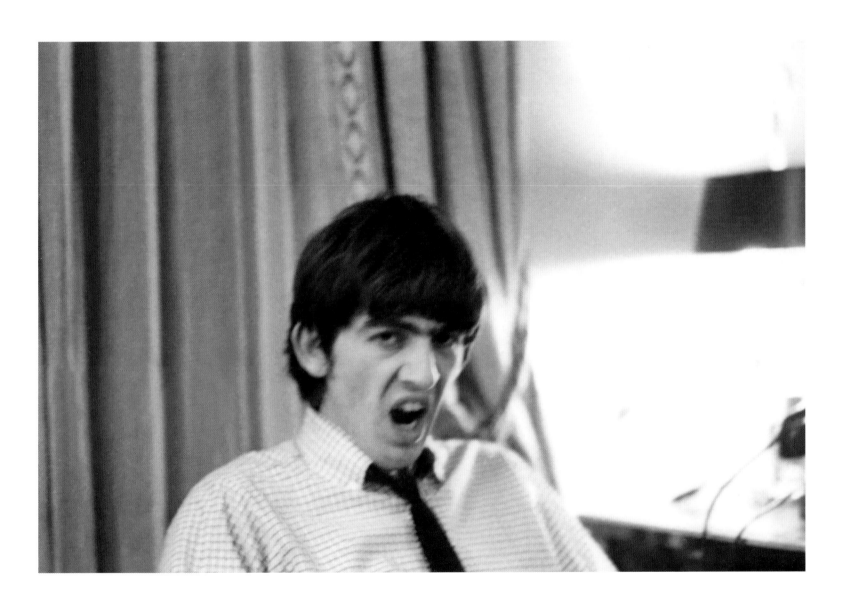

Our driver Bill looking elegant with his cigarette.
At this time, smoking was as commonplace as a cup of tea.

Our road manager Neil and John in our hotel suite.

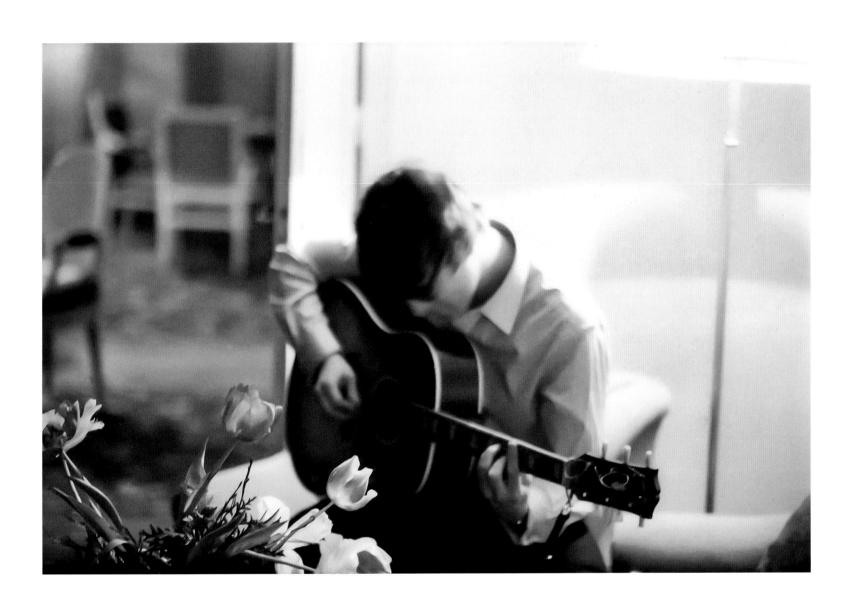

French actress Sophie Hardy.

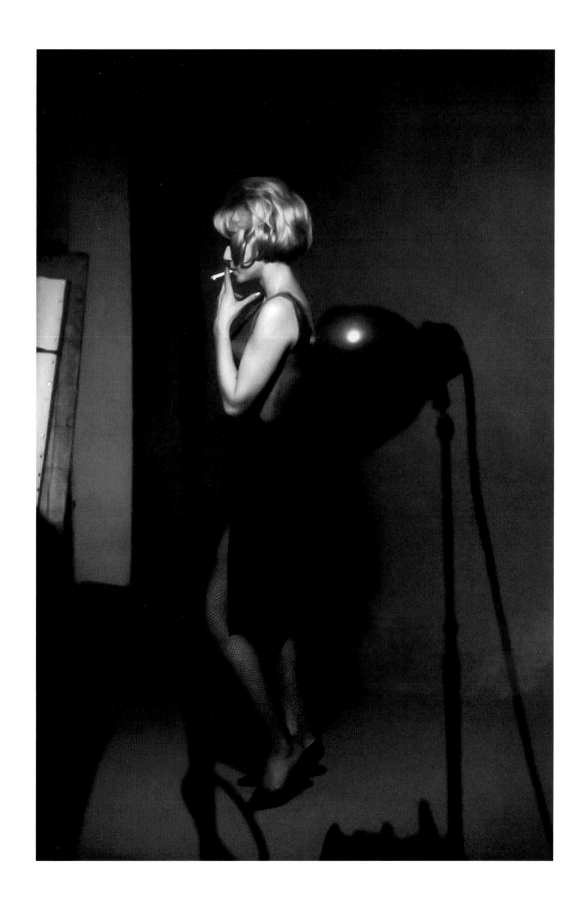

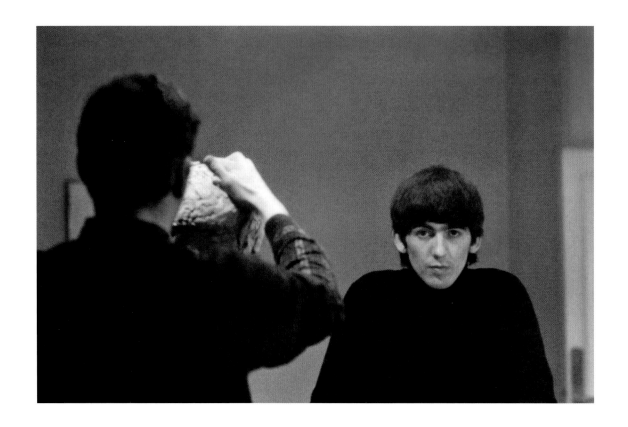

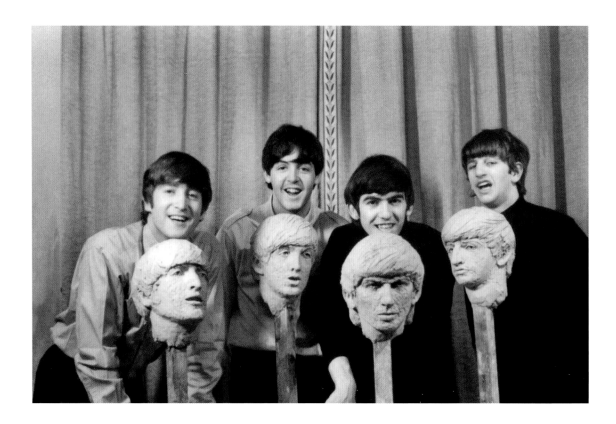

Sculptor David Wynne creating our likenesses in clay moulds for a set of bronze busts.

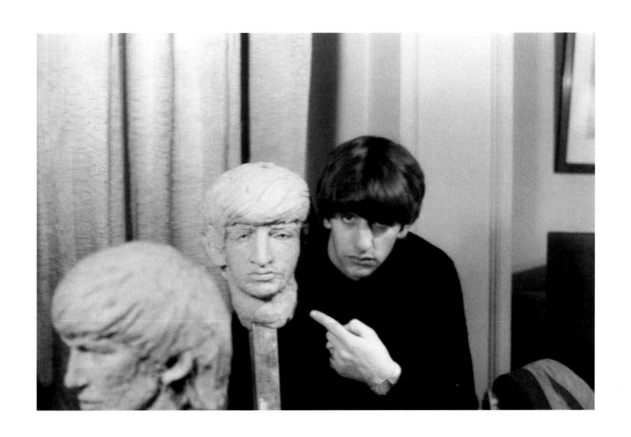

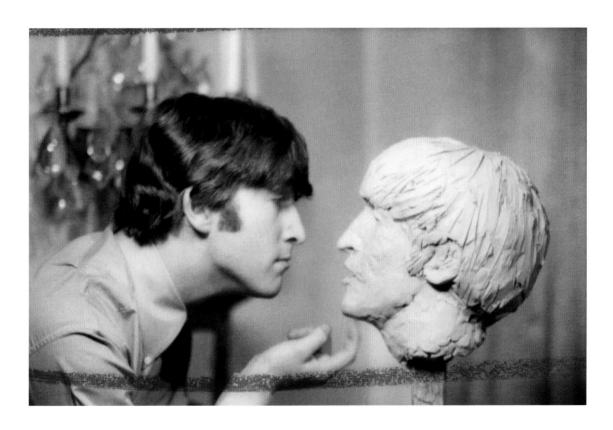

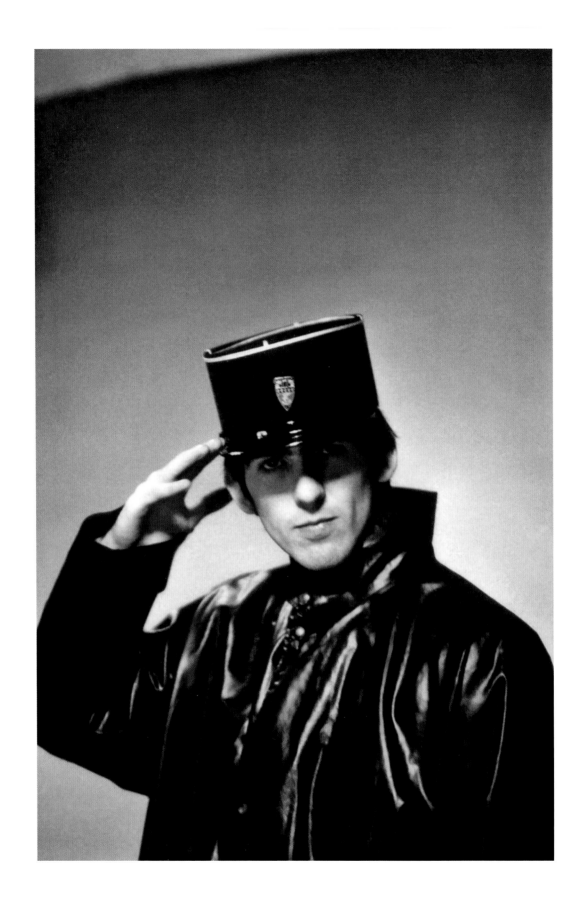

A photo session for a French magazine.

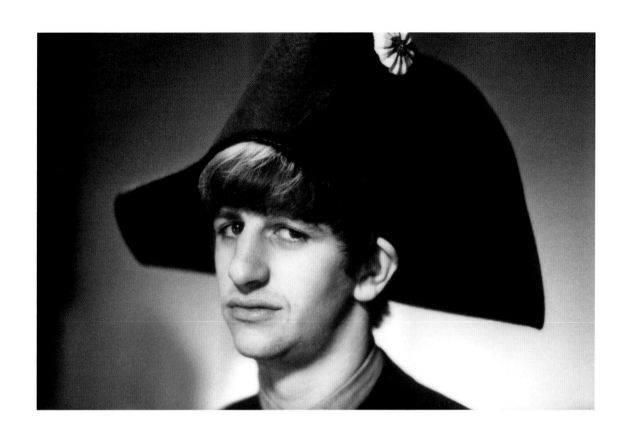

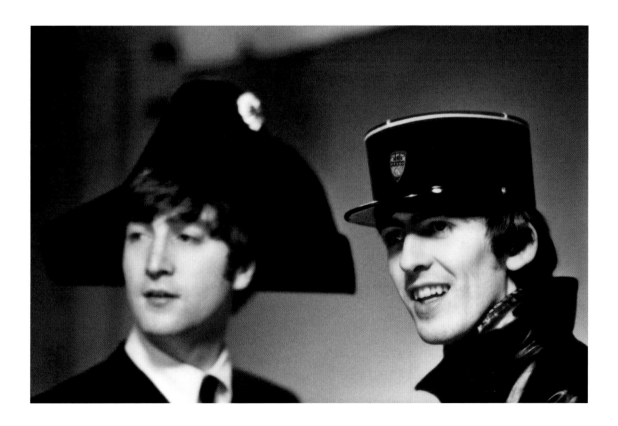

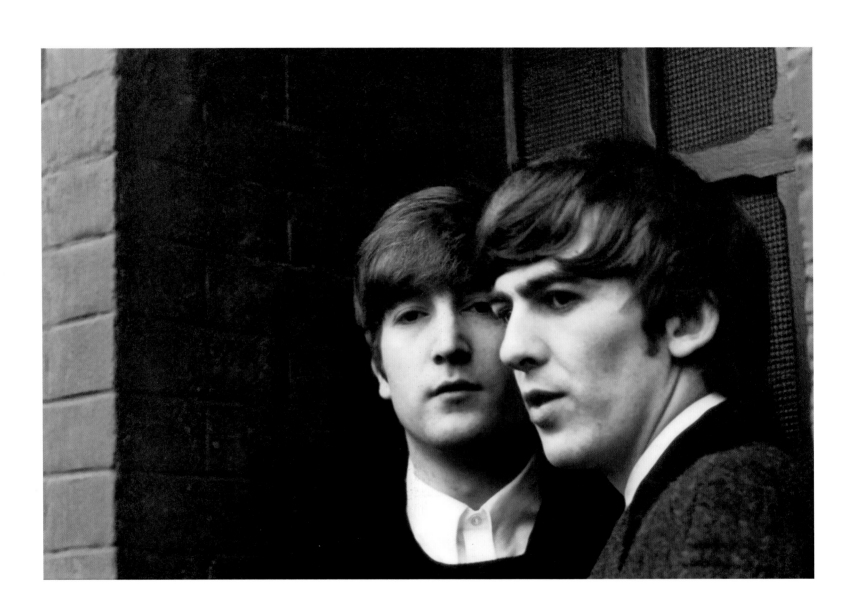

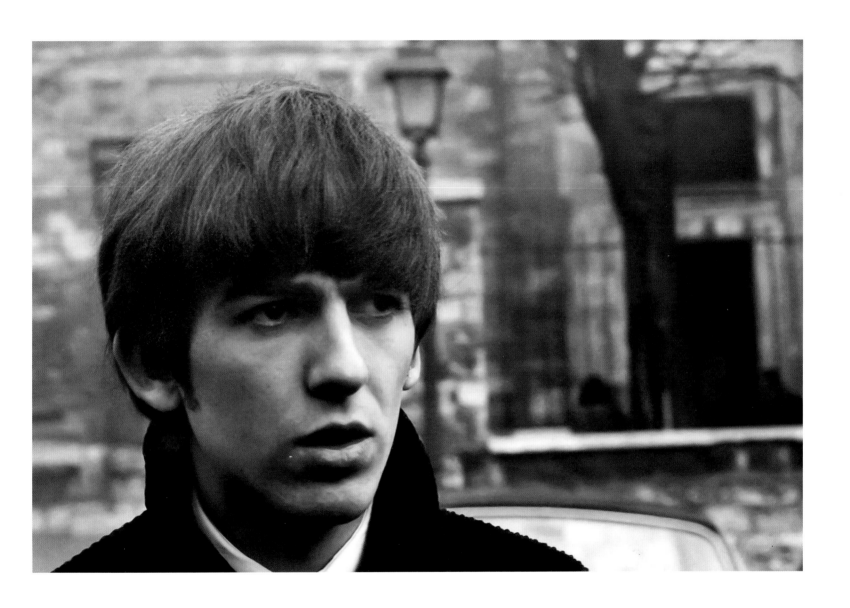

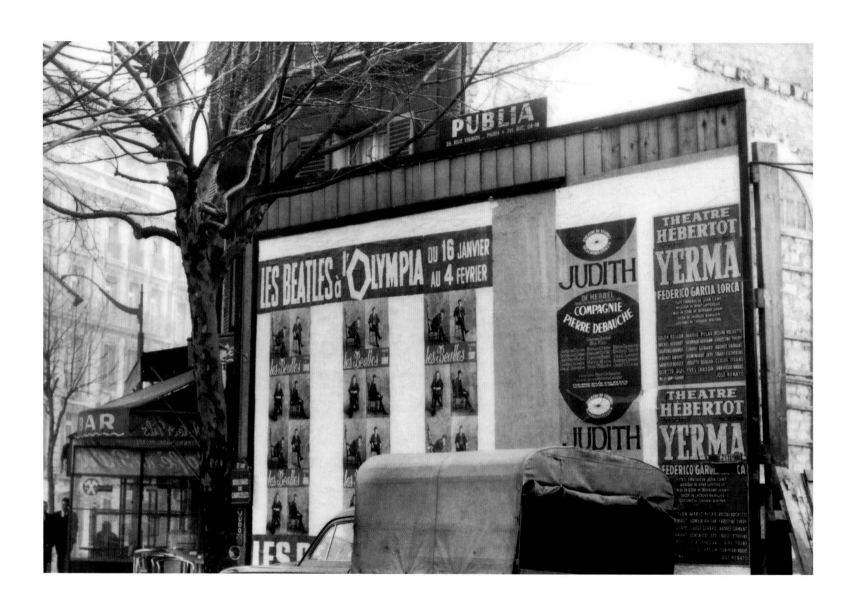

Parisian billboards using the photography of our friend Astrid Kirchherr.

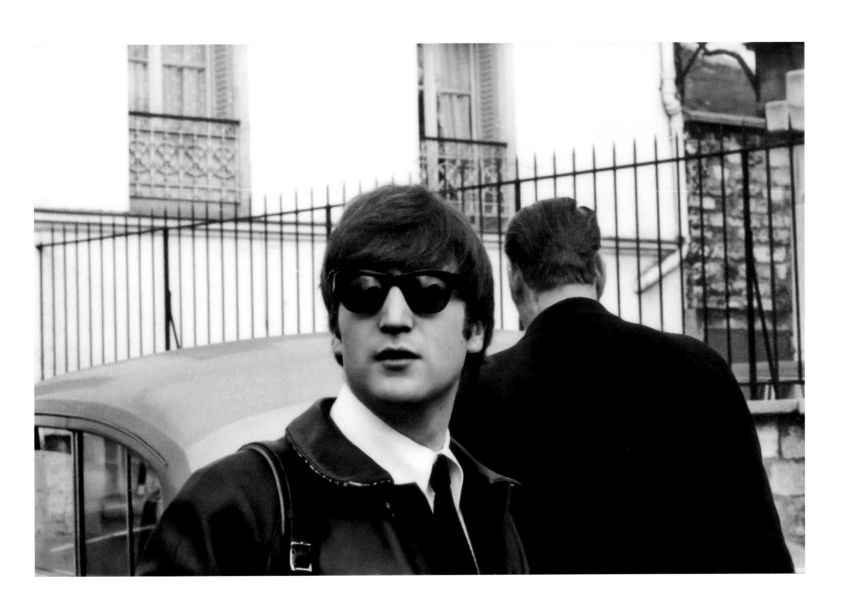

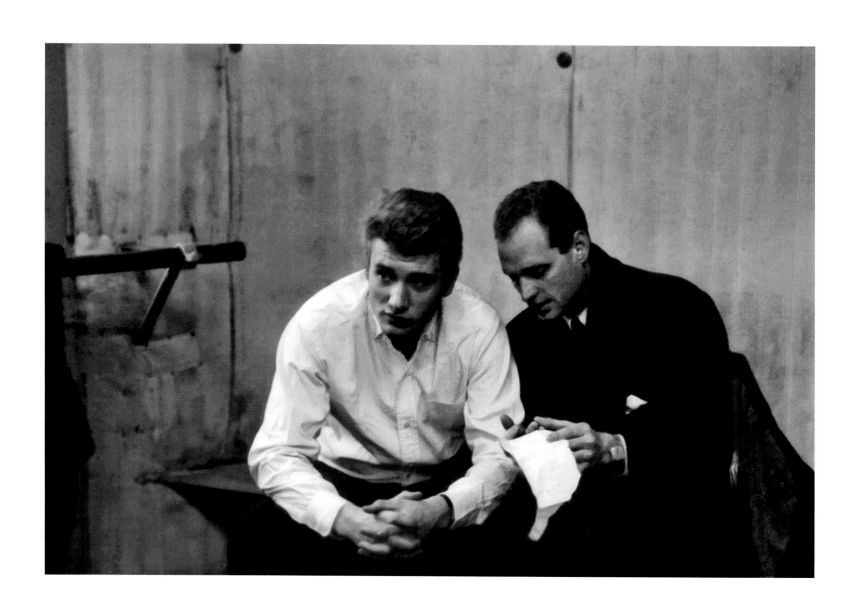

Johnny Hallyday and jazz musicians at Pathé Marconi Studios.

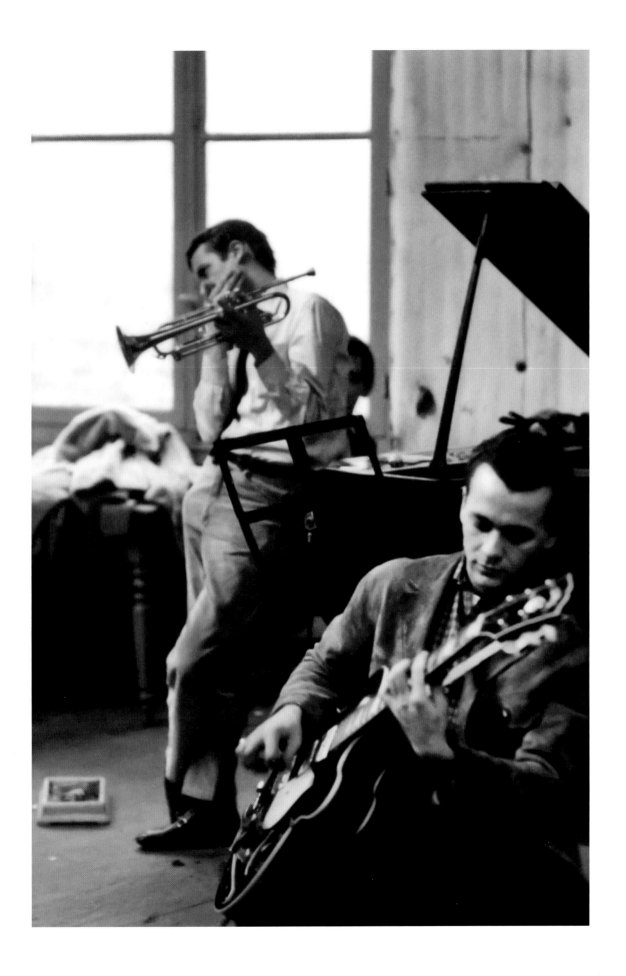

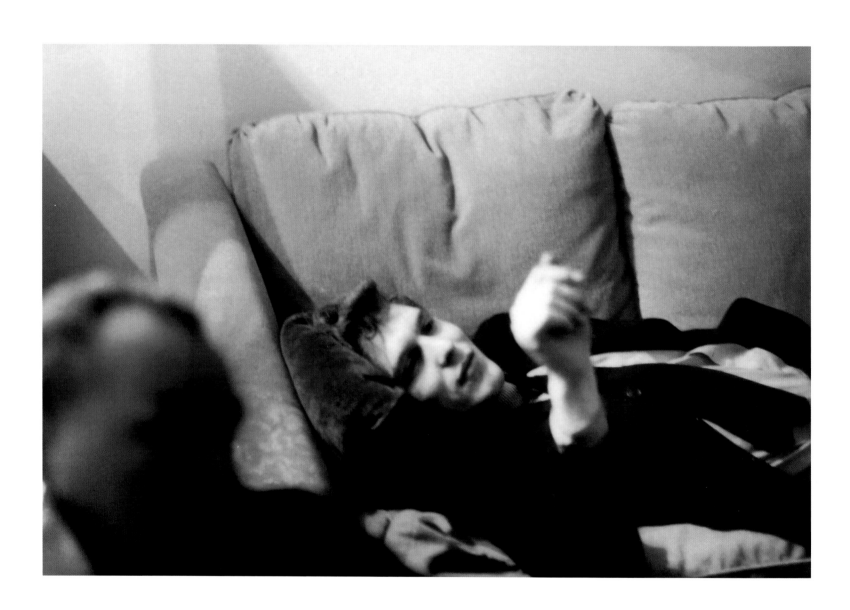

Neil taking a break at the George V Hotel.

An elegantly poised sitter in our George V Hotel suite.

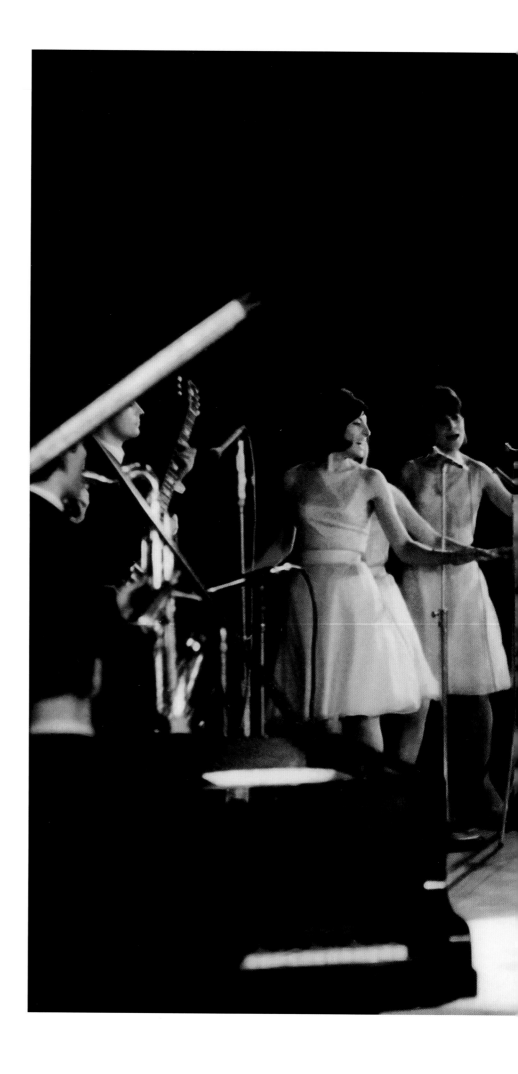

166 Sylvie Vartan on stage at l'Olympia.

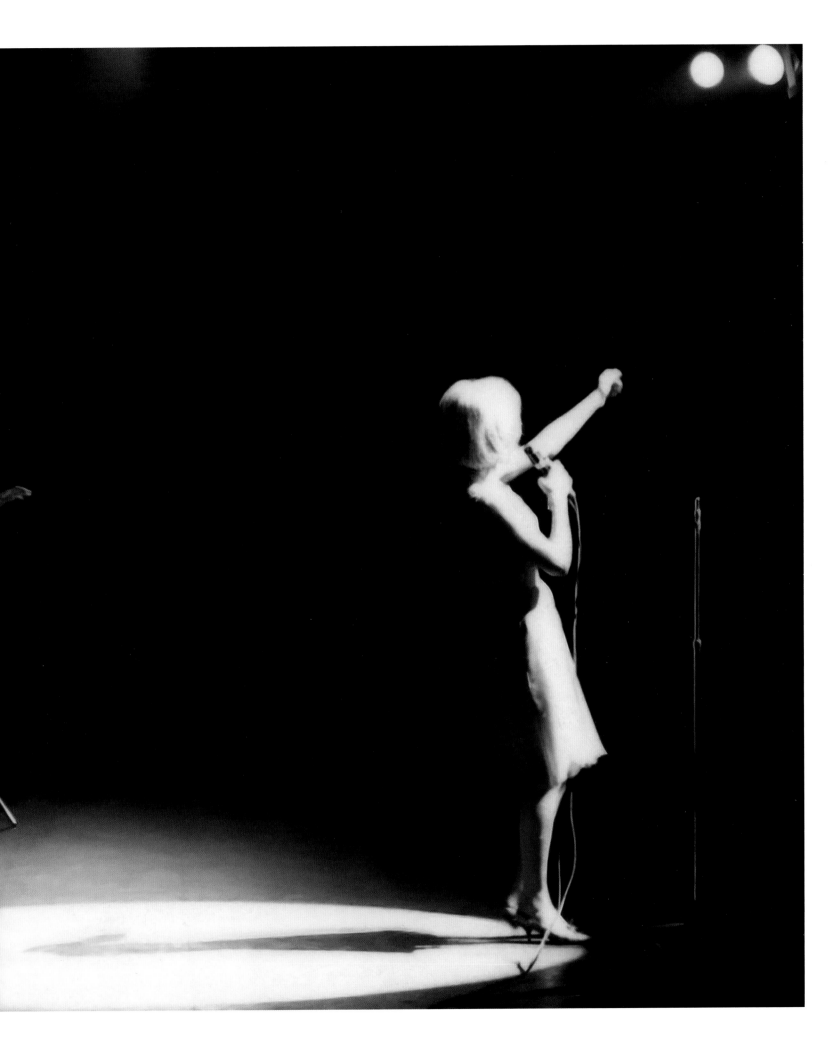

Liverpool
London
Paris
New York
Washington, D.C.
Miami

NEW YORK.

7th – 11th February
12th – 13th February
1964

Success in America was what we'd always wanted, and when we were growing up, it was where all the film stars came from – people like Marilyn Monroe, Marlon Brando and James Dean. Even to my dad's generation, it was the home of Bing Crosby, Fred Astaire and Ginger Rogers. And everything we listened to was from America. You didn't really listen to many British bands, but if you did, they were getting their influences from America, too. Without the music of Elvis, Buddy Holly, Little Richard, the Everly Brothers and so many more, there wouldn't have been The Beatles.

I still get asked about the pressure of that first trip to the U.S. So many people back home were rooting for us – it was a huge deal for a British band to be No. 1 over there. It sounds like a lot to put on the shoulders of four lads in their early twenties but, in reality, we were just wisecracking guys and we had fun with each other whatever we did and wherever we went. I think this comes across in my photos.

But nothing could have prepared me for the wild Friday afternoon that launched even higher levels of hysteria and madness – the 'Beatlemania', as they already called it back home – that characterised 1964 for us. Looking at these pictures today, I'm still taken aback by it all. Landing at JFK Airport to this huge reception of fans and press was only the start, as it became even more chaotic during the rest of our first trip to the U.S.

At the airport press conference we found that the American reporters were obsessed with our hair and asked if we were going to get haircuts. George replied that he'd had one the day before. That still makes me smile. It was just perfect because once they saw we weren't going to be scared of them, they loved throwing their questions at us and we would just bat them right back. It became a fun little game. I remember there was one journalist who always asked the same question, 'What are you going to do when the bubble bursts?' It got to the point where it became a running joke and *we'd* ask him to ask us: 'What are you going to do when the bubble bursts?' Our answer? 'Well, we would go pop!'

You can see in the photos the fans chasing us and waving to us along the New York streets. We had these portable radios with us, so in the car we discovered WABC, one of the city's most influential Top 40 stations. They were broadcasting things like: 'The Beatles are now in town!' Murray the K, a famous radio DJ on the WINS station at the time, latched onto us. We liked him. He was a ballsy New Yorker who we thought was funny. We were staying at the Plaza Hotel, who were pretty horrified by all the hullabaloo, with photographers from magazines and newspapers we'd never heard of lined up in the crowded corridors, trying to get something exclusive. A number of adventurous fans were also doing everything they could to try and sneak into our rooms.

The tourist angle that I had explored in my Paris photos comes back in New York, where I focus on American billboards or views from skyscrapers. The pictures also show the commotion that followed our arrival in the city. There is the frenzied crowd chasing us down West Fifty-Eighth Street, between the Plaza and Avenue of the Americas, that I caught out of the rear window of the car. Or the photos showing the number of mounted policemen that were trying to control the crowds of waiting fans. We did a photo shoot in Central Park, and I had my camera with me, so I've captured people taking pictures of me up close and you can see how we were constantly surrounded by cameras. These photos juxtapose with those from our hotel suite, which show unguarded, quiet moments.

When I'm looking at the photos, fun little memories come floating back and I find, with memories, it's often the more trivial things that seem to stick. In the U.K. we had been used to wearing a pancake make-up called Leichner 27 – but for *The Ed Sullivan Show*, the make-up artists were suddenly packing on this orange stuff. Layer after layer. And we were going, 'Are you *sure* about this?' They said, 'Yeah, we know. We know the show.' The show was broadcast in black and white, with many American shows changing to colour a year or two later, so they knew that make-up had to be thick. And they were right! We came out the colour of orange juice, but on the show you can't really tell we are wearing make-up.

When I watch that first *Ed Sullivan Show* performance now, I'm struck by how much fun we're having. Following commercials for Aero Shave and Griffin Liquid Wax shoe polish, we played three songs: 'All My Loving', 'Till There Was You' and 'She Loves You'. Then, later in the show, we performed 'I Saw Her Standing There' and, finally, 'I Want To Hold Your Hand'. Apparently almost everyone in America watched *The Ed Sullivan Show*, but on this night, there was a far greater audience than usual. Seventy-three million people, way more than the entire U.K. population. It was a wildly exciting time and went far beyond our expectations – as did the rest of that visit to the U.S.

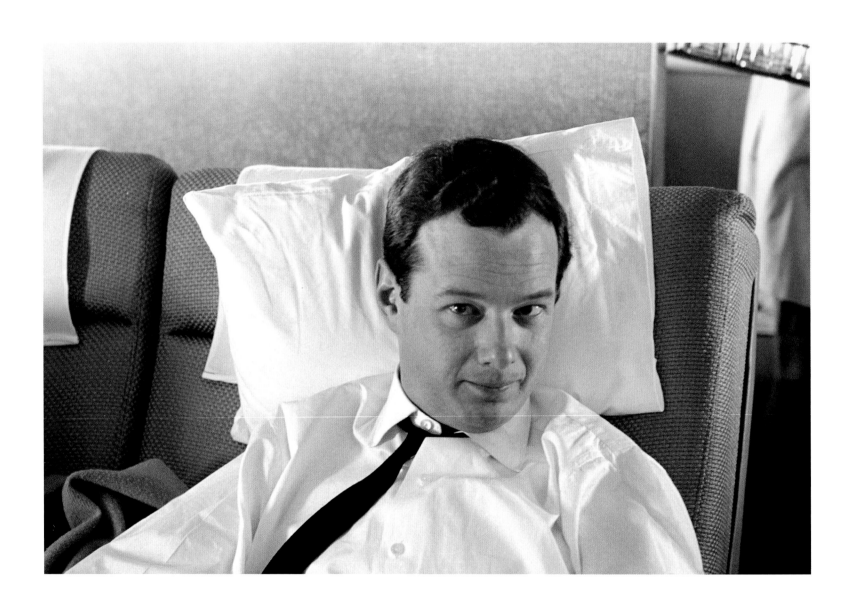

Pan Am flight 101 from London to New York City, Friday 7 February.

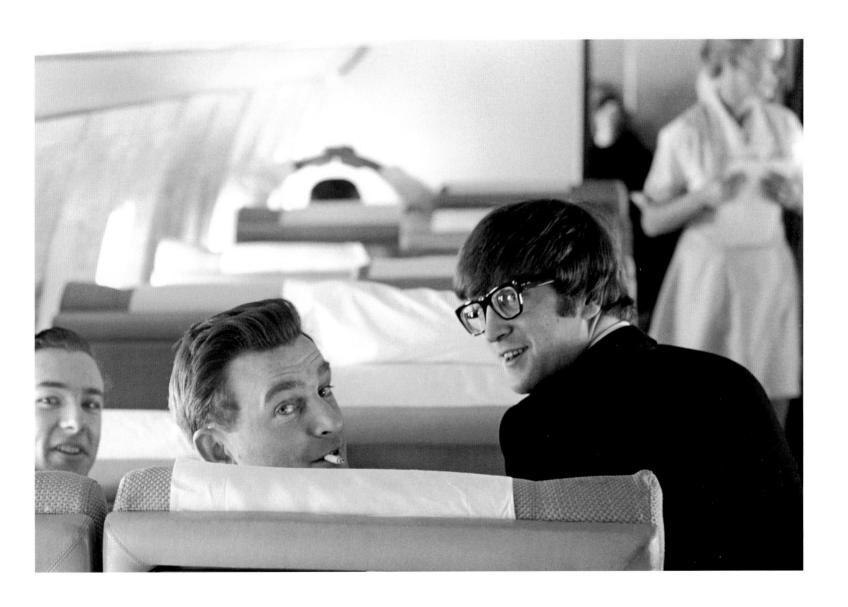

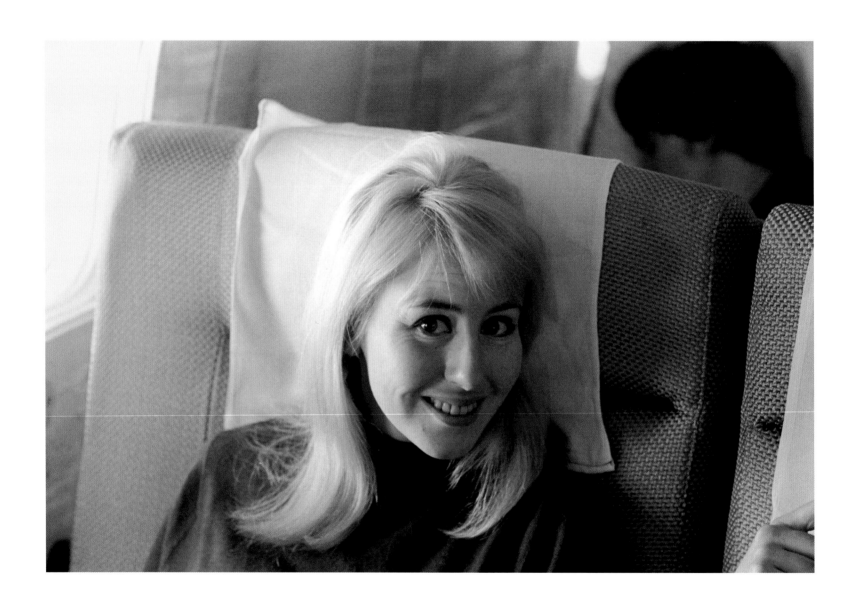

Cynthia Lennon and George on the flight to JFK Airport, New York.

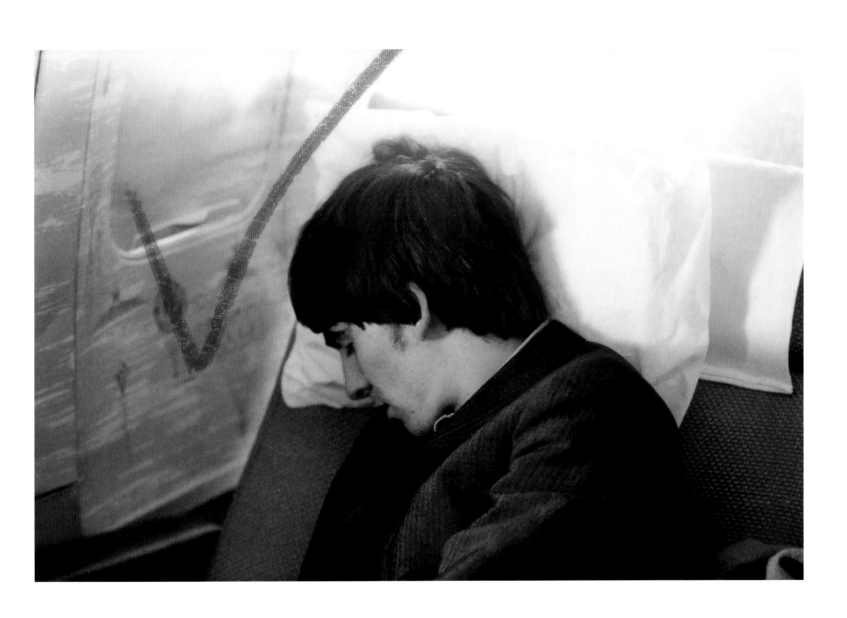

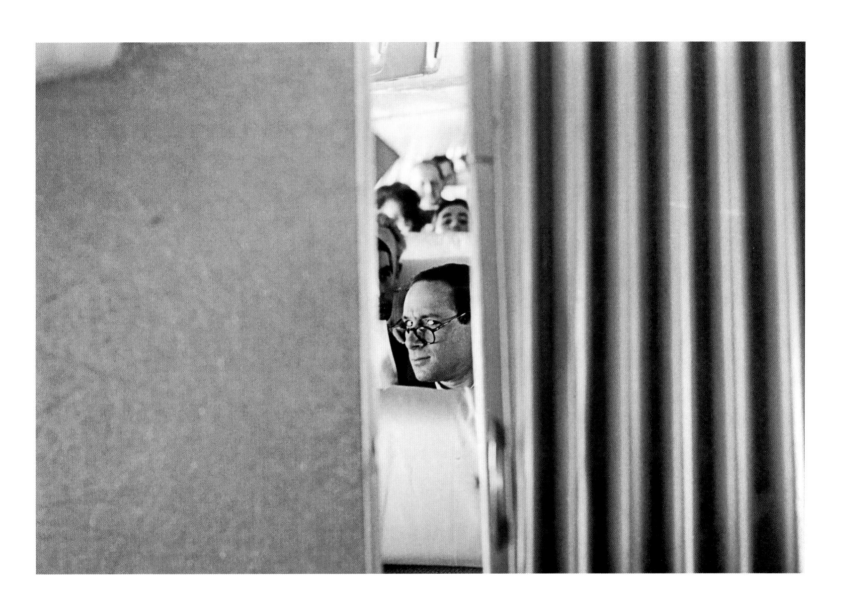

Michael Braun's beady eye was always on us.

Following page: Columbus Circle, a very mid-century New York scene.

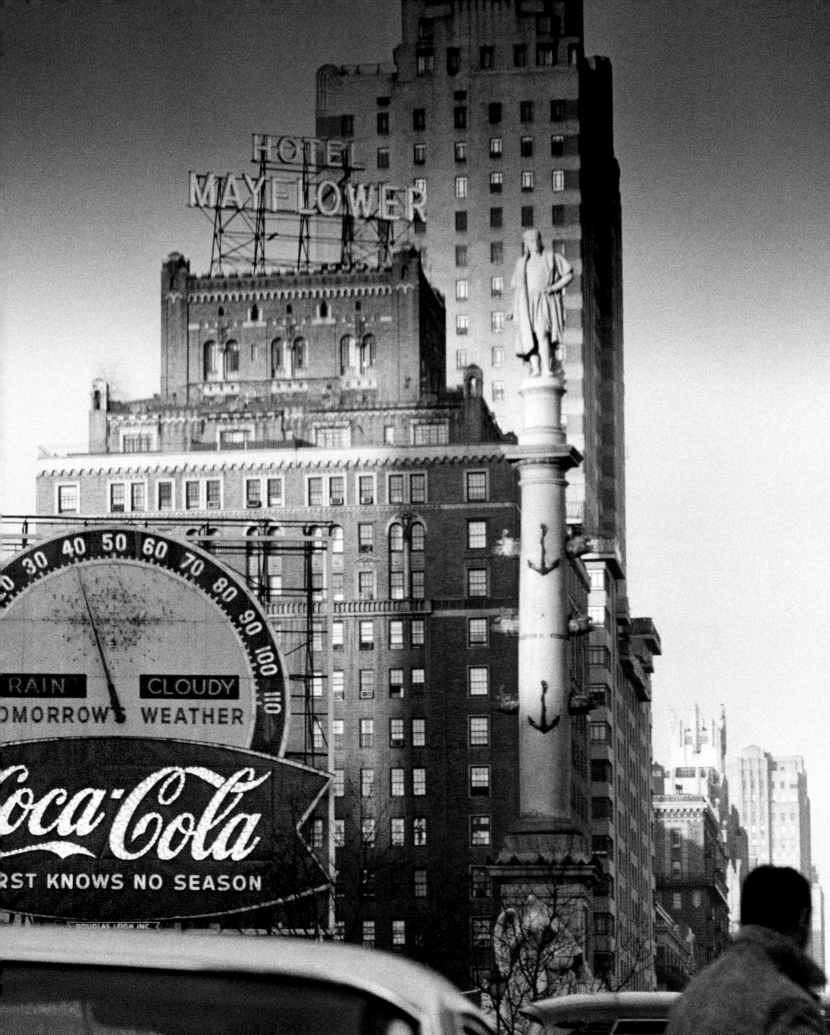

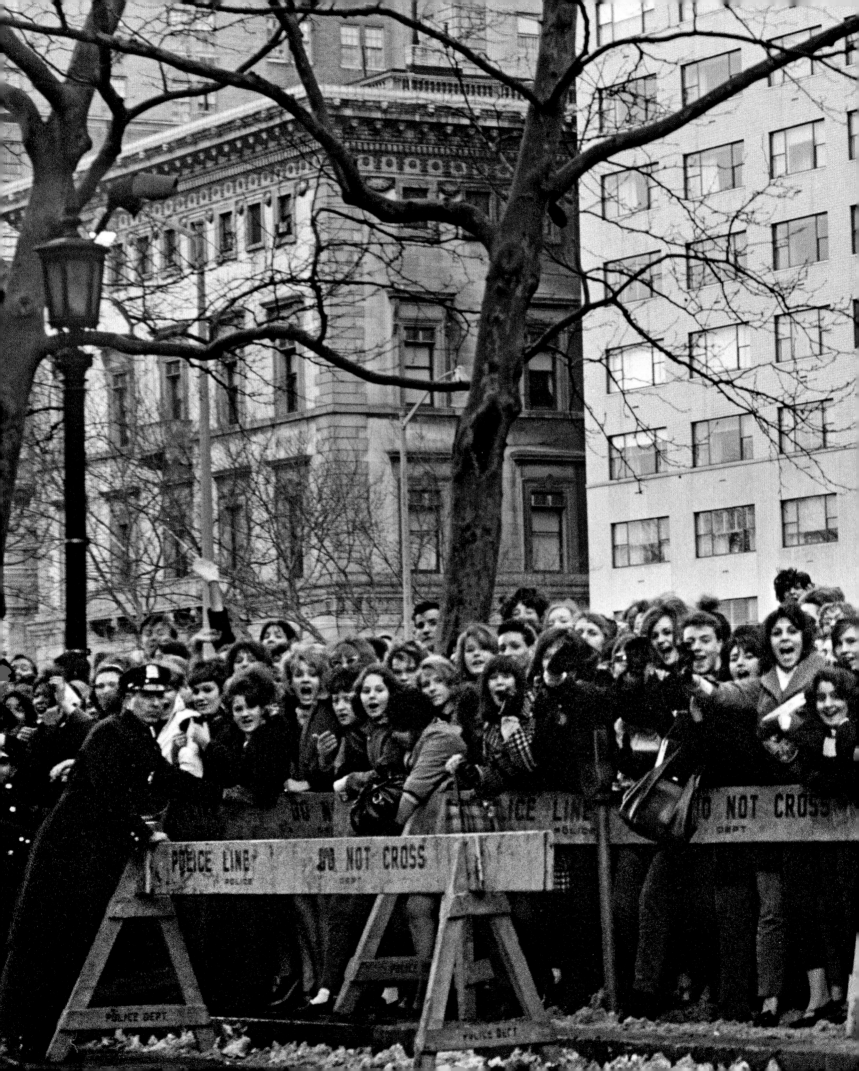

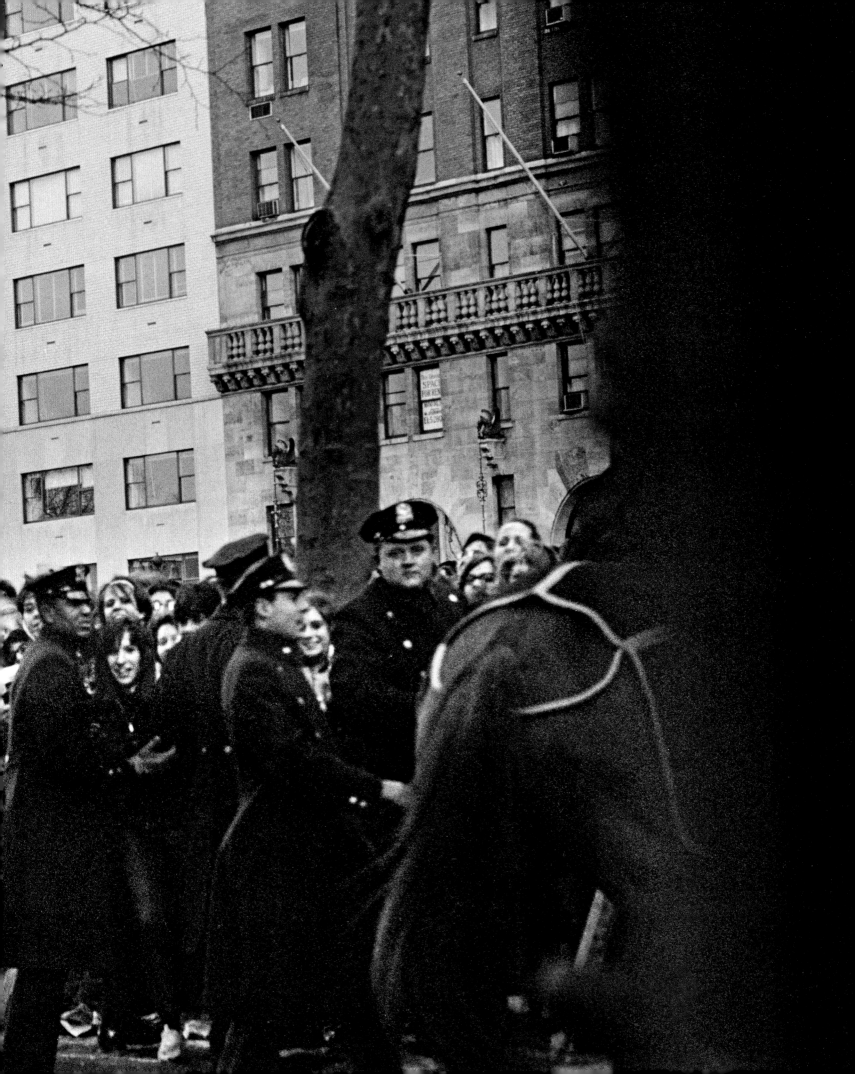

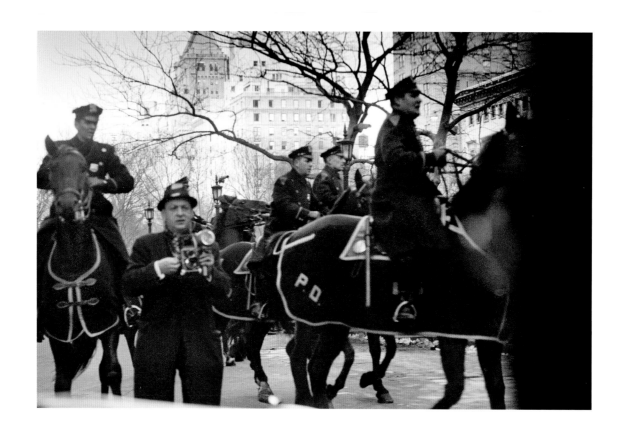

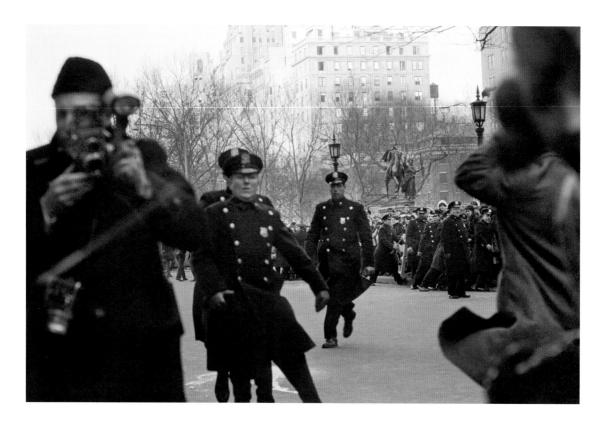

Previous page: Our welcoming American fans at Central Park.
They were as loud and crazy as our British fans, but with different accents.

Above: The waiting fans were looked after by the NYPD.

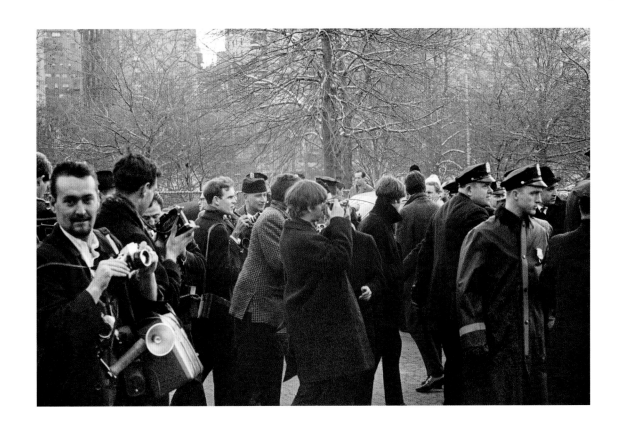

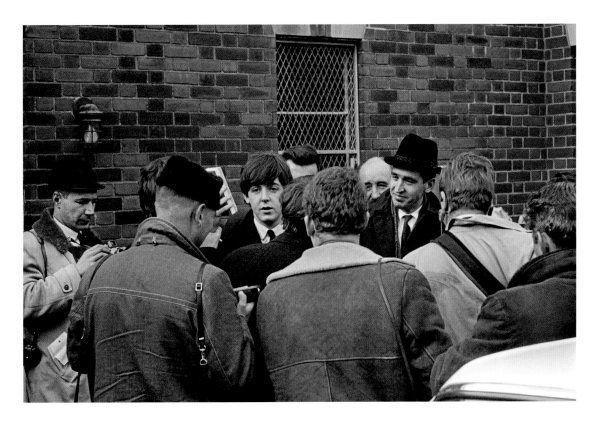

We were surrounded by people everywhere we went.

Following page: The crowds chasing us in *A Hard Day's Night* were based on moments like this.
Taken out of the back of our car on West Fifty-Eighth, crossing the Avenue of the Americas.

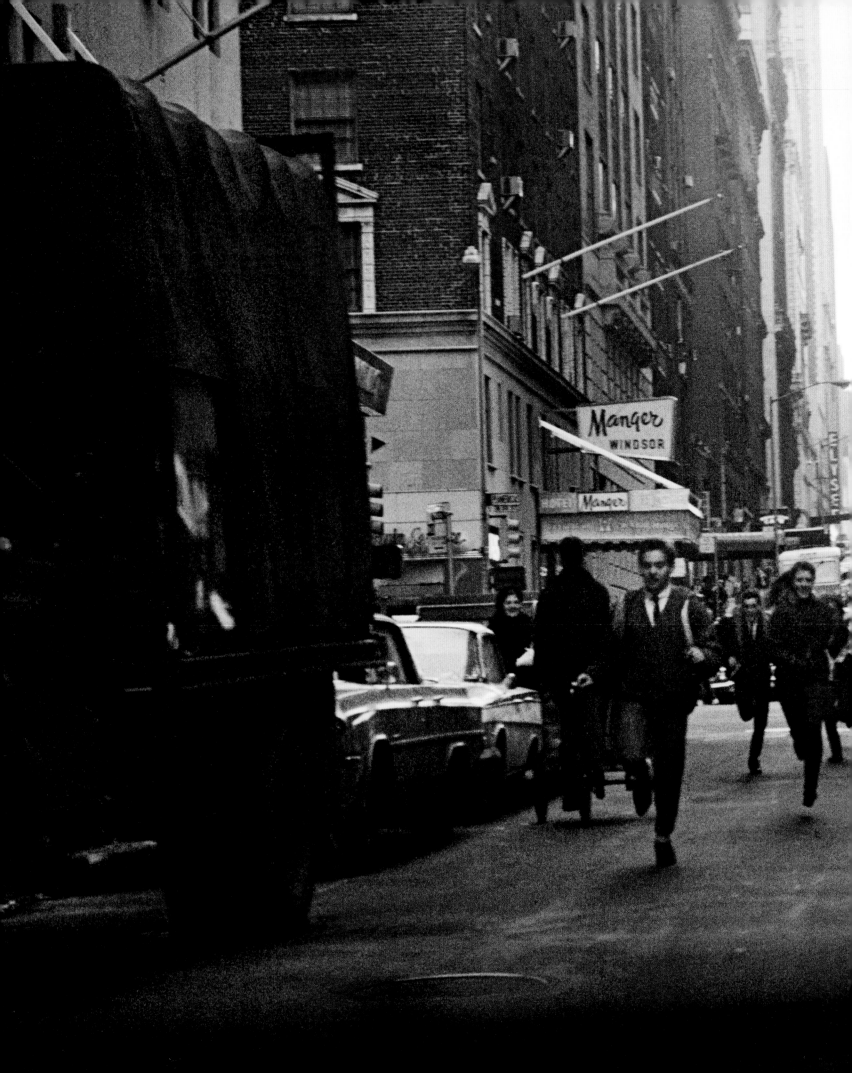

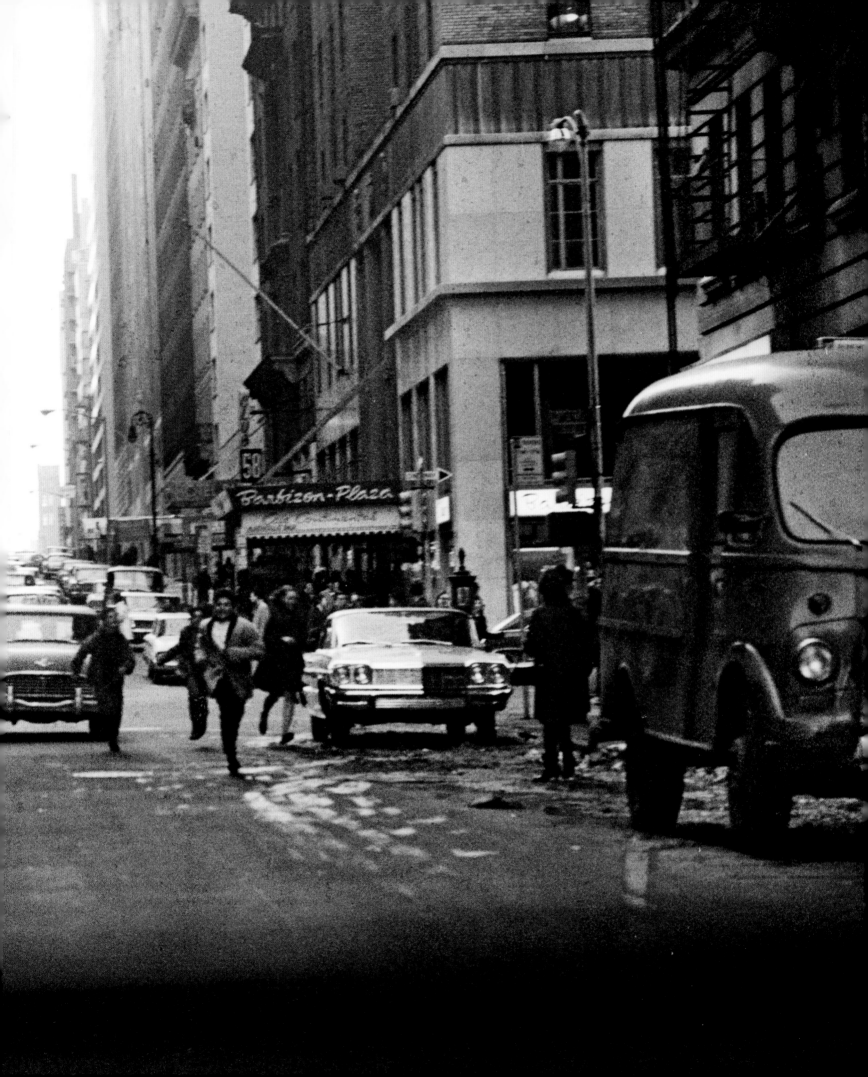

I like these portraits of 'New York's finest'. They capture the friendly and
curious gaze we found ourselves under every day.

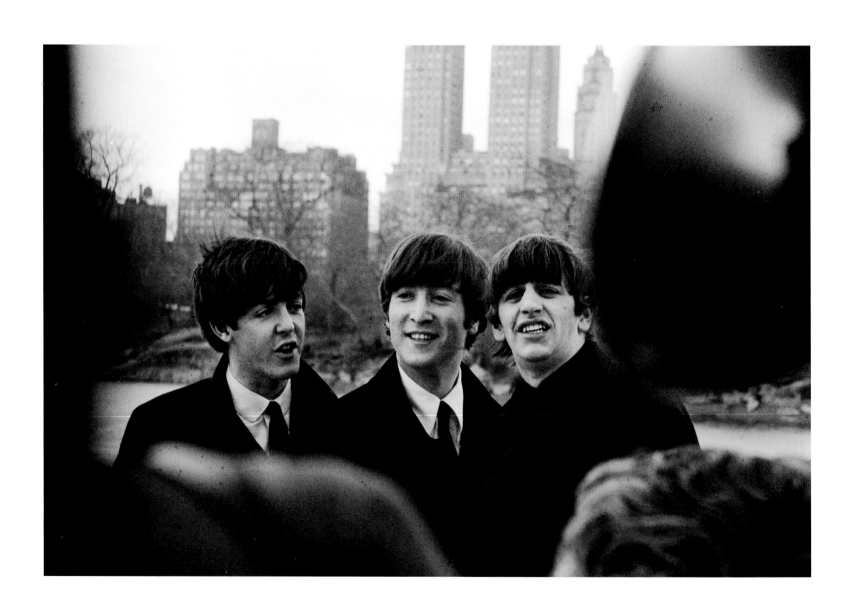

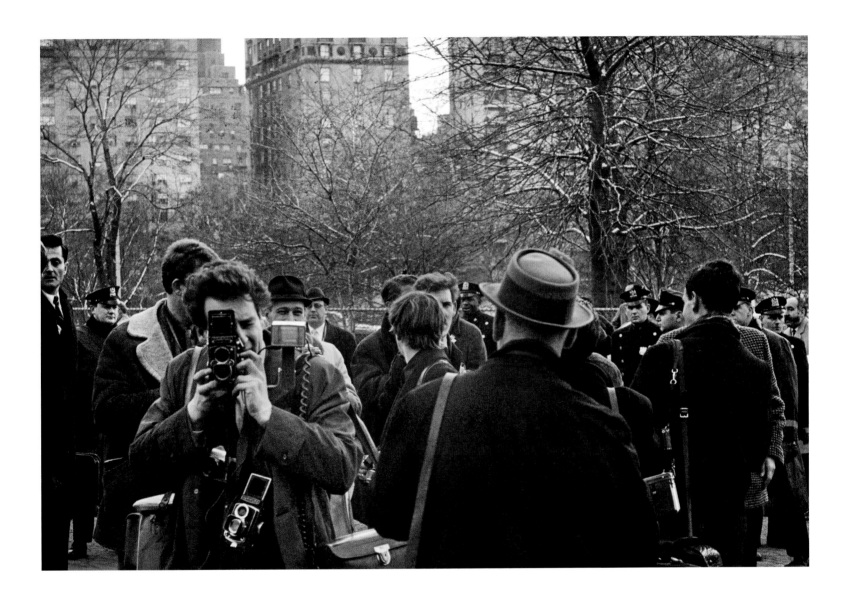

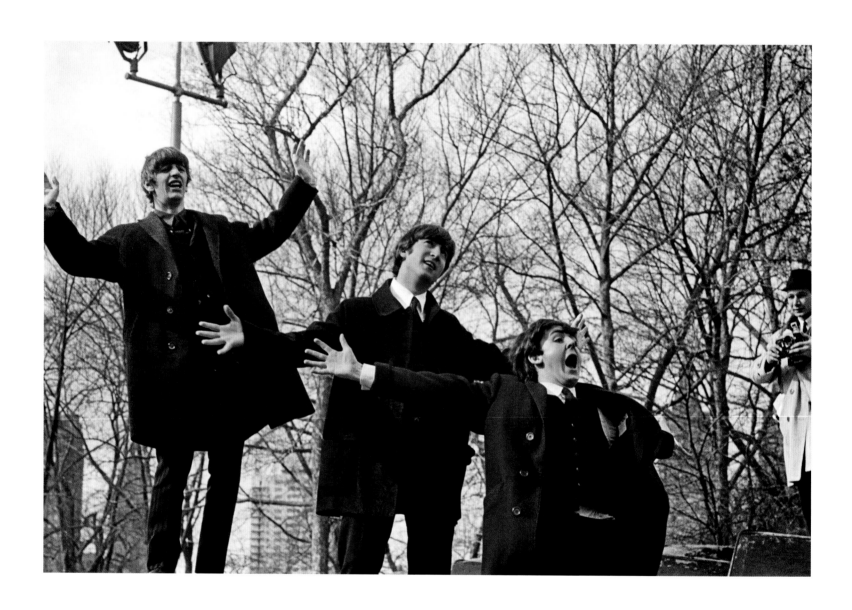

190 Goofing around in Central Park in the *eyes of the storm*.

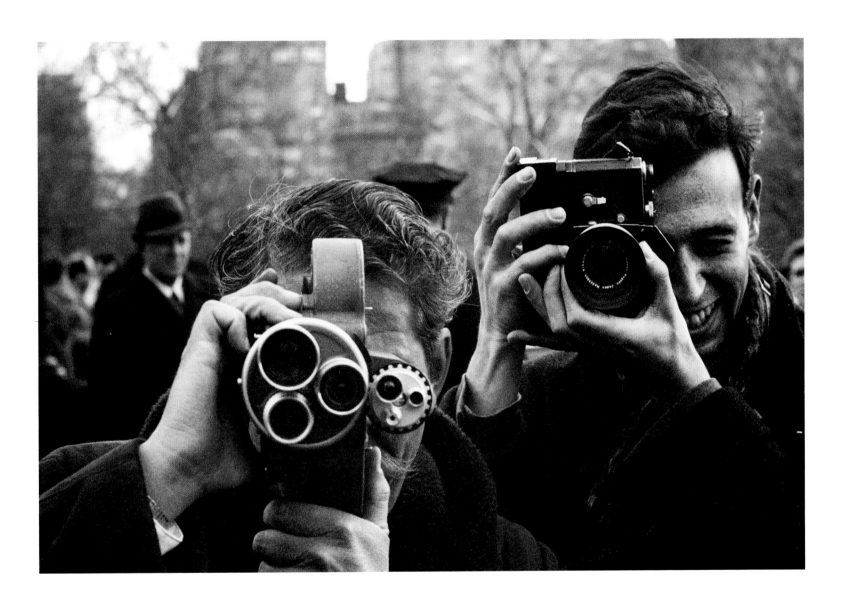

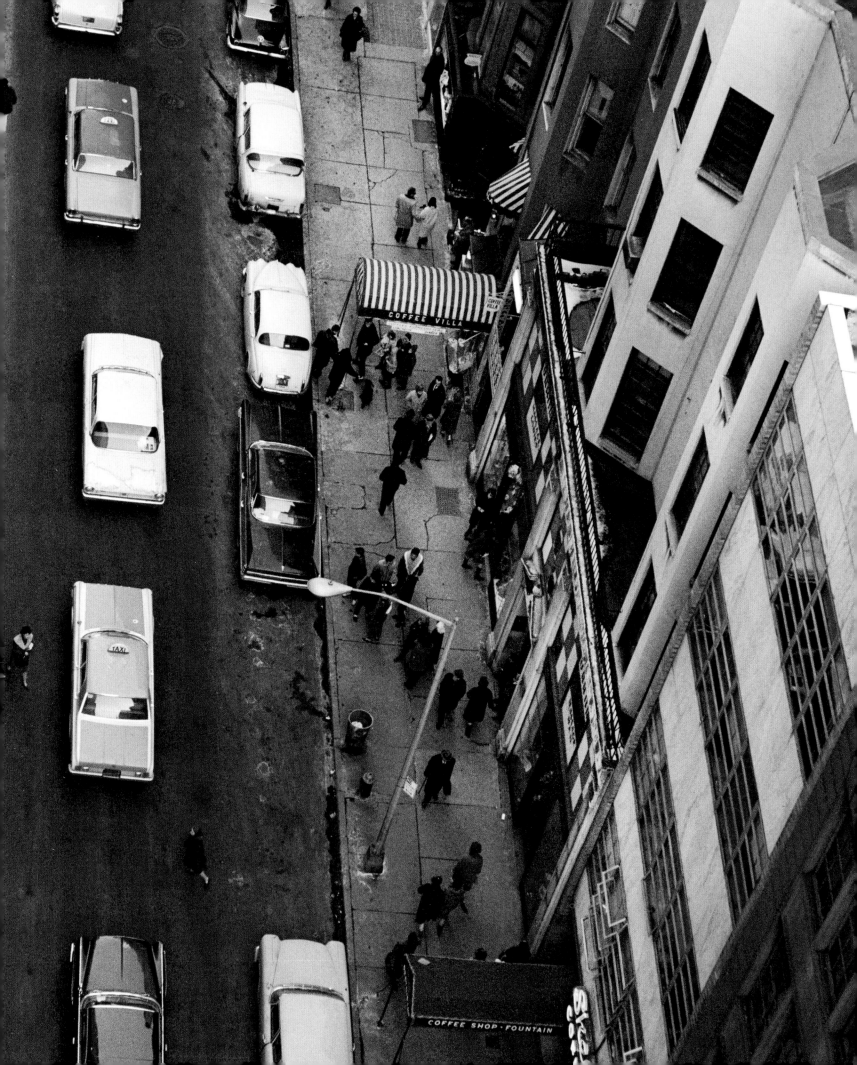

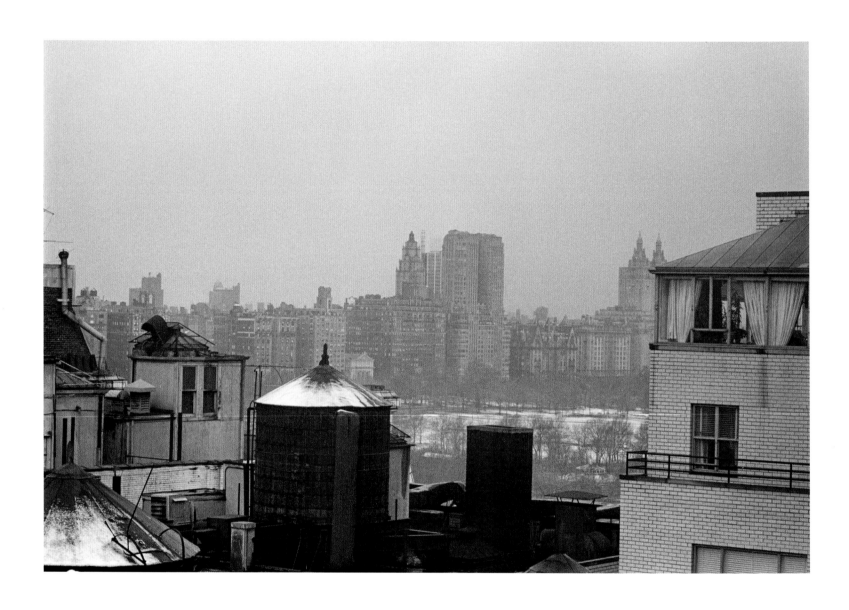

I love New York's water towers.

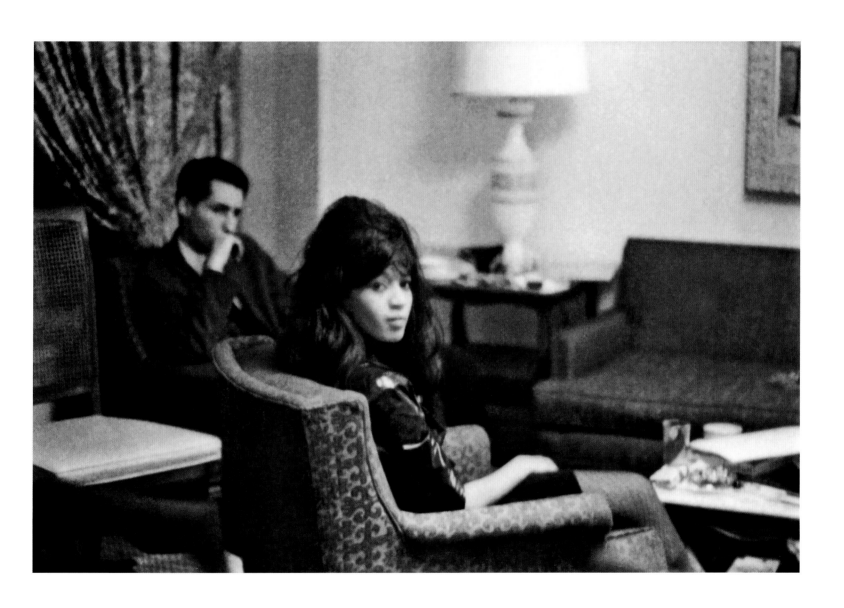

Ronnie Spector in our Plaza hotel suite. All four of us loved The Ronettes.

We became friendly with American DJ Murray the K, who played our records.

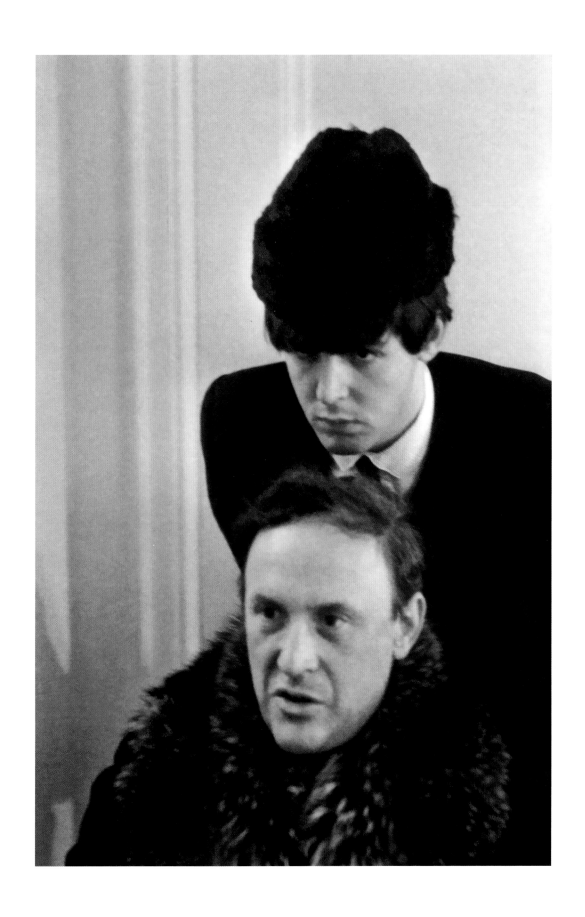

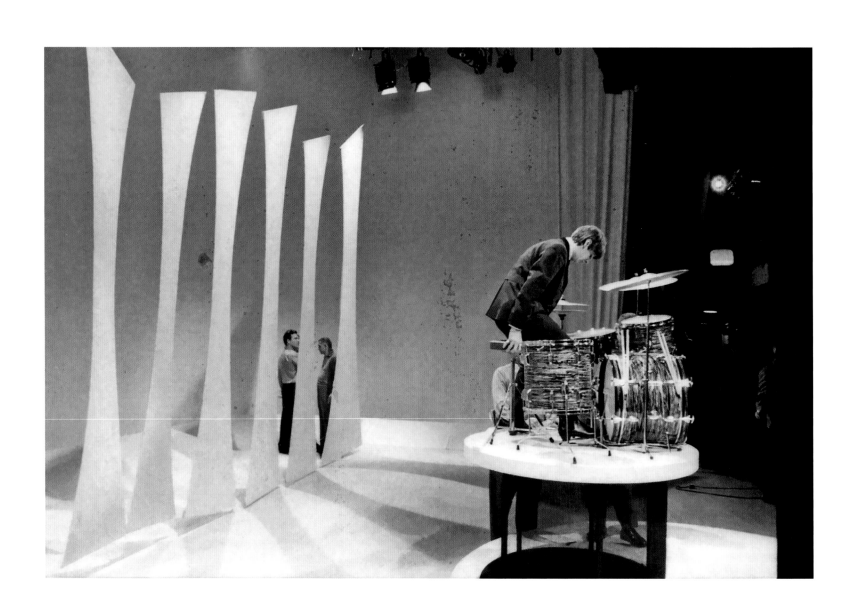

Ringo setting up his precariously perched drum kit during rehearsals for *The Ed Sullivan Show*.

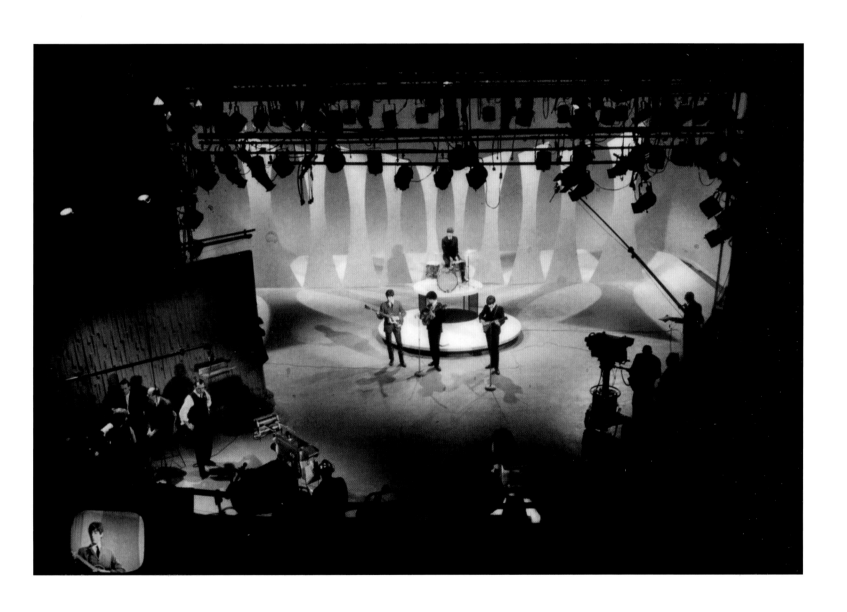

Because George was in bed with tonsillitis, Vince Calandra, from the show's crew, stood in for rehearsals and wore a Beatles wig. He never stopped talking about it.

Liverpool
London
Paris
New York
Washington, D.C.
Miami

WASHINGTON, D.C.

11th – 12th February 1964

We had originally planned to fly from New York to Washington, but it was snowing so heavily that we had to take the train. A blanket of snow covered the whole city – the roads, pavements and even the White House – which gave it an added character and beauty. The train journey to Washington was a good place to take photographs uninterrupted. I enjoyed the American landscape we saw en route and the workers we passed. Coming from the working classes, I often say it is a big mistake to underestimate them, yet so many people do.

The assassination of President Kennedy had only happened a few months before our visit, and it seemed as if Washington, the seat of American democracy, was still in mourning. Like pretty much everyone in our generation, we admired Kennedy, and his death really shook us. To this day, I am very happy that Britain doesn't have the gun culture that exists in the U.S.

We arrived at Union Station and were greeted by hordes of fans who had braved the snow to see us. Our visit seemed to jolt the city. Like in Paris and New York, several photos were taken from the back seat of the car. I was surprised to spot a very British name, Christine Keeler, in lights at a seedy-looking cinema. The Profumo affair had been big news back home, but I wasn't expecting to see her name on an American movie theatre marquee. There is a photograph I've taken – again from inside the car,

because it was one of the few places that I had the space to photograph from – of a young girl in a headscarf looking serene. Yet the next frame on the roll shows a grown woman enthusiastically waving and chasing after the car. Each photo shows a different moment in time. Today people are so often looking down at their phones that they forget to look up. To engage and notice what is passing them by. I like to think I still try to do this, and it seems that's exactly what I was doing in the photos I took in the States.

We only spent a day in Washington, but I'll always remember our first American concert at the Coliseum. The gig itself was crazy. We played *in the round*, which we'd never done before. The Coliseum was a sports venue, so the seating all pointed towards the middle of the room, and Ringo was supposed to move his drum kit every three or four numbers. We would play in one direction, as it were, to the east. Then we'd have to turn to another point on the compass and suddenly Ringo had to get up and move with us. Watching the footage of us struggling to help him, you'd never know we were 'taking a country by storm'.

The other thing was that the fans, and they were mainly girls, seemed to have read *everything* about us. Somewhere, probably in a British publication, they'd seen the question: 'What's your favourite sweet?' (This translated into American as 'What's your favourite

candy?') We had answered, 'Jelly Babies', which we kind of liked. In the U.S. they didn't have Jelly Babies, but they did have jelly beans, which are much, much harder. I think they were even selling them at the venue. So, during the gig, fans started throwing them at us onstage. Like bullets, they were, mini-missiles. We had to dodge them while we were playing. They could have had our eyes out. The worst thing was, we stood on them onstage and they were sticky as hell.

The excitement didn't stop when the show was over. We were invited to a do at the British embassy and were asked lots of quite brash questions, like 'Which one are you?' So, we had some fun with it. 'Me? I'm Roger.' And John would say, 'No, I'm not John. I'm Charlie. That's John,' pointing to George. Someone even came up behind Ringo with a pair of scissors and snipped off a lock of his hair! There was always this obsession with our hair. The record label hadn't helped. Before we even came over, they'd plastered millions of stickers and posters across the country saying, 'The Beatles are coming!' with an illustration of four hairdos. No faces: just hairstyles. Capitol Records even gave out Beatles wigs.

After our whirlwind Washington visit, the next day we returned to New York for two shows at Carnegie Hall. There was such a demand for tickets, they even put chairs on the stage. It reminds me of that old joke: 'How do you get to Carnegie Hall?' 'Practice! Practice! Practice!' How did we get to Carnegie Hall that particular night? We sneaked out through the Plaza Hotel's kitchen and took a cab!

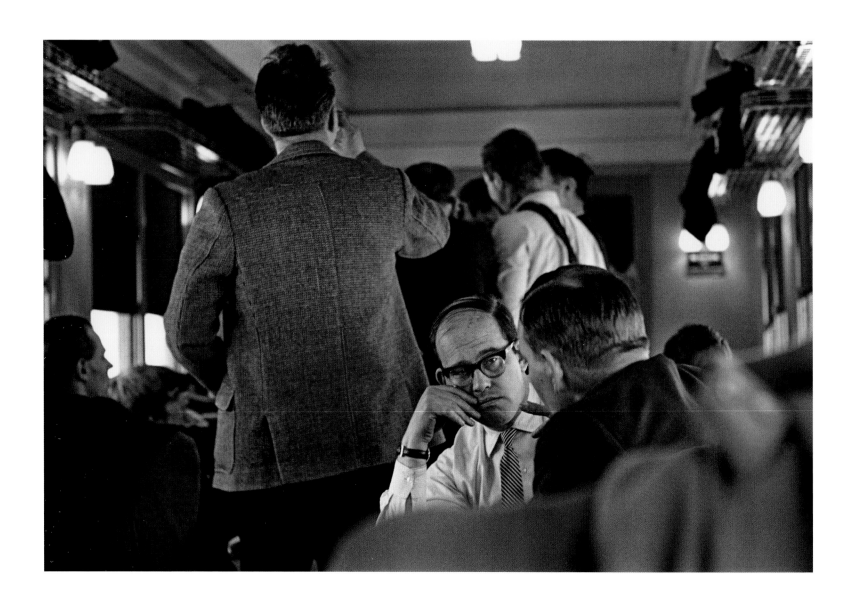

Our publicist Brian Sommerville on board the Pennsylvania Railroad express to Washington.

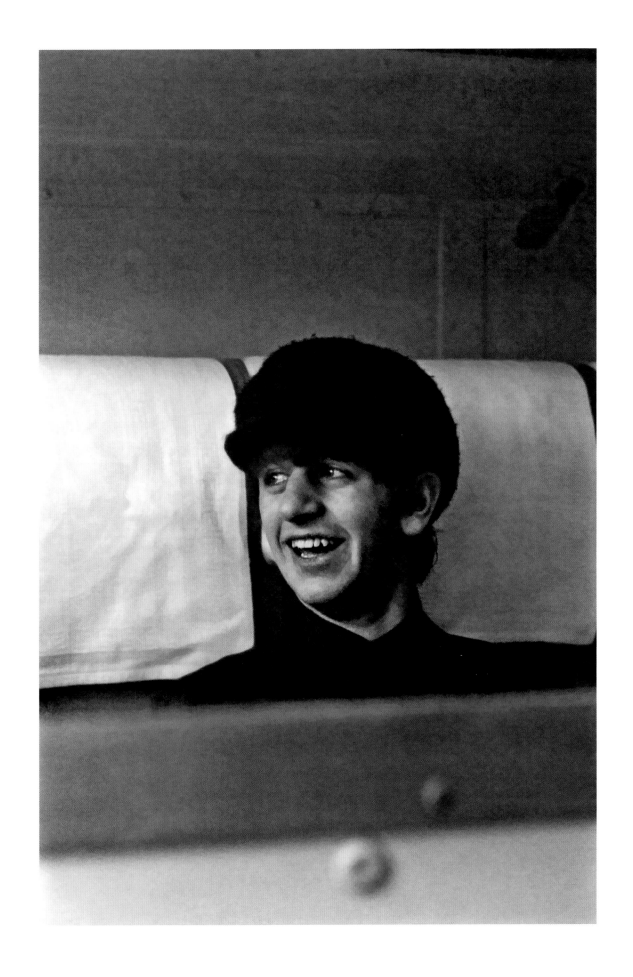

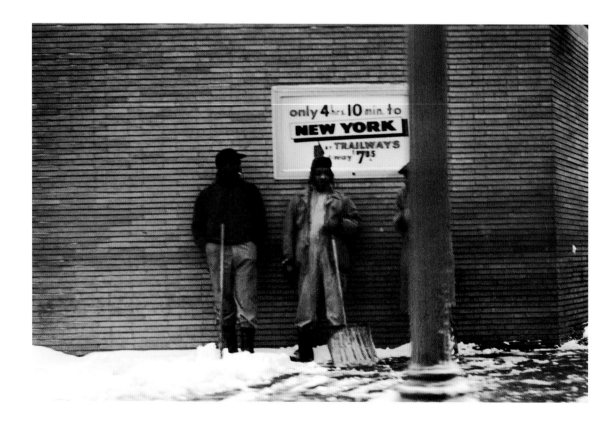

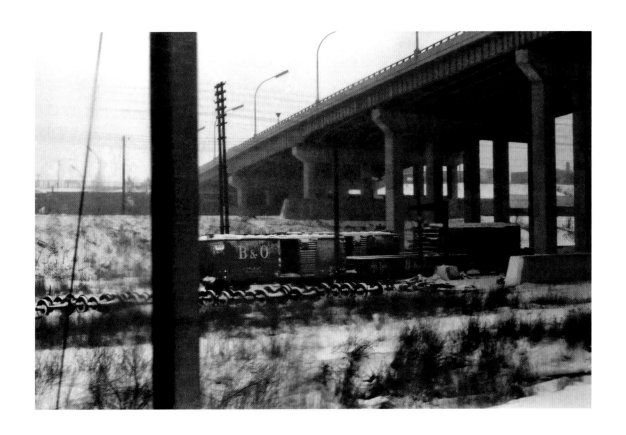

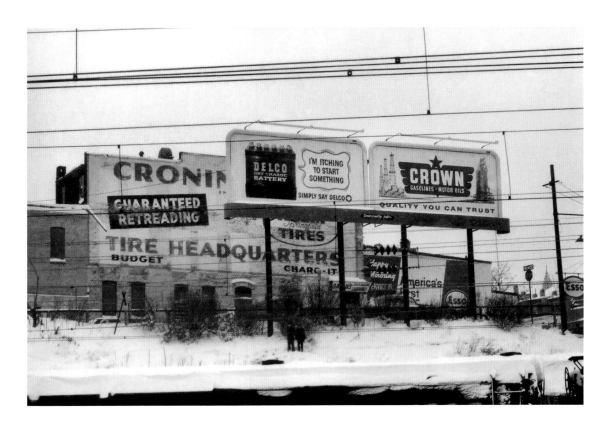

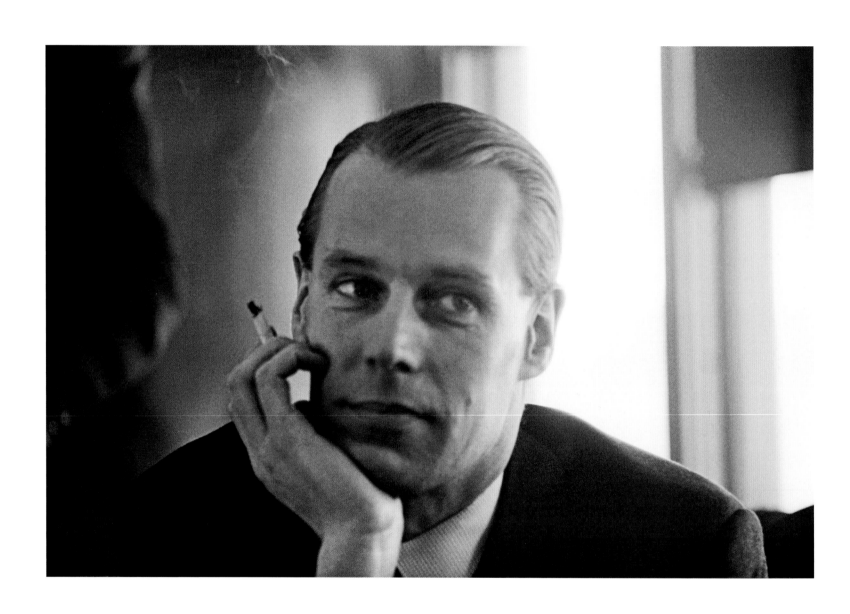

The impeccably dressed gentleman George Martin,
sitting alongside George Harrison's sister, Louise, who had recently moved to Illinois.

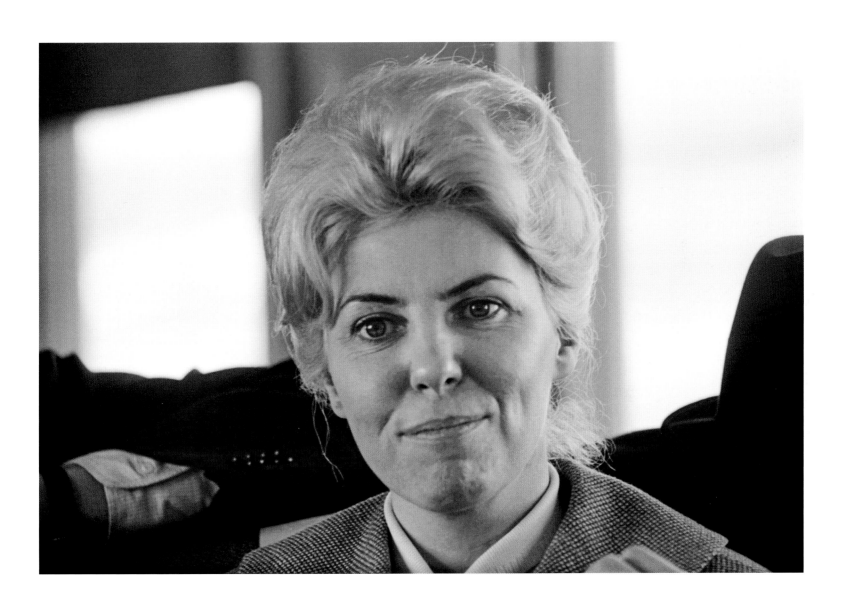

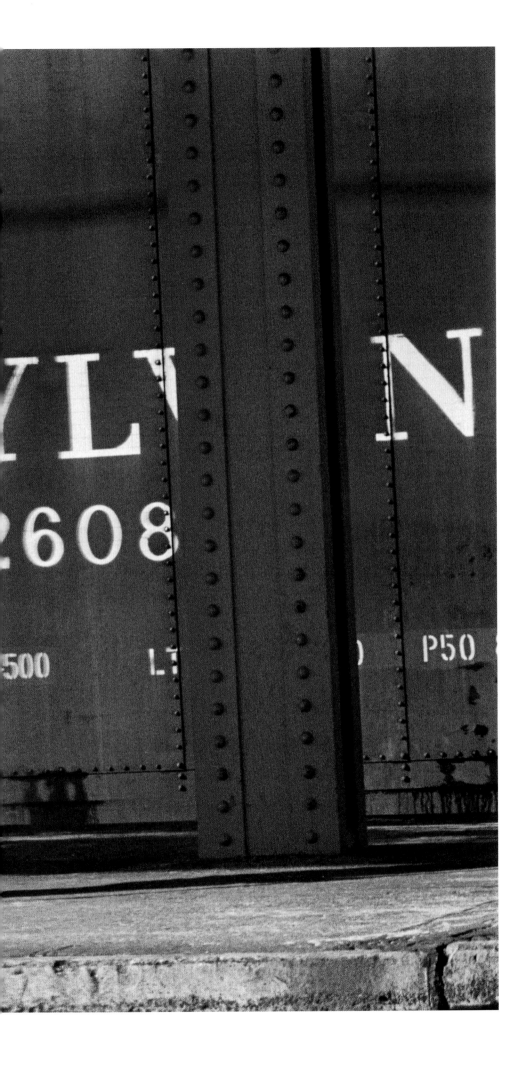

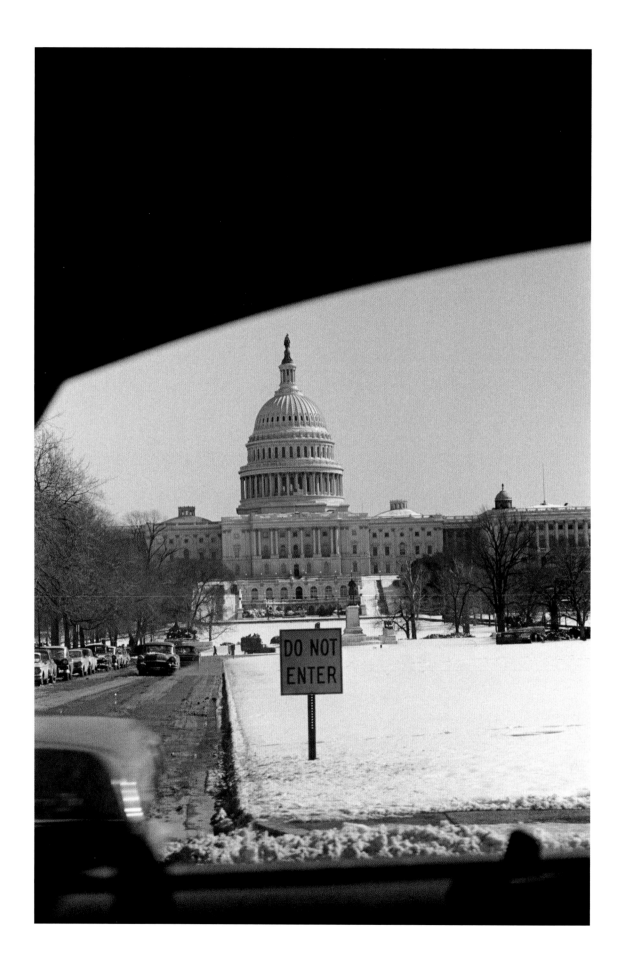

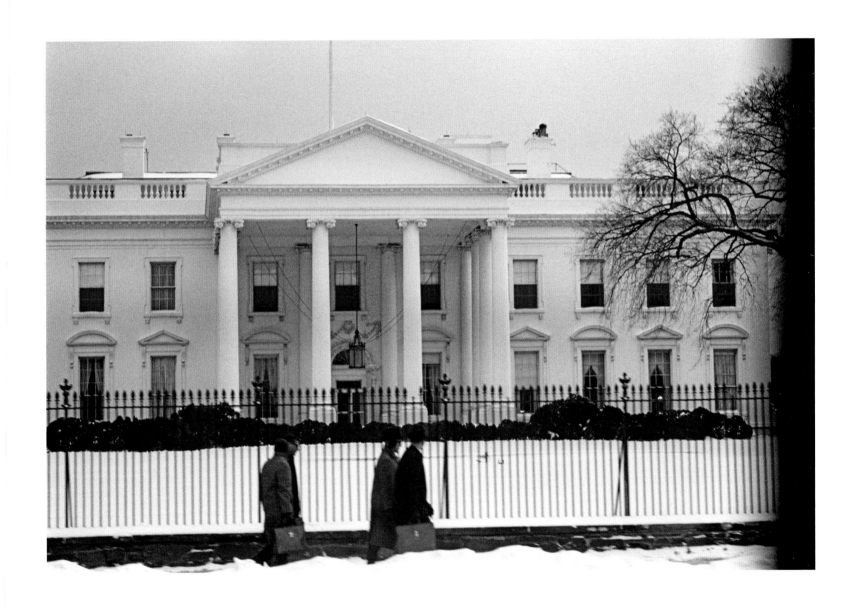

My first view of these famous Washington landmarks, the Capitol and the White House.

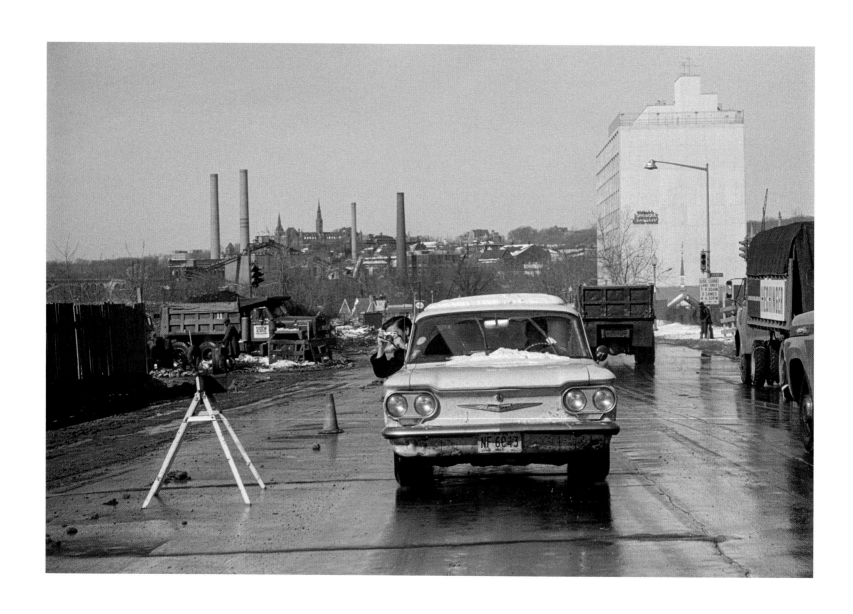

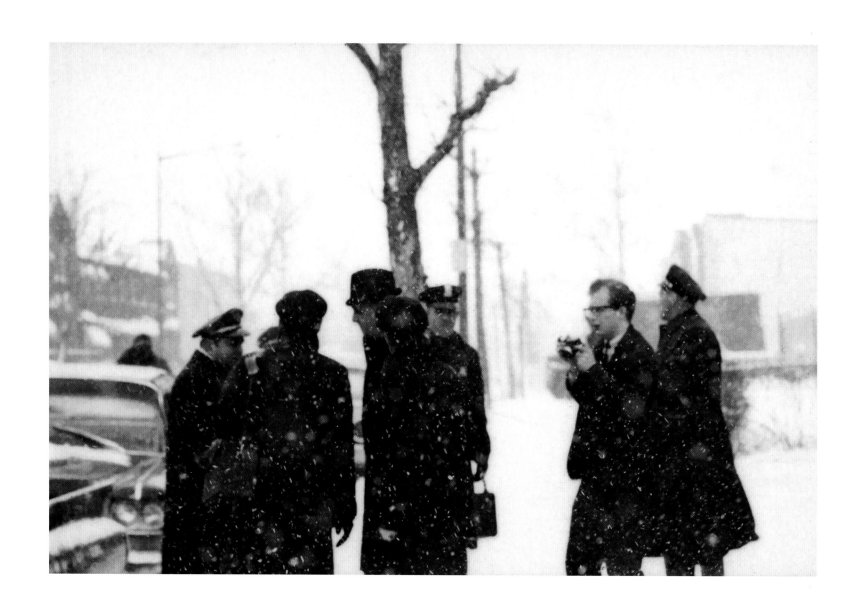

Brrr . . .

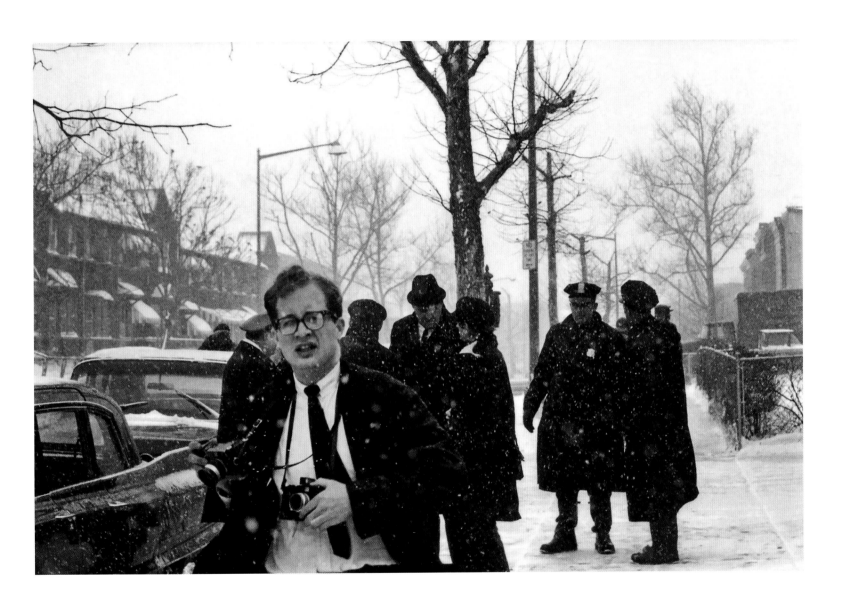

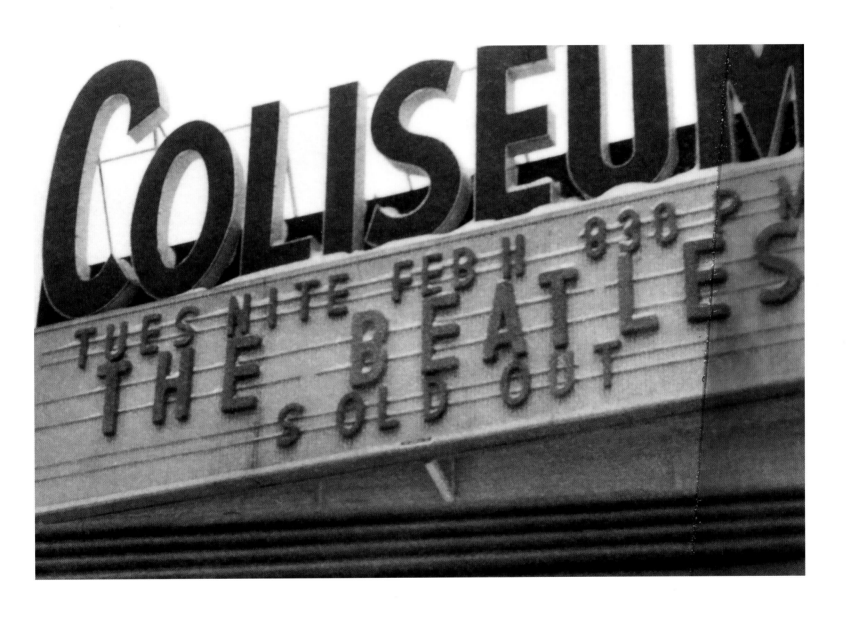

The show at the Washington Coliseum was our first in the U.S.

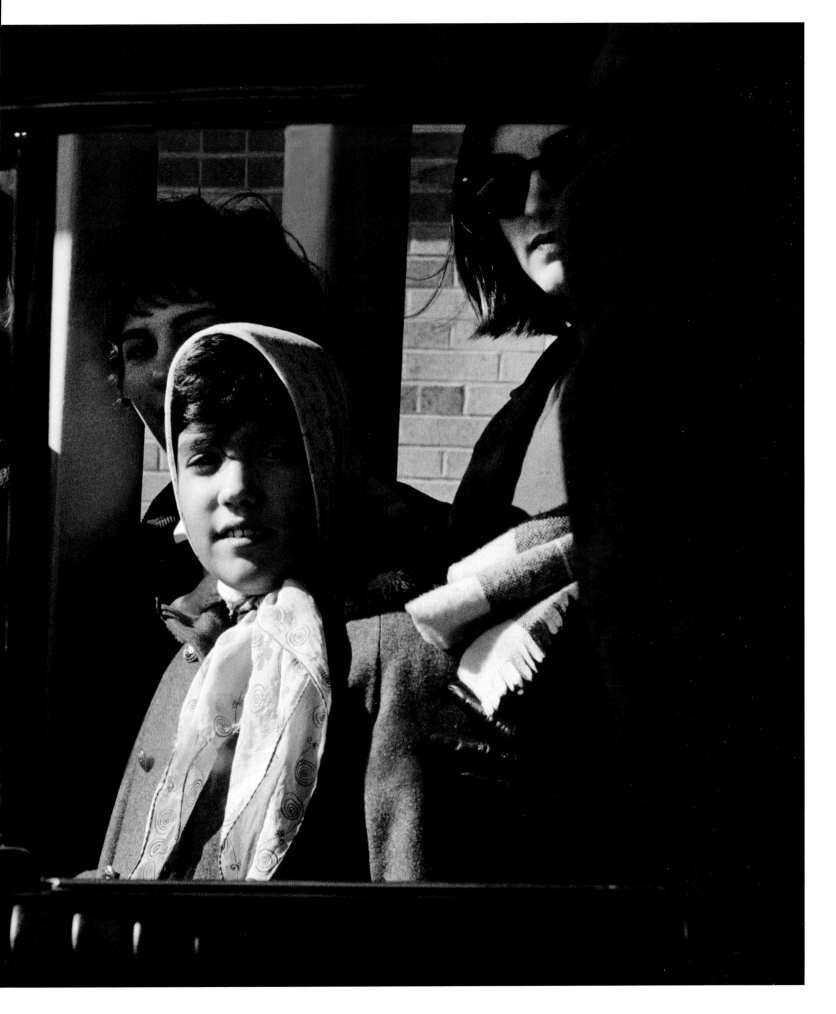

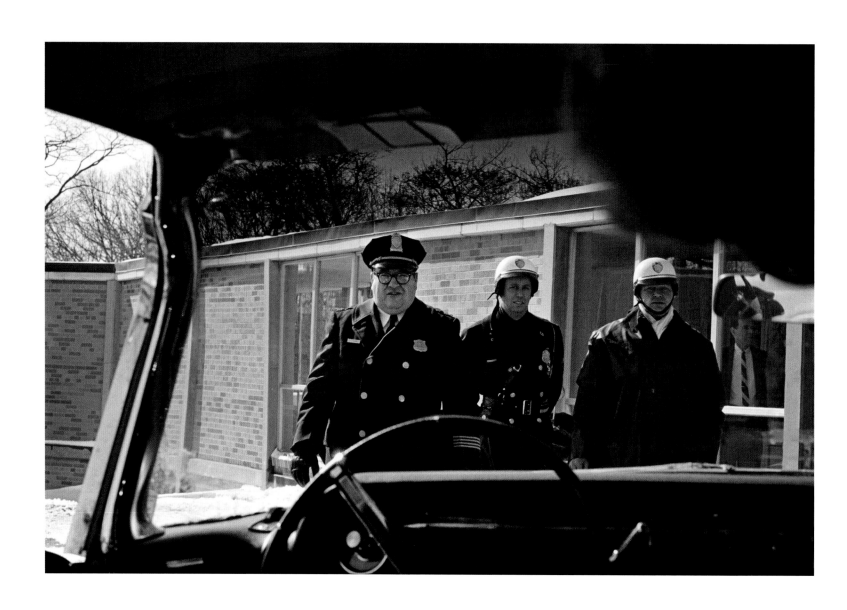

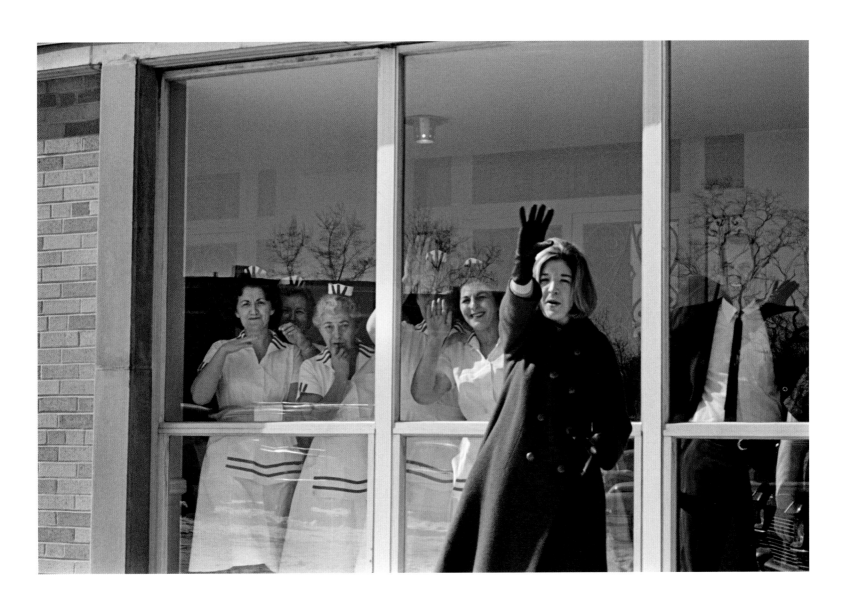

We had fans from all walks of life.

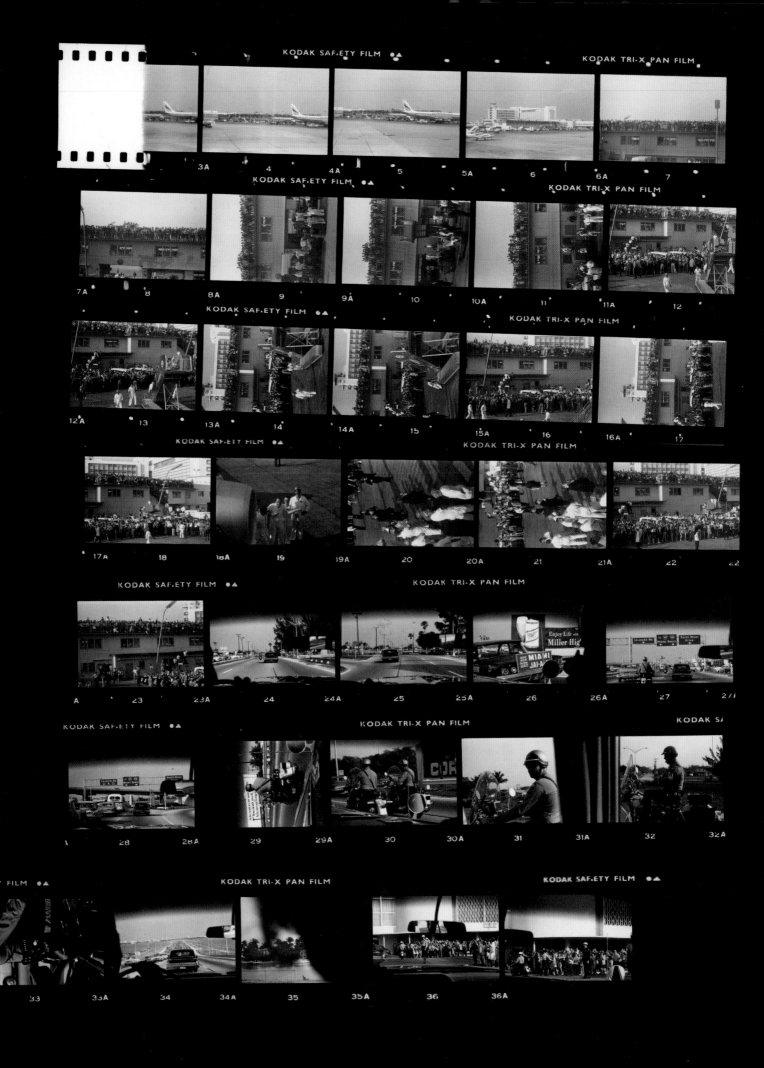

Liverpool
London
Paris
New York
Washington, D.C.
Miami

MIAMI

13th – 21st February 1964

Miami was unknown territory to me, but it turned out to be a thrilling place. I knew it would be sunny. Going to the beach when I was growing up in Liverpool was a big thing. It usually meant holiday time, but the sun in Miami Beach was very different to the sun in Liverpool.

The colours there were so vibrant. Compared to the photos I took in Liverpool, London, Paris, New York and Washington, D.C. – which were varying shades of black and grey – Miami, even in early February, was all blue skies and sapphire seas. I switched to Kodachrome film to do it justice. In the early 1960s art world, colour photography was not yet taken seriously, reserved for family snapshots or advertising. Many films and almost all British TV shows were still made in black and white. But most of these photos essentially *are* holiday snaps, revealing the personal side of The Beatles, such as us relaxing poolside, giving an insight into parts of the trip that fans and press photographers didn't get to see.

We arrived at the Miami airport to a sea of people, from beauty queens to workmen covering their ears from the screams of the waiting crowd. Of the photos I took on the journey from the airport to the hotel, one of the most striking, for me, is of an armed policeman on his motorcycle. His gun was framed perfectly through the window, and I managed to focus on his gun and ammunition. It was still slightly shocking for us to see a gun in real life, as we didn't have armed police officers back home. I don't like guns. The violence they're responsible for is the antithesis of everything The Beatles stood for.

Our second appearance on *The Ed Sullivan Show* was at the beginning of our time in Miami. We rehearsed, performed and then we were allowed a few days' holiday. The Miami Beach crowd was a little older than the audience in New York. But there were still a lot of screaming girls in the audience and, as you can see in one of the photos, they left messages to us in unmissably big letters in the sand that could be read from our hotel bedrooms.

While it was exciting to appear on *The Ed Sullivan Show* again, the really fabulous things happened offstage. We hung out at houses with pools, went water-skiing and made the most of our first days off in months. The British car company MG loaned each of us a convertible sports car. We knew it was a great advertisement for them, but we didn't mind at the time. Driving with the roof down in this weather felt very glamourous. We lapped up all the new sights and experiences. You'd meet a girl, go on a date in your MG to a drive-in movie (something I had never been to before), and I was young enough to be totally impressed by it all. It was just like, 'Yeah, look at me. Got my Peter Stuyvesant cigarettes, a fancy car and the run of the city!' It felt great.

We enjoyed every minute of our time in Miami. It was just an exciting place to be. In a posh hotel, they usually supply you with a dressing gown, a robe, and it's made from towelling, but in Miami they gave us little towelling jackets and you'll see in the pictures that we're wearing them all over the place. We didn't want to take them off! Someone else you can see in the photos is our bodyguard while we were in town, Sergeant Buddy Dresner. He was a nice guy, and we enjoyed his company. One of my favourite features of The Beatles' world was that if we were with someone for any length of time, we invariably became friendly with them.

We flew back to New York and then back home to the U.K. Having that respite in Miami, away from the world's eye, felt like a short and much-needed pause. We were all in our early twenties and were too self-conscious to think of ourselves as artists. We were just four guys having fun and doing what we loved, which was playing music. But, looking back, I can see we were of course artists. We were reacting to events and the world around us and writing about them. We were expressing what we, four young men, felt about life, and our lives. We used our instruments to tell our stories. I think I used my camera in the same way with total freedom. On the flight home, I was excited to get the photos developed. But, of course, when we landed, the whole world swept us up and wanted something from us and we were happy to oblige. The photos sat patiently waiting, nearly forgotten, and it's taken a while to finally get around to showing them. I think it's been worth the wait.

Before we went to the States, we thought we wanted to get rich so we could retire. But once we became successful, we were able to experiment as much as we wanted in the studio and no one at our record company would say anything about it. Success gave us total freedom.

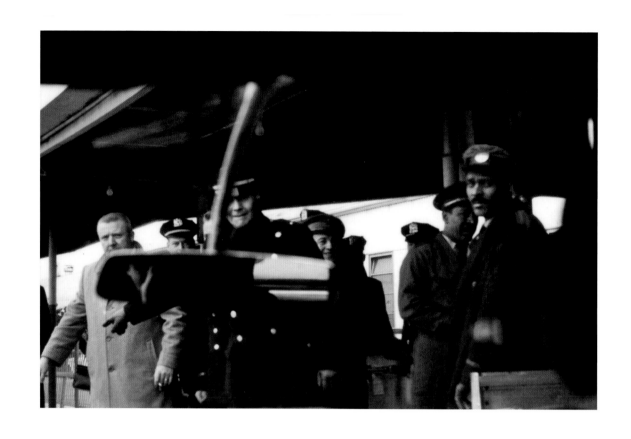

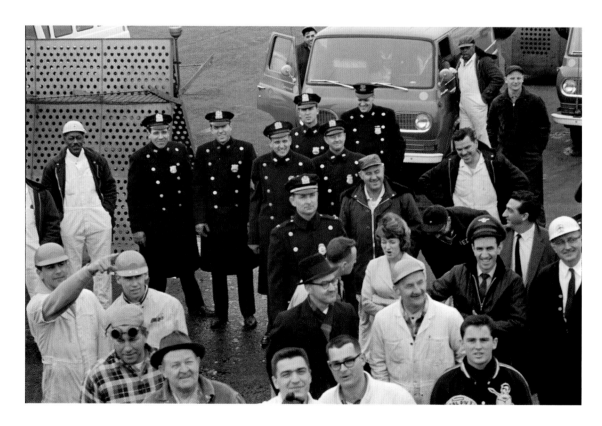

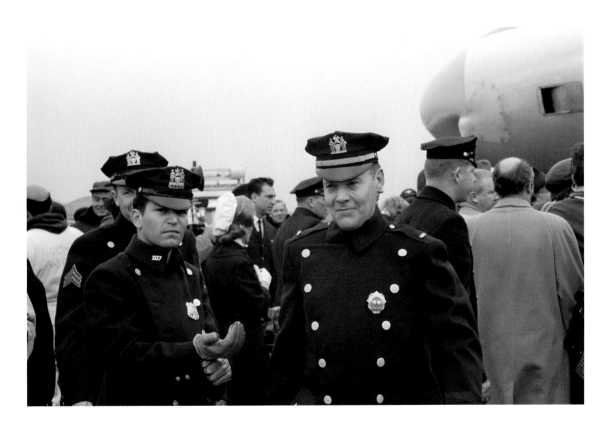

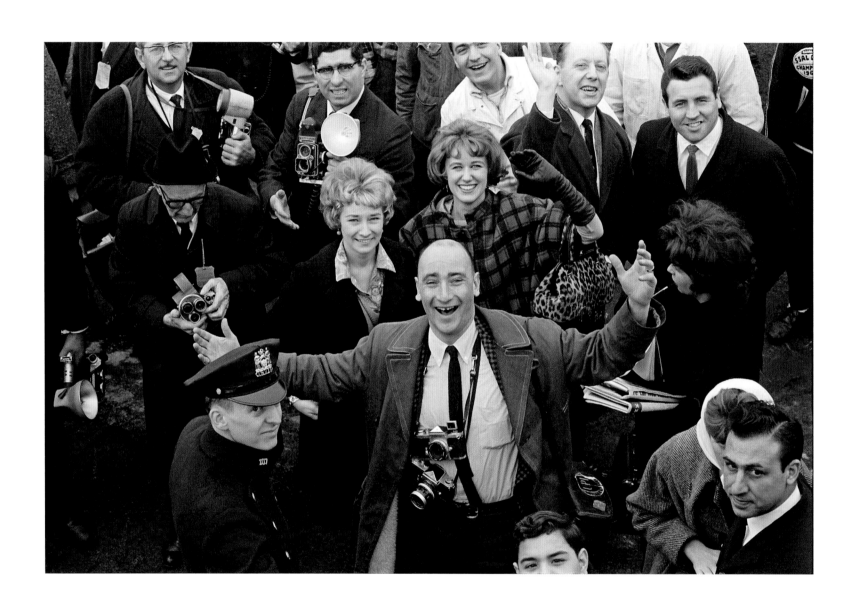

This press photographer seems delighted to have the tables turned on him.

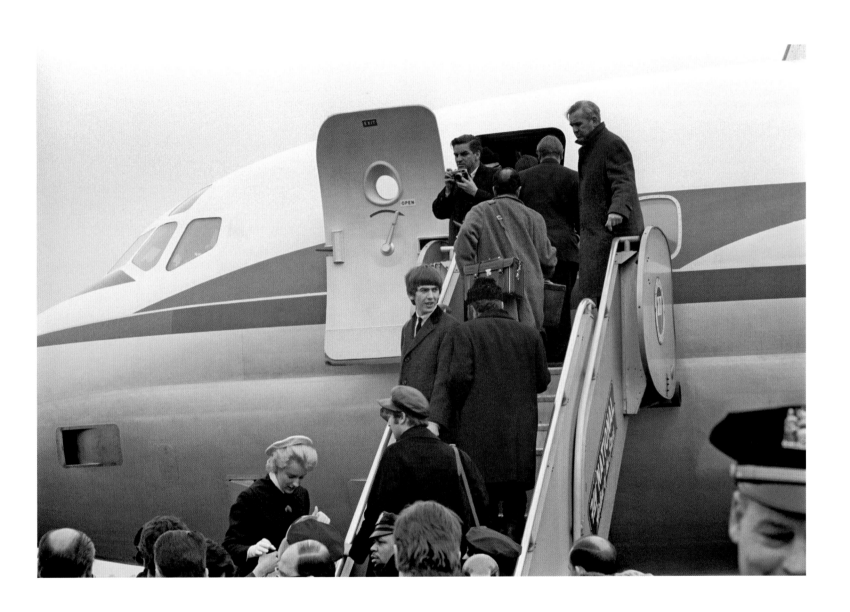

Leaving New York for the sun.

I've always enjoyed the moment when the plane rises above the clouds to reveal the vast sky.

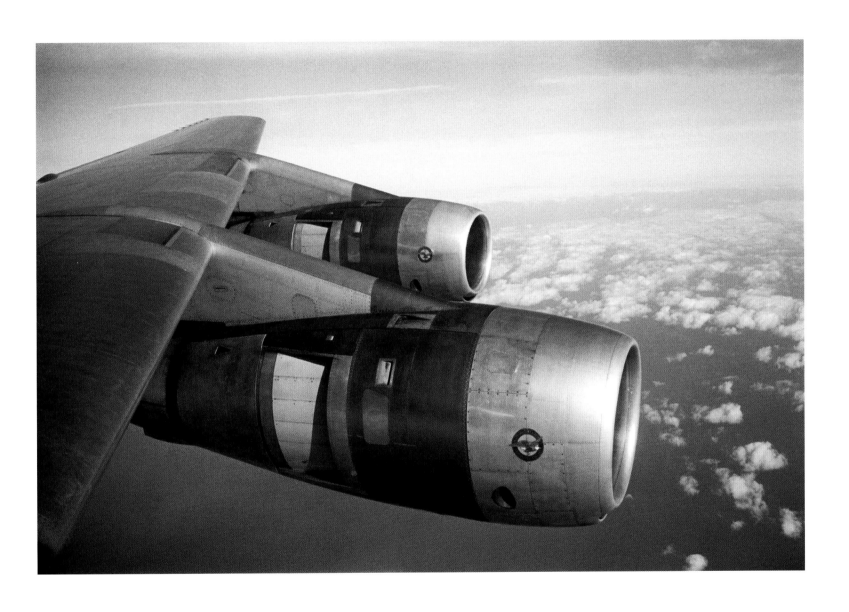

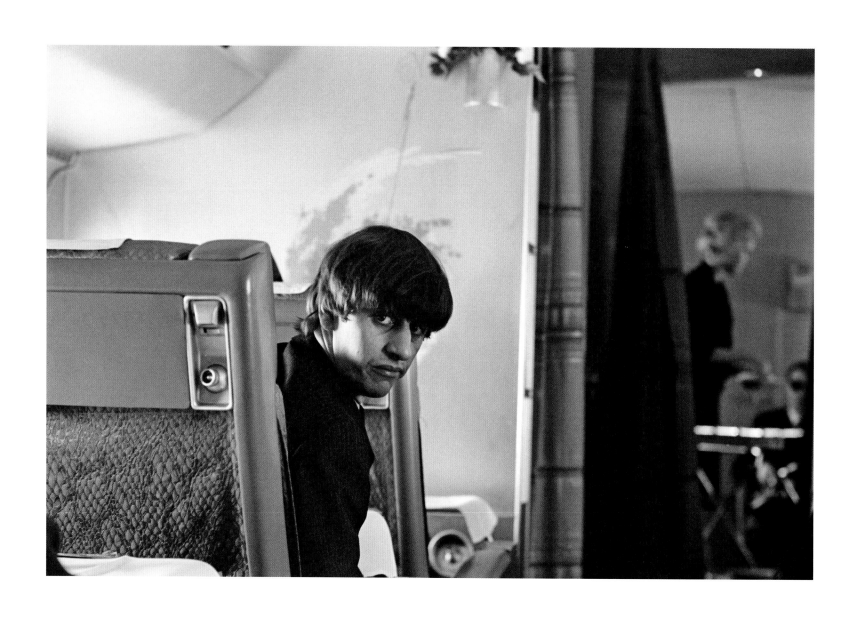

Following our U.S. trip, Ringo coined the phrase 'Tomorrow never knows'.
As true today as it was back then.

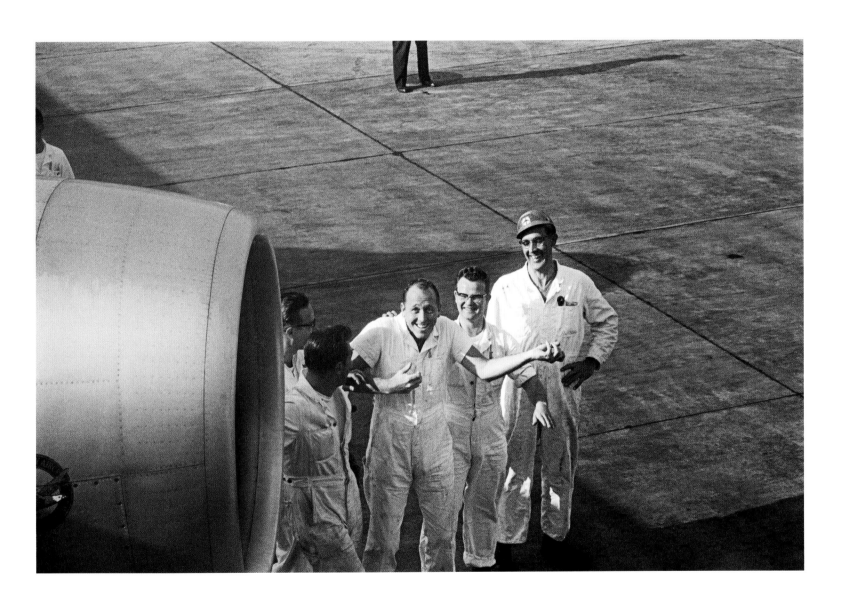

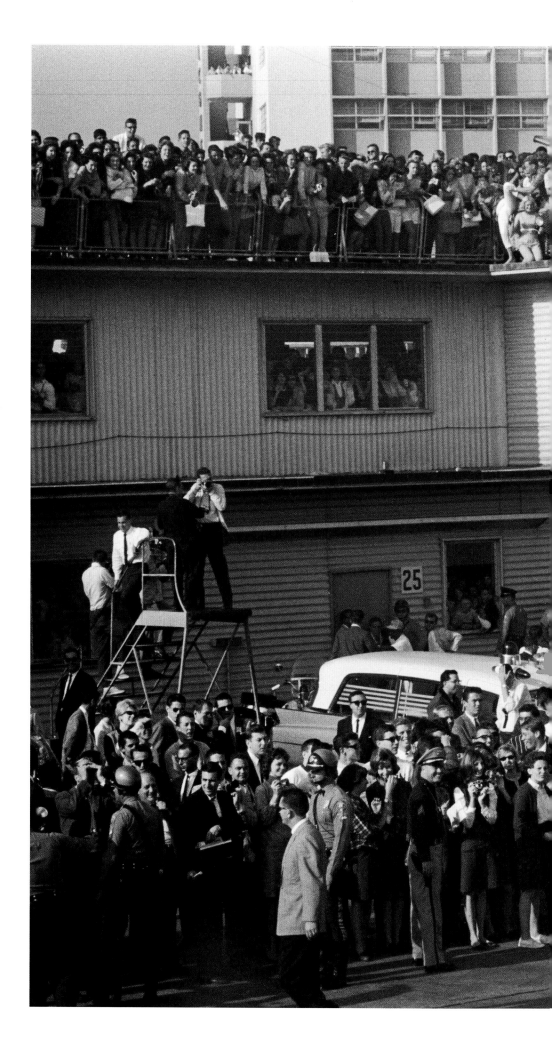

240 A fabulous welcoming committee.

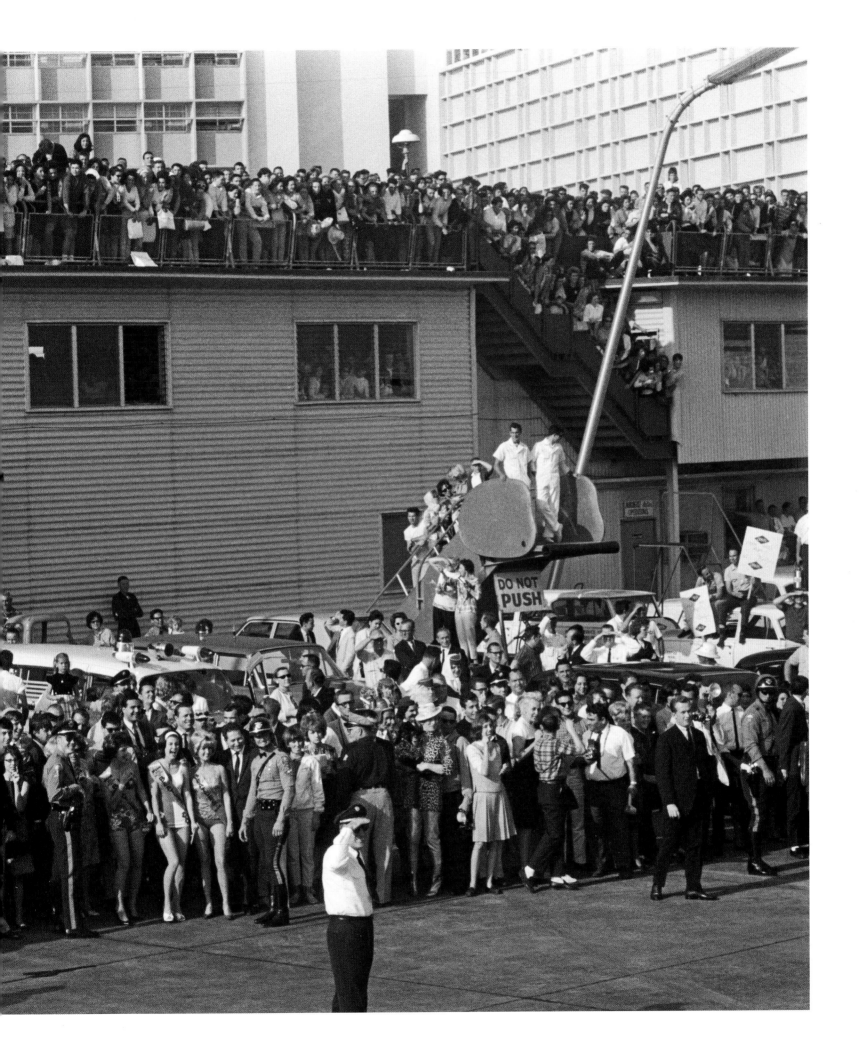

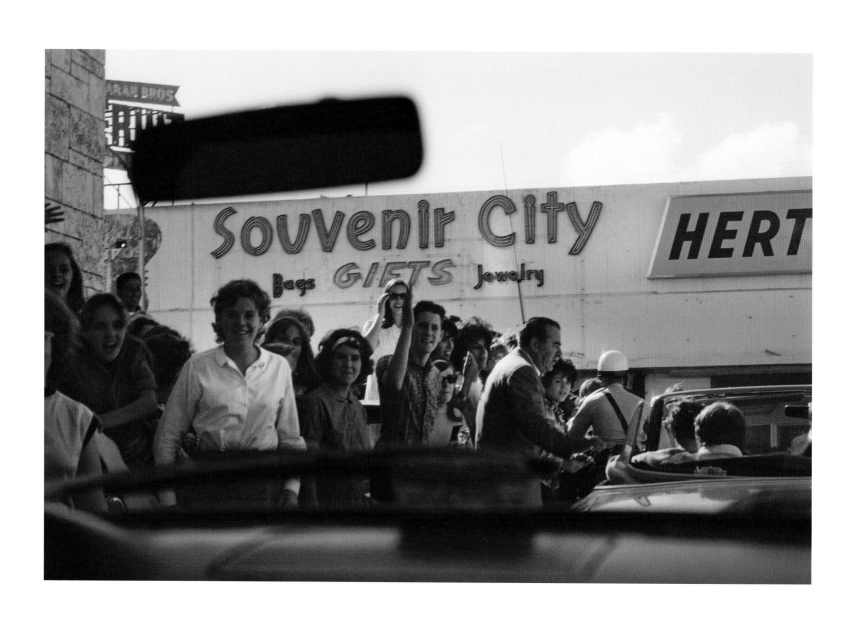

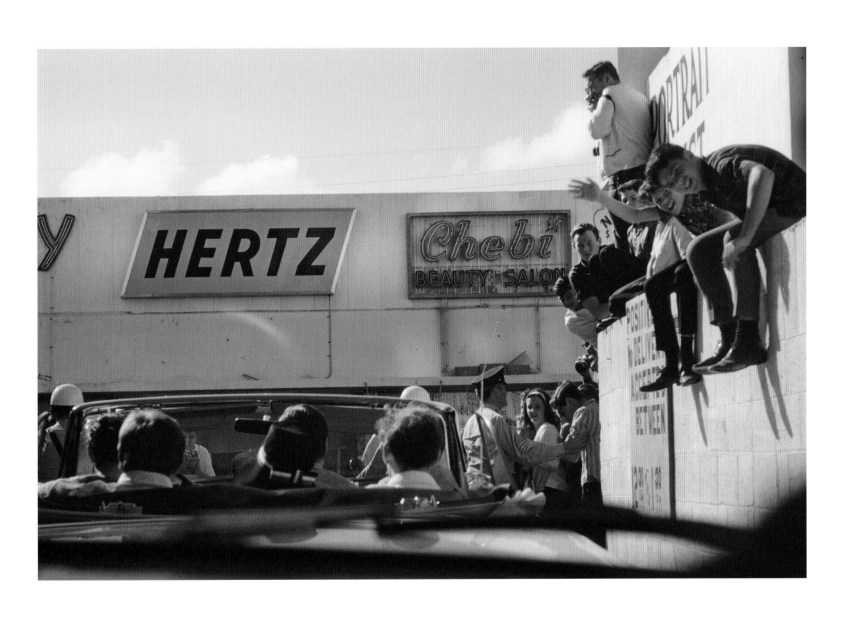

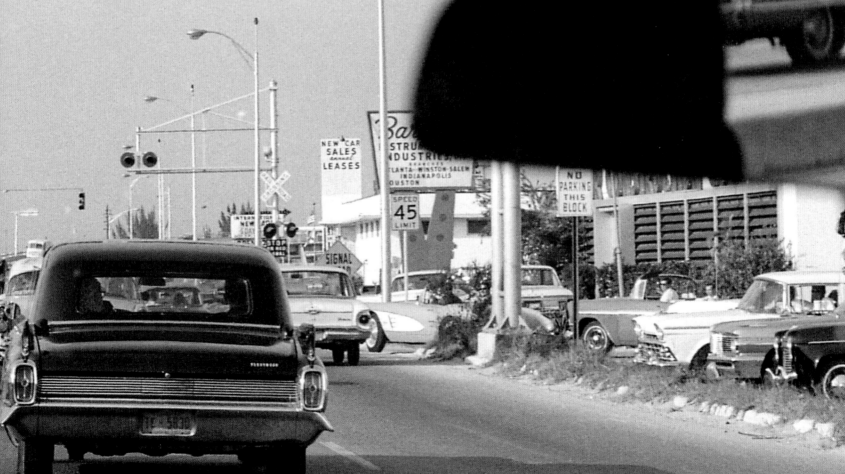

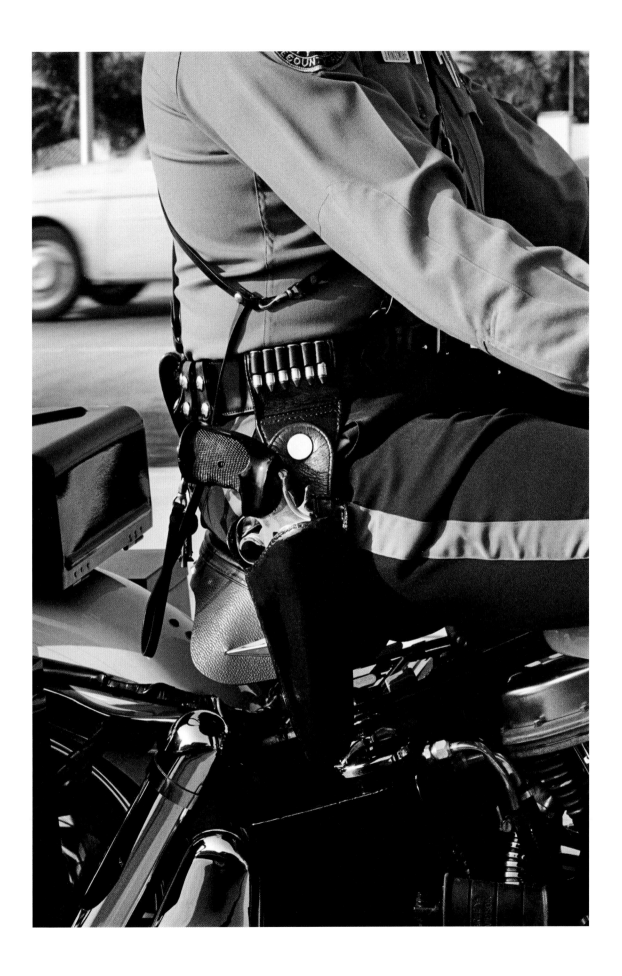

This armed officer pulled up alongside us, the first time I had ever seen something like that.

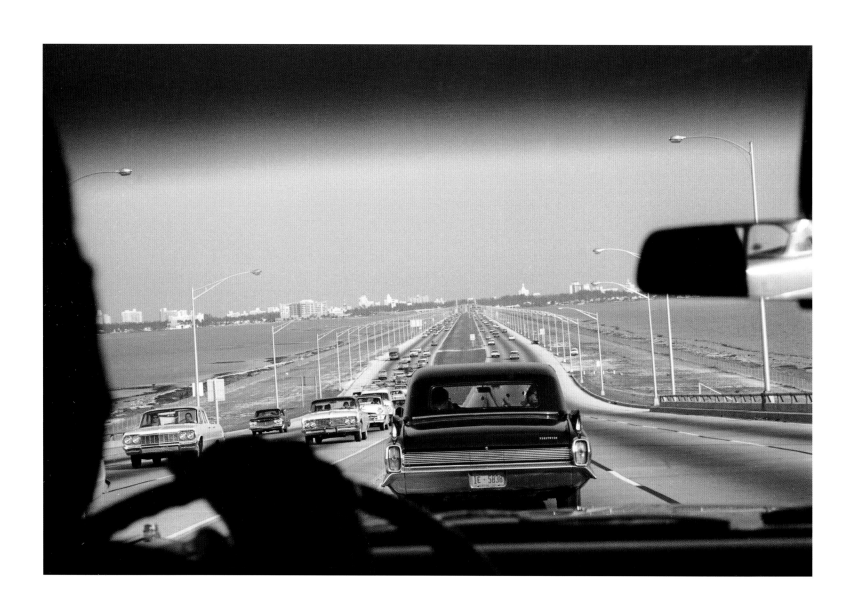

The Julia Tuttle Causeway.

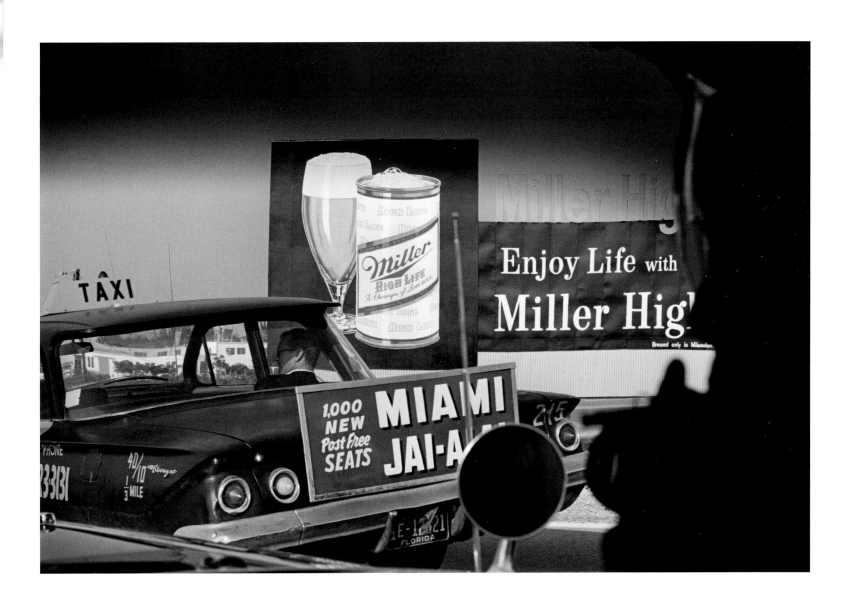

Previous page: Arriving at the Deauville Hotel.

Opposite: I can almost hear this girl's scream.

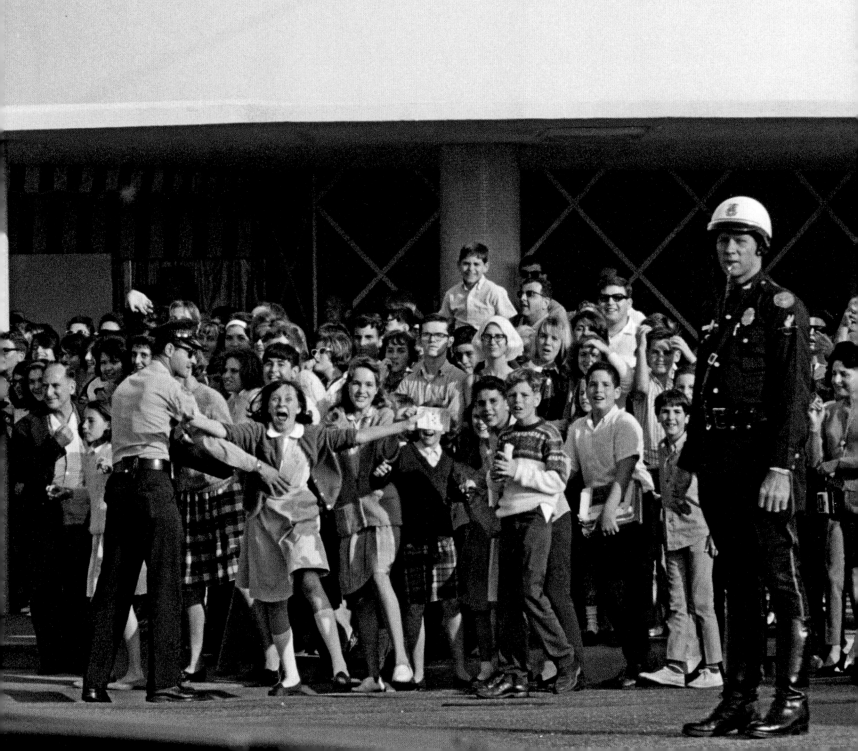

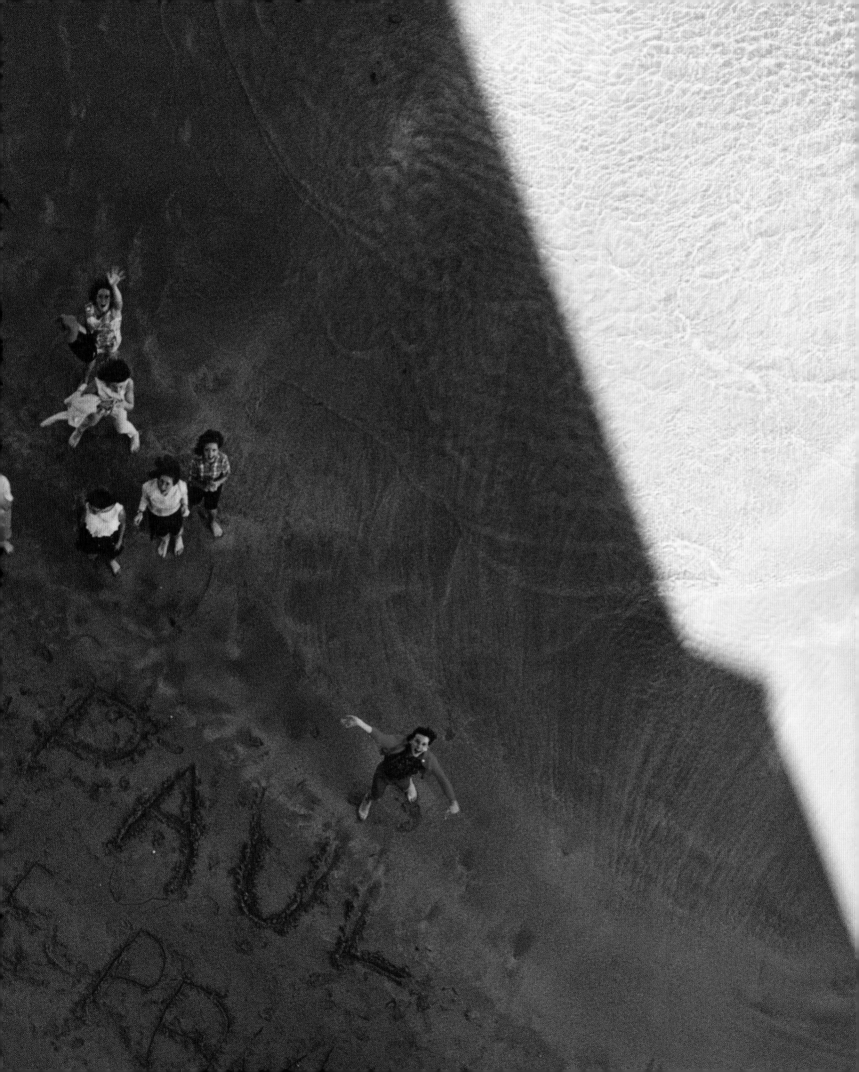

Waves from the window.

Taken during a photo shoot.

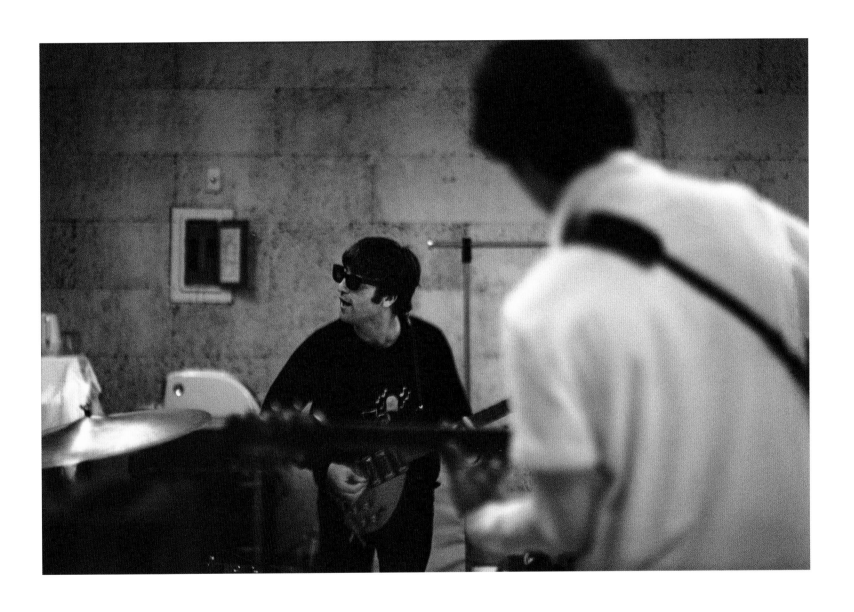

Rehearsing for our second live appearance on *The Ed Sullivan Show*.

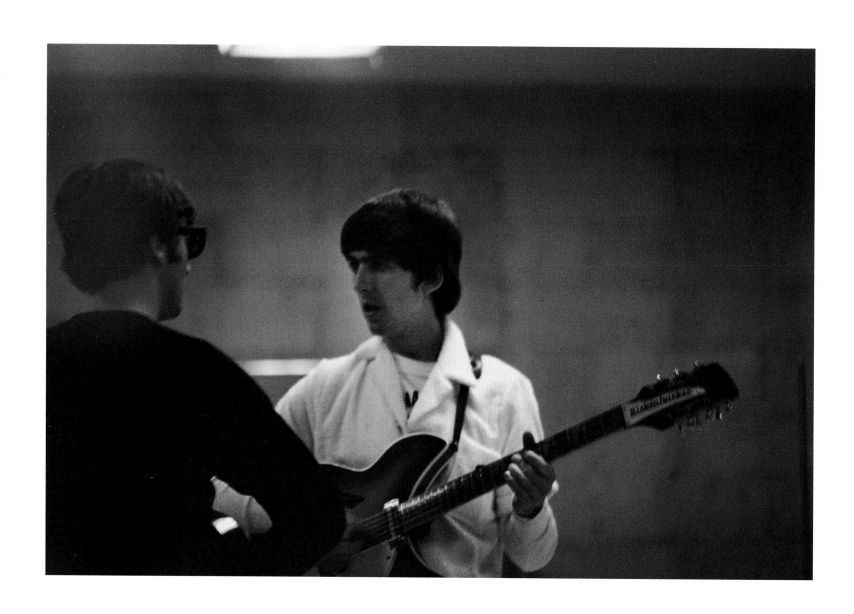

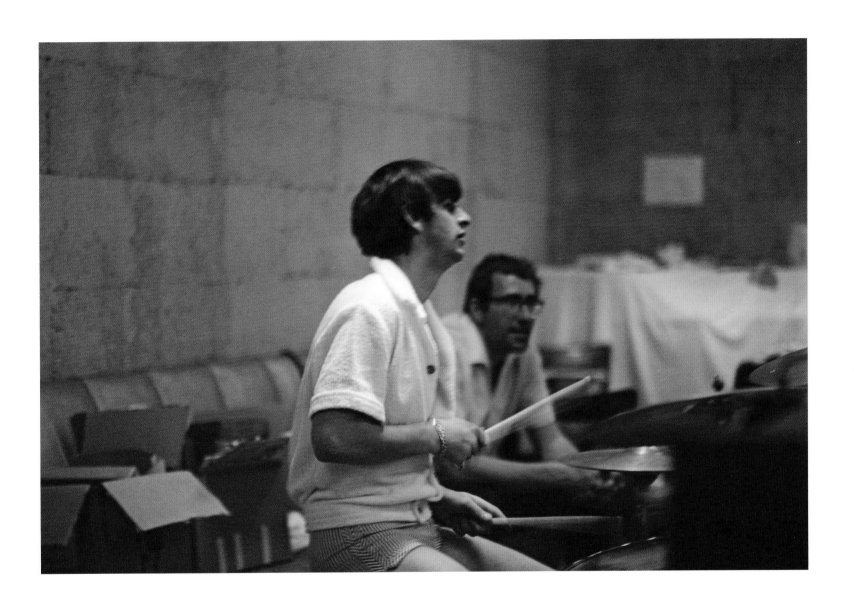

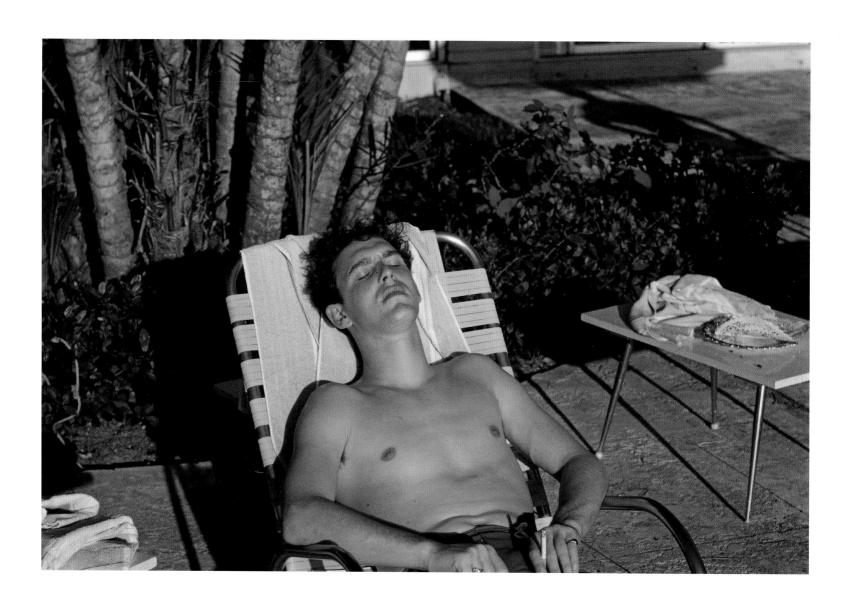

Neil and Ringo enjoying a day off.

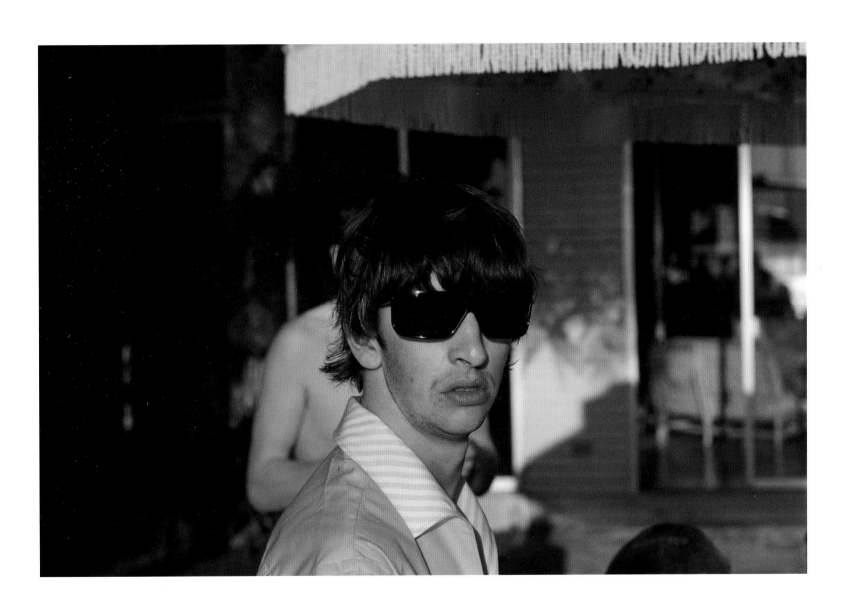

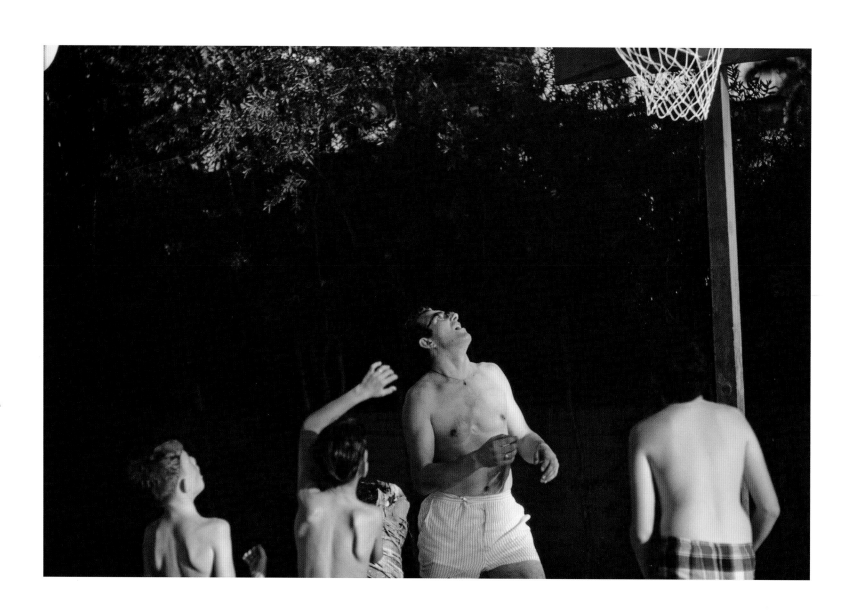

Mal's height made him a natural at basketball.

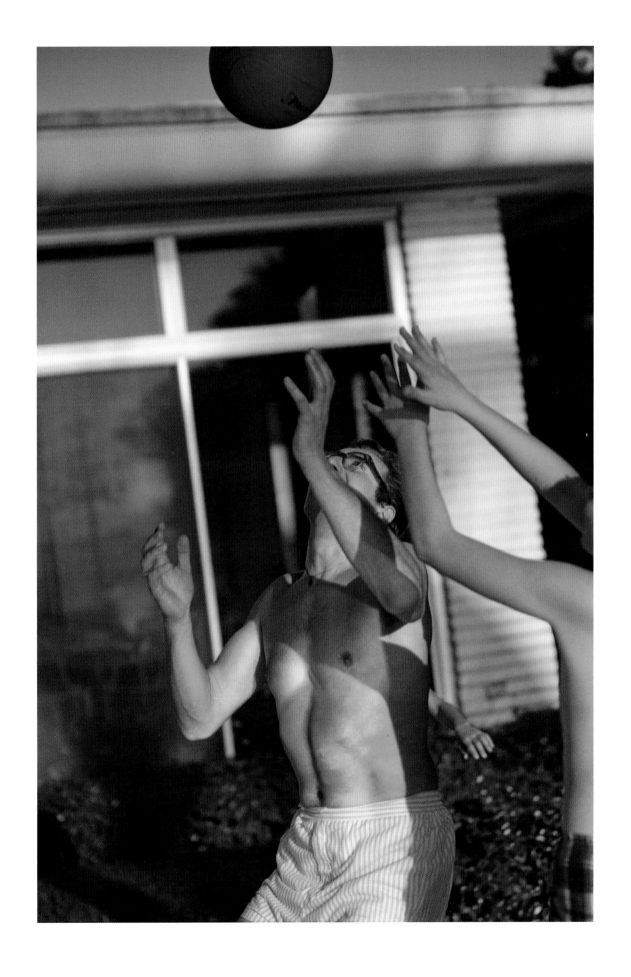

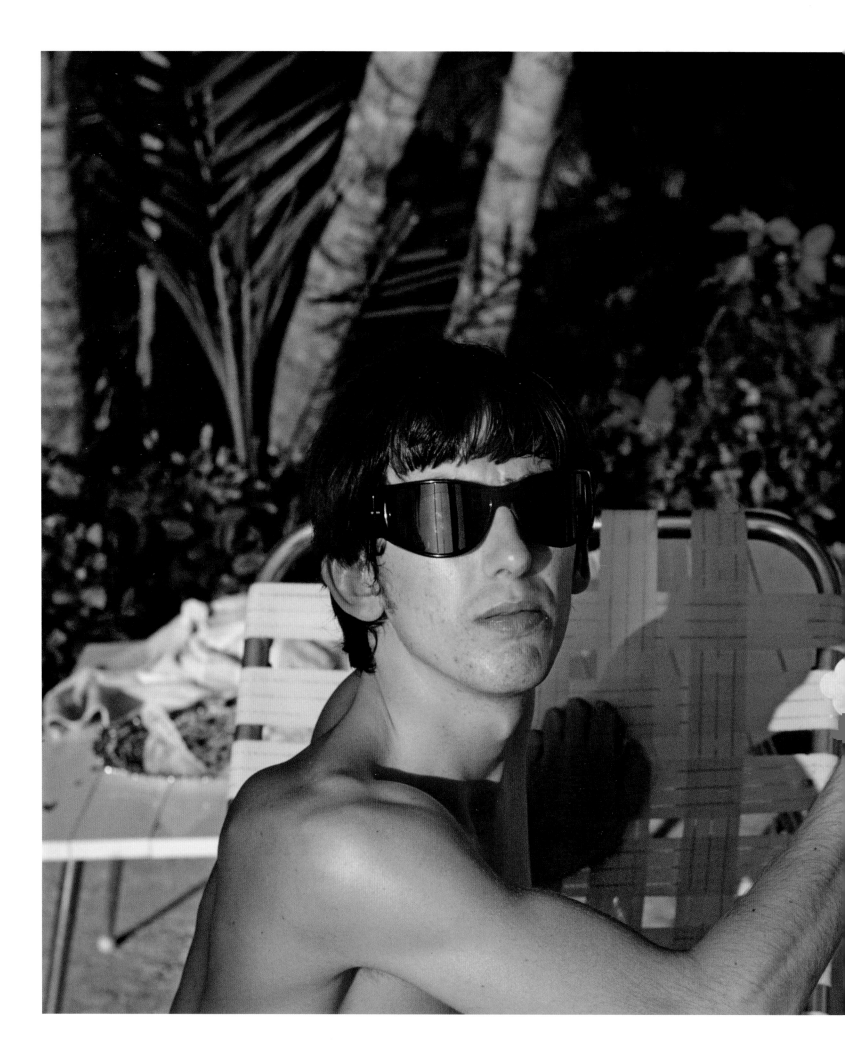

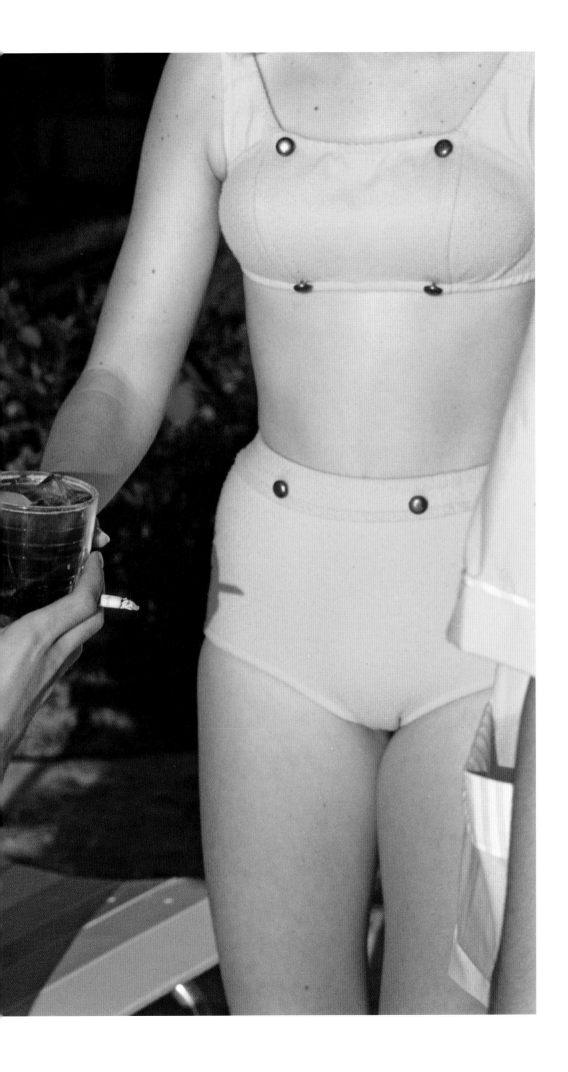

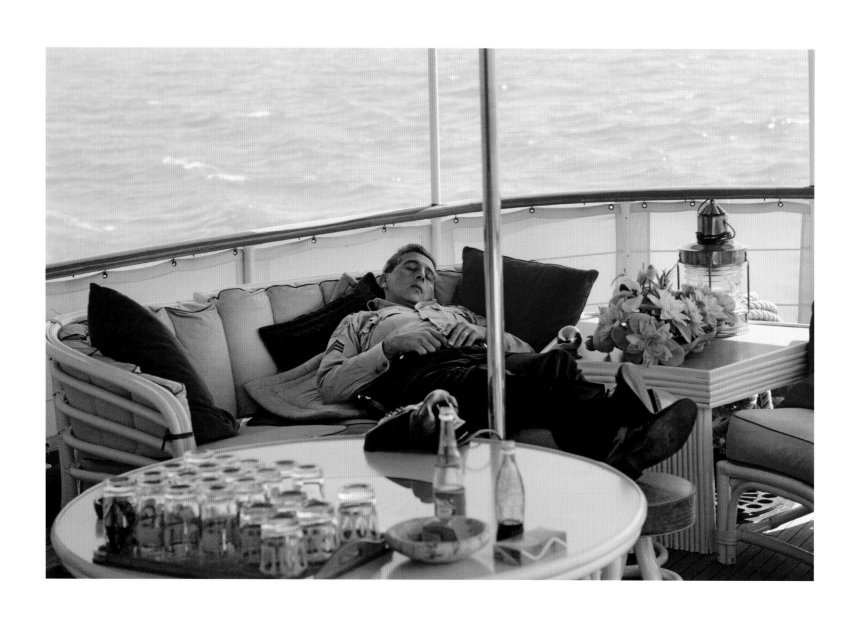

Previous page: George looking young, handsome and relaxed. Living the life.

Above: Sergeant Buddy Dresner taking security seriously.

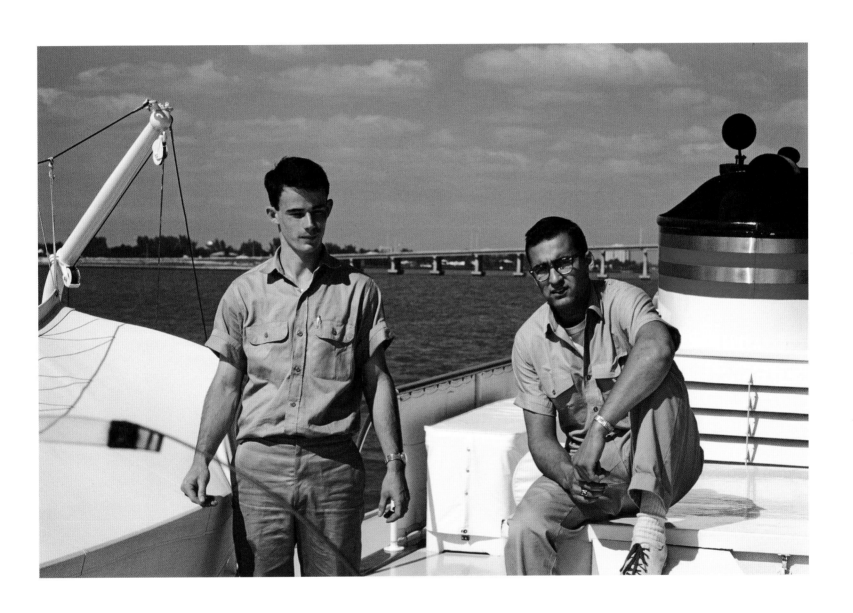

Crew members on the *Southern Trail*.

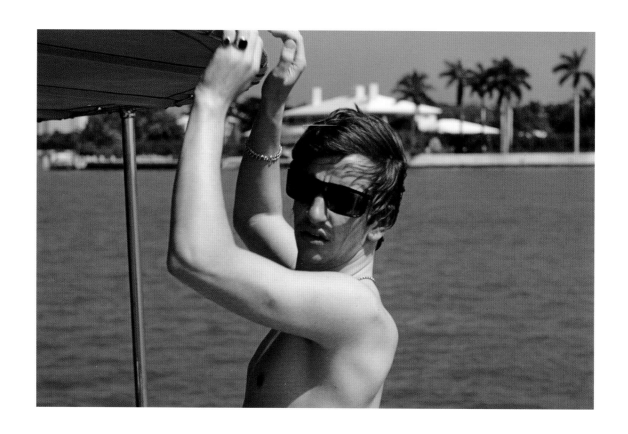

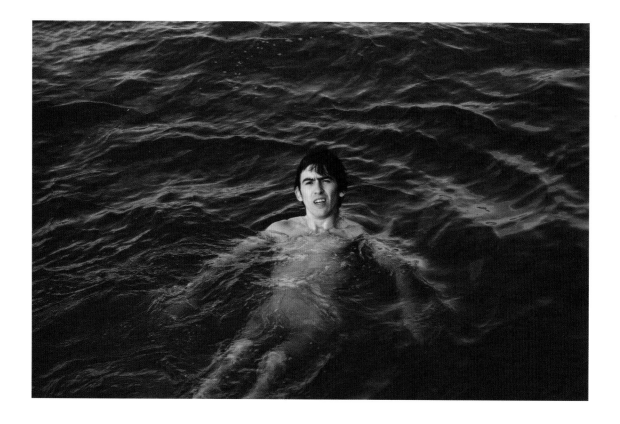

The four of us spent so much time working together that it's good to see us just relaxing and enjoying ourselves.

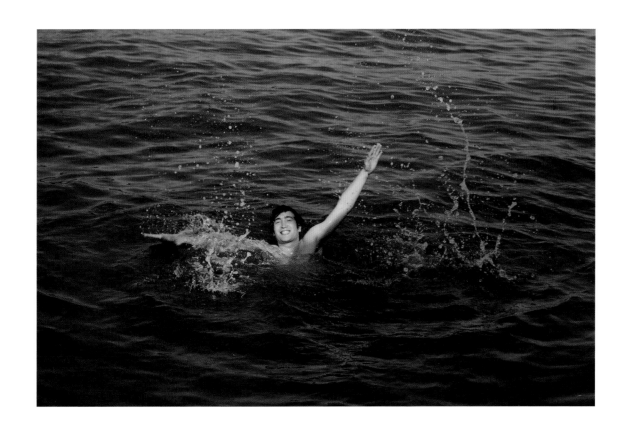

The blue skies of Miami contrast to those of New York and Washington.

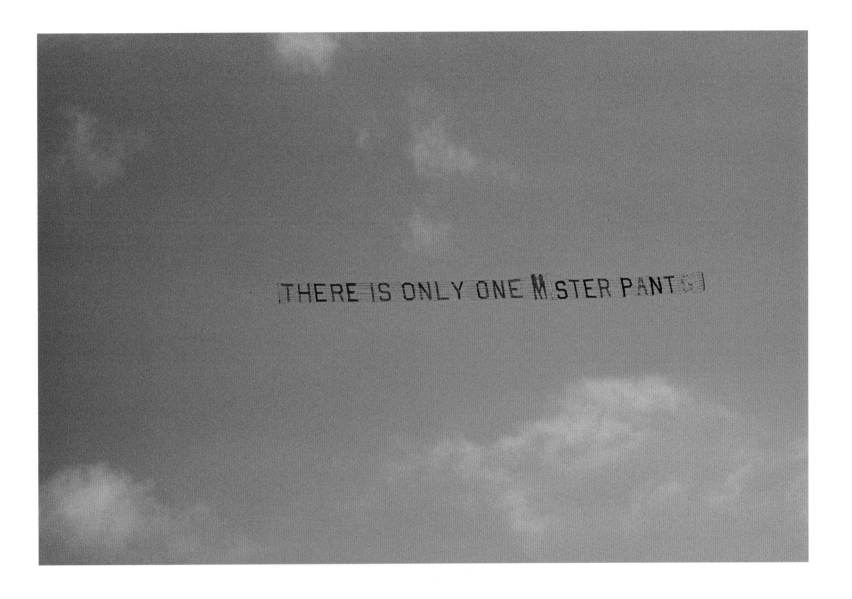

Would anyone ever claim to be the second Mister Pants?

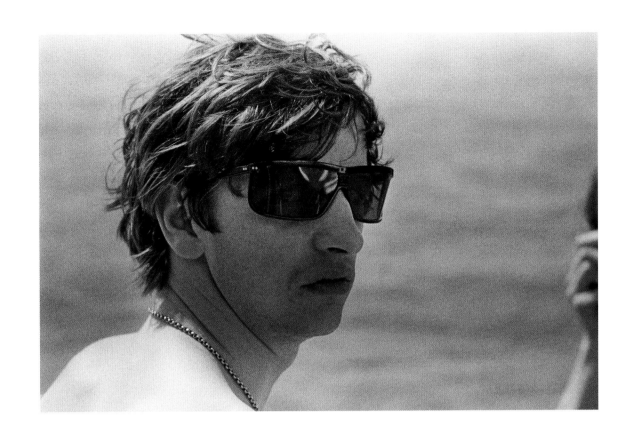

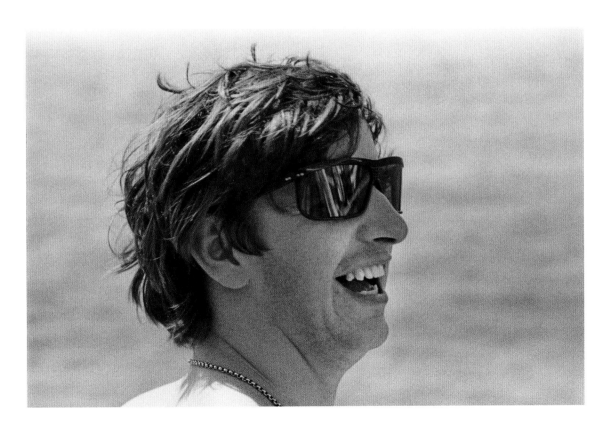

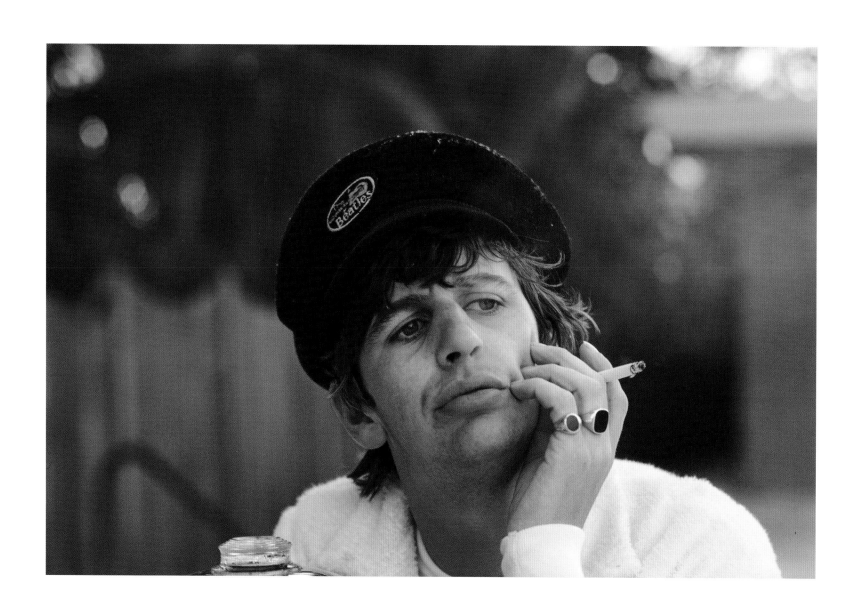

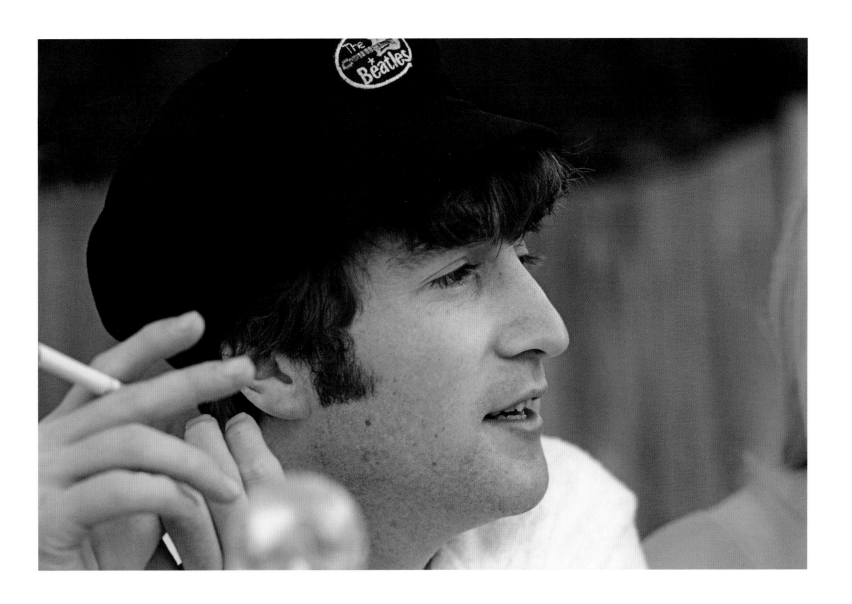

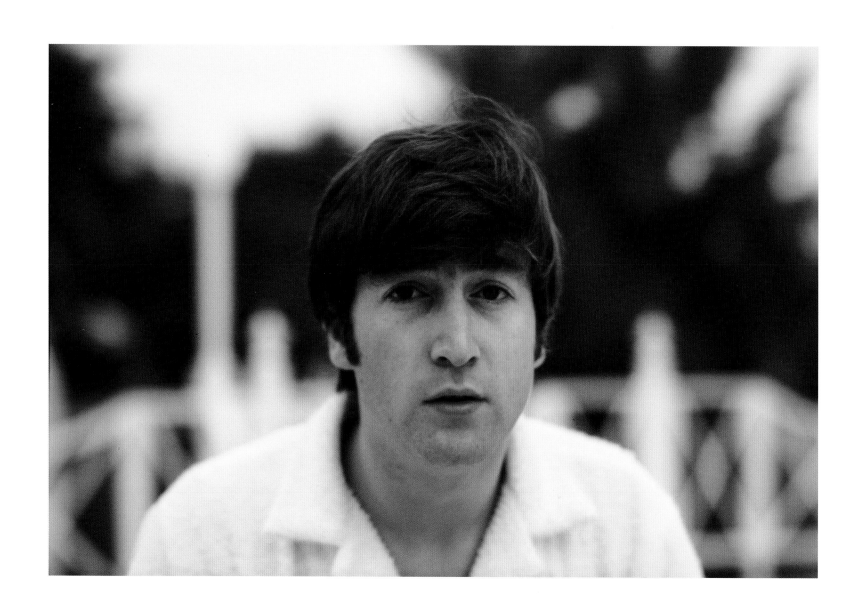

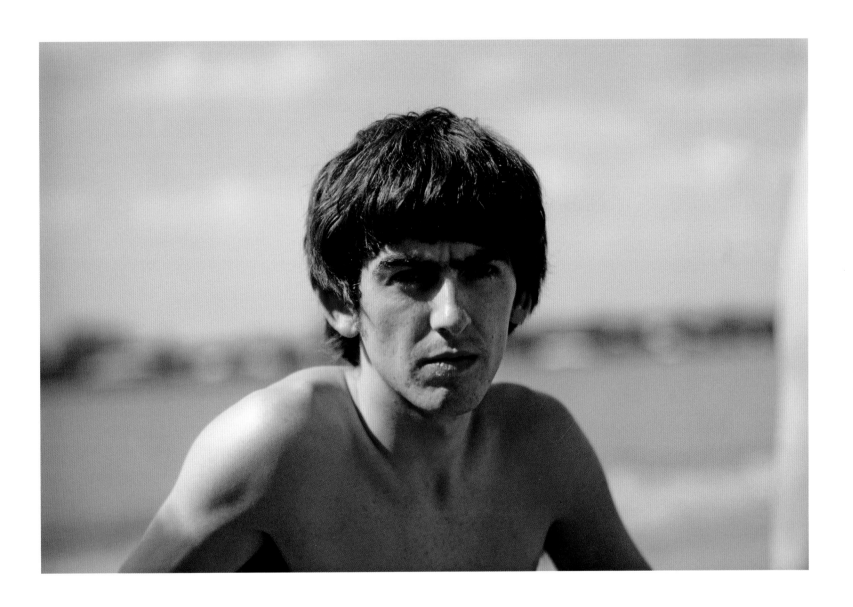

I love and miss them both dearly.

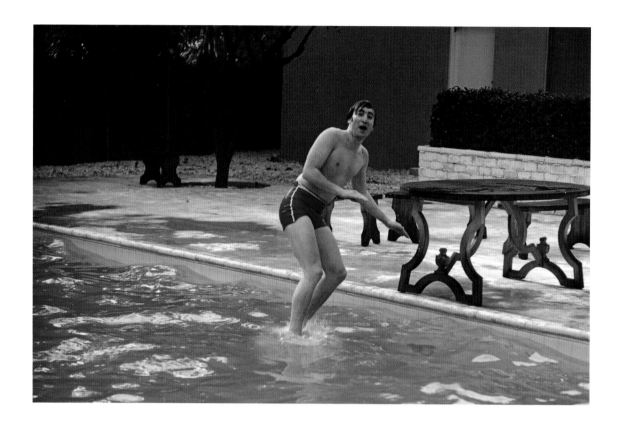

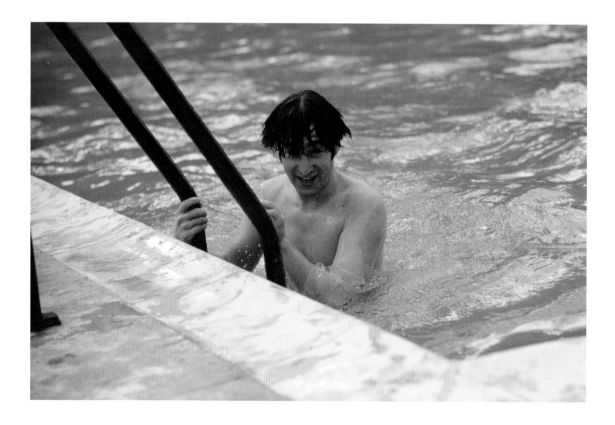

Having our own private pool was a luxury we couldn't ignore.

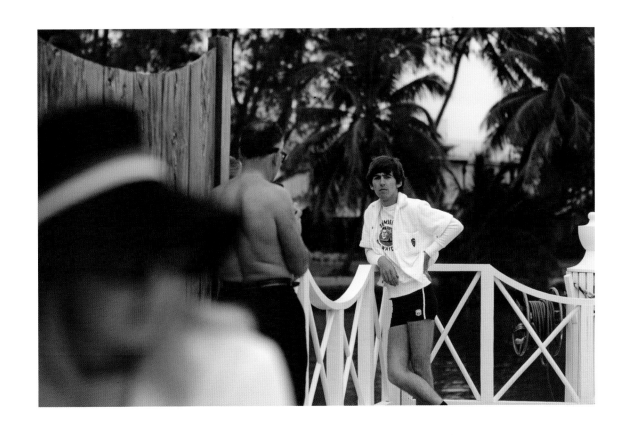

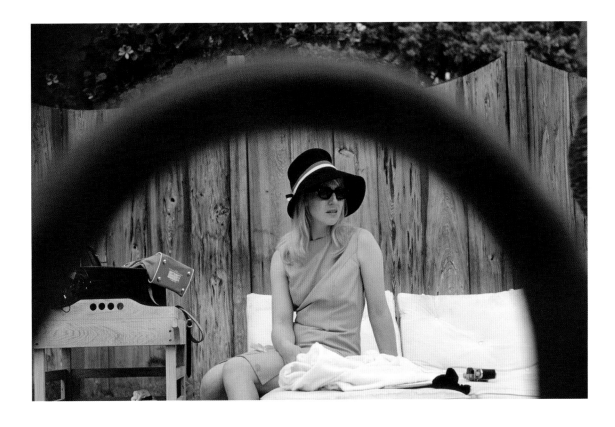

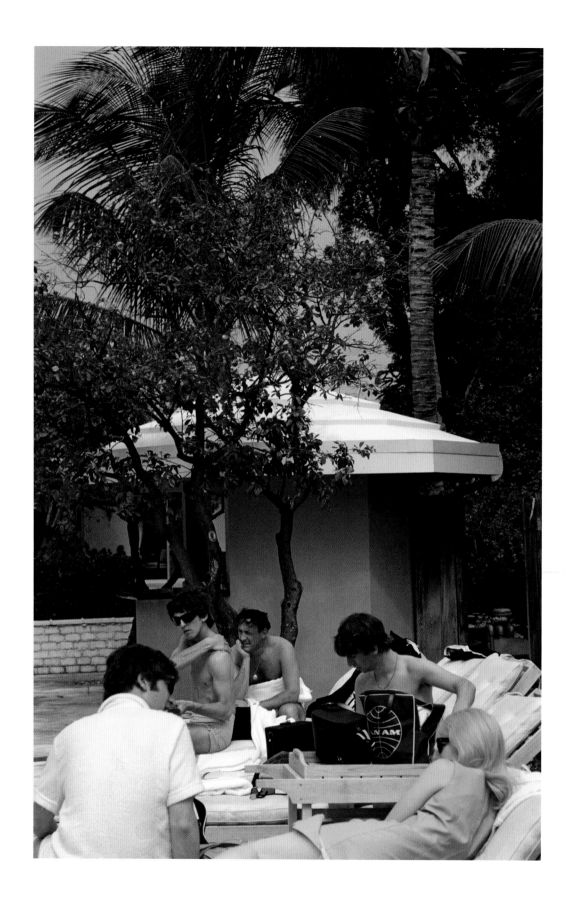

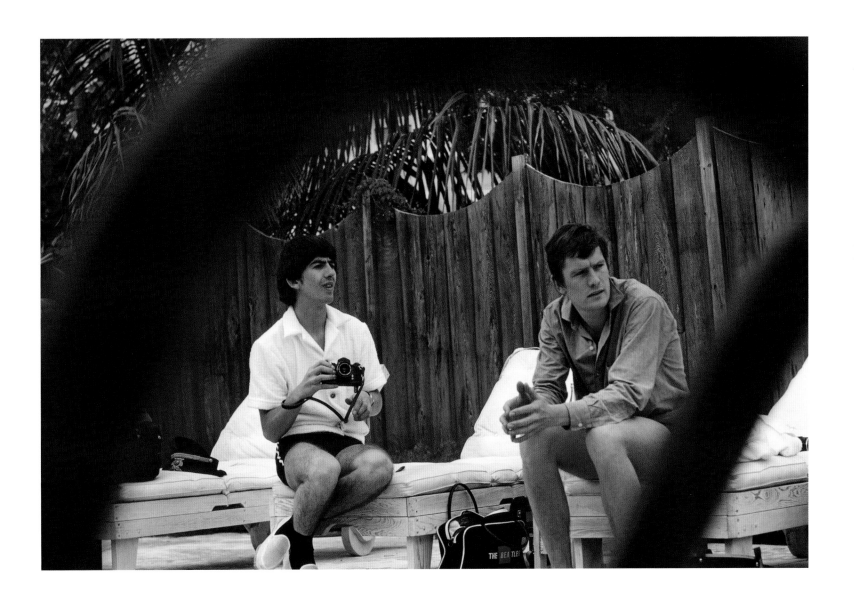

Poolside moments.

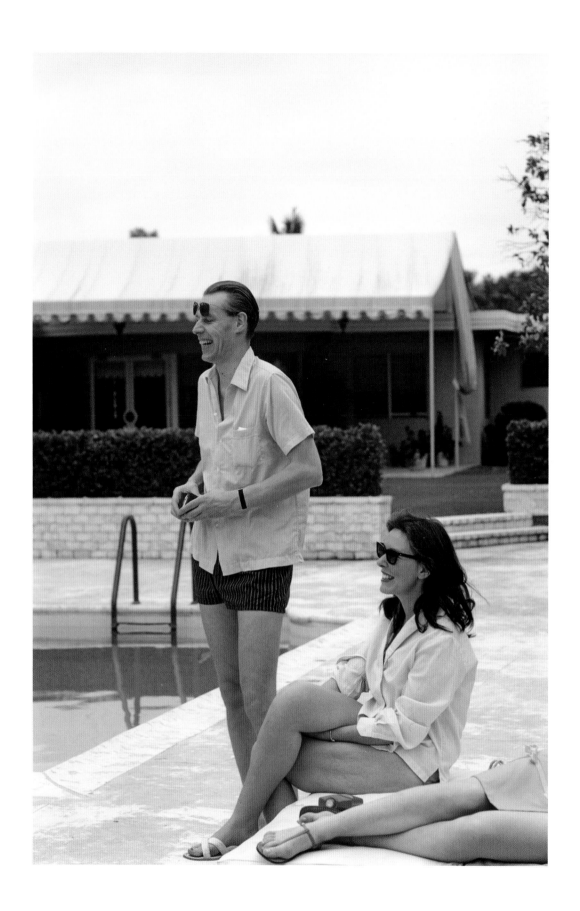

George Martin and Judy Lockhart-Smith, later to be Mrs Judy Martin.

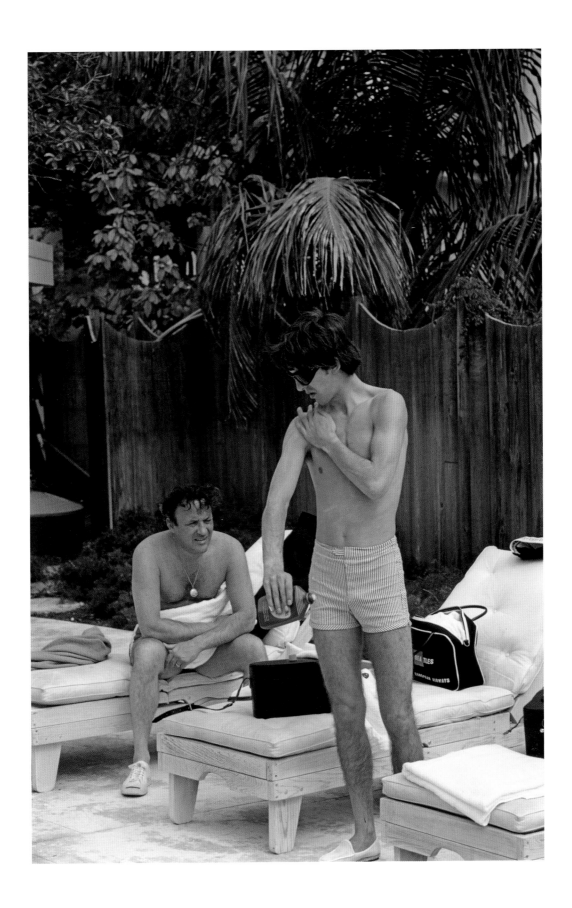

Murray the K admiring George's sunscreen application skills.

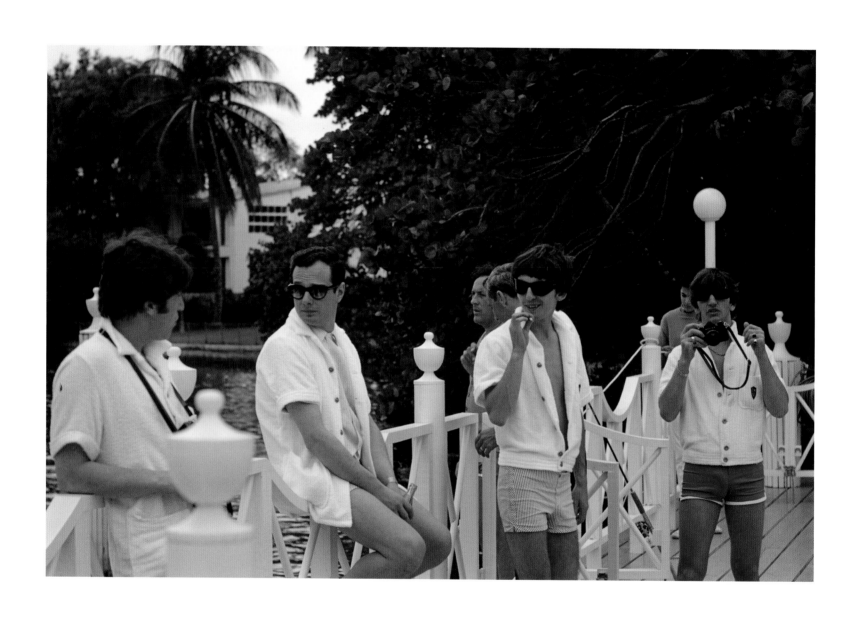

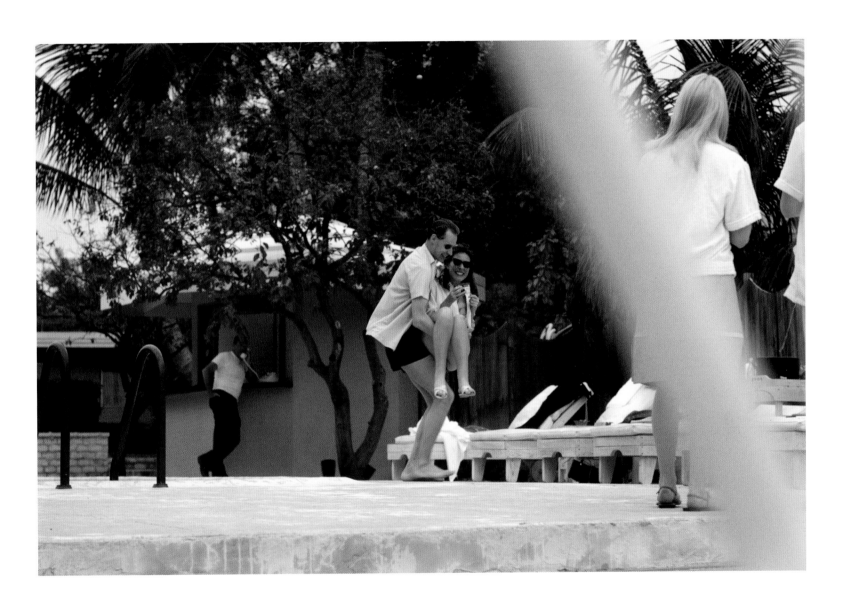

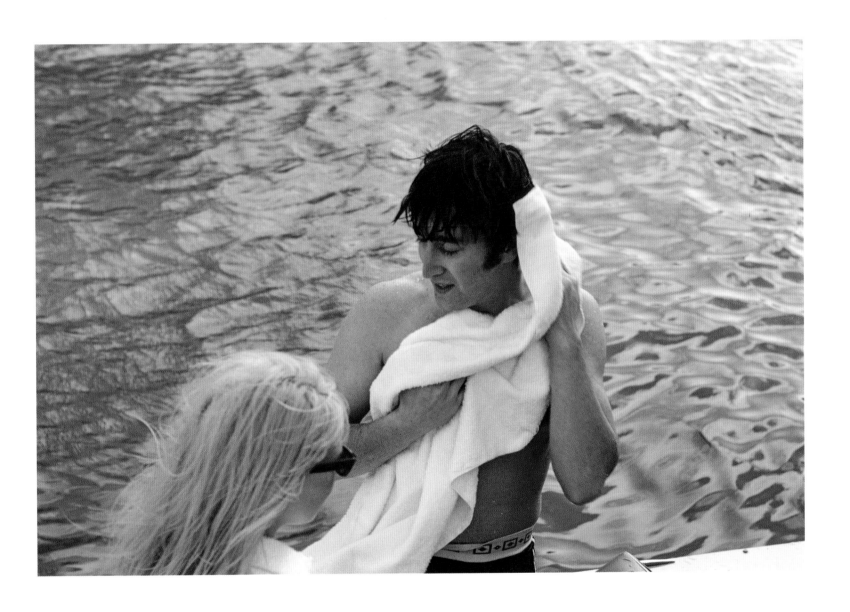

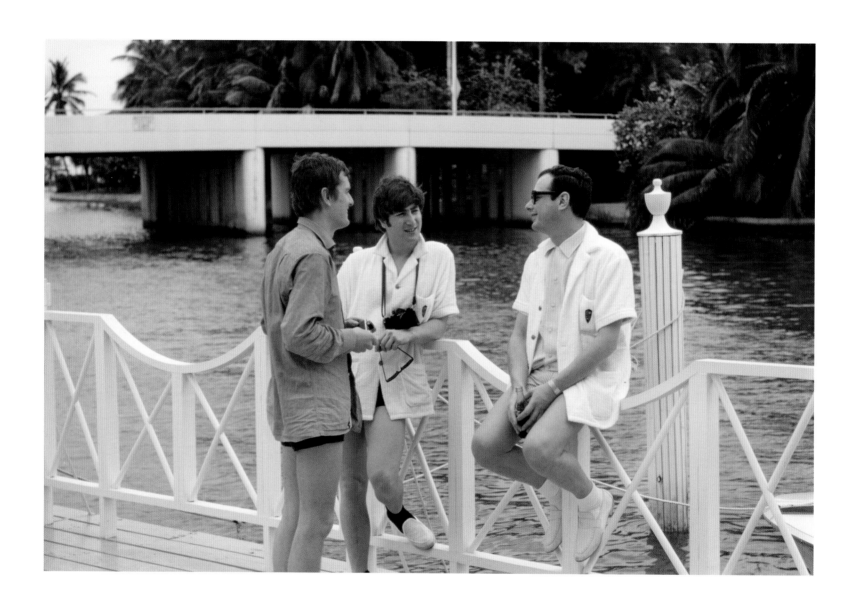

A quiet moment. It was unusual to see Brian out of his suit and in a hotel towelling jacket.

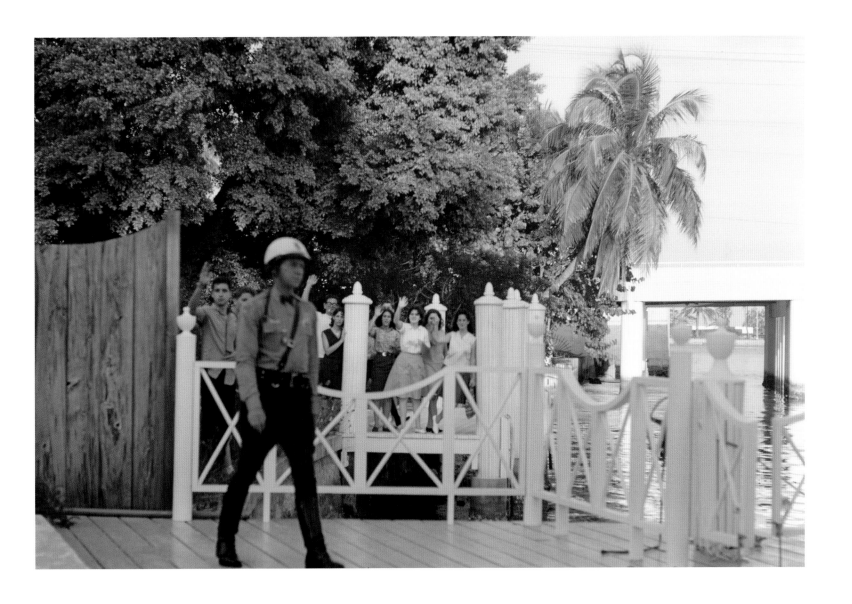

A not-so-quiet moment.

Brian was only a few years older than us, but we always thought of him as the suave grown-up.

Fishing didn't suit me, so I put this one straight back!

My Miami date Diane Levine. A fellow Gemini.

I called for Ms Levine at her father's office and then we went to a drive-in movie together.

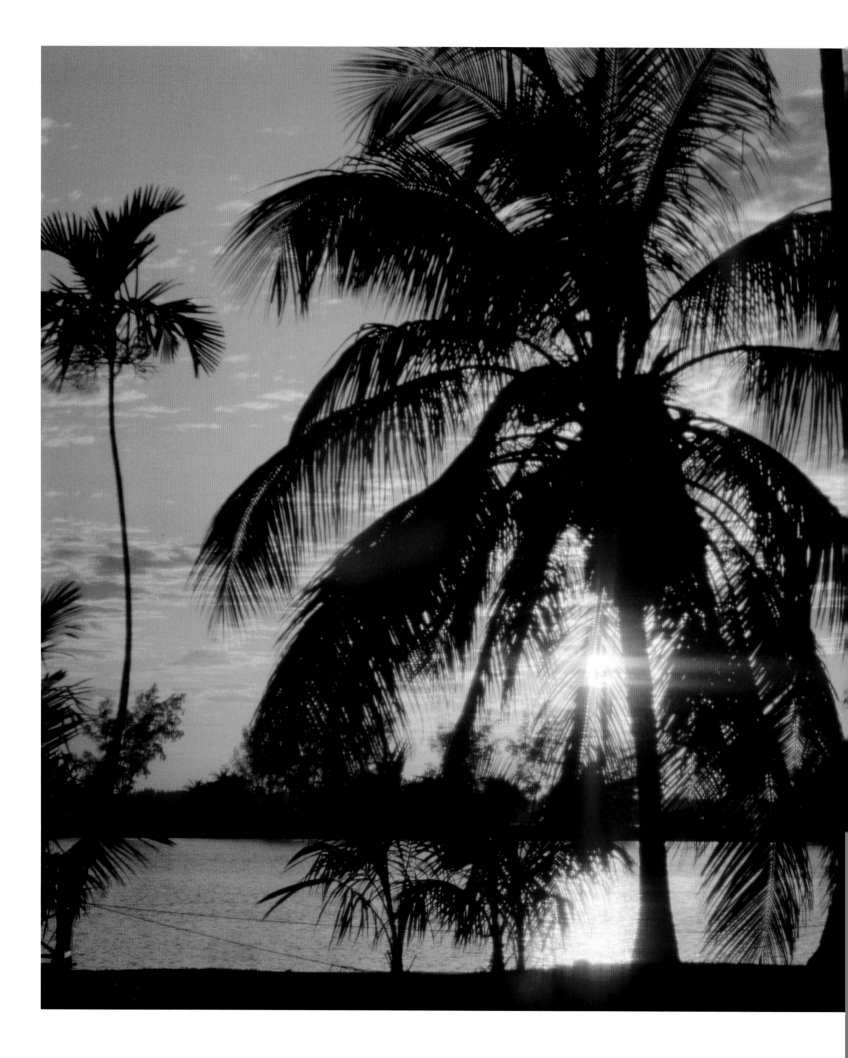

CODA

At the beginning of a rollercoaster ride, you're gradually raised into the sky. There's a brief pause at the top when everything is nervous anticipation . . . before all hell breaks loose. For us Beatles, that exact moment was 9 February 1964 and *The Ed Sullivan Show*. We spent the months and years afterwards holding on for dear life. Words cannot describe what happened to us – but imagine every dream you've had coming true, and you might get close.

My photographs for the rest of 1964 are sporadic, barely covering what followed. I didn't lose interest in photography – far from it. My love and interest in the arts grew exponentially as we found ourselves face-to-face with the best artists of the day. We worked with photographers David Bailey, Don McCullin, Richard Avedon and my wife Linda Eastman. People like Robert Fraser introduced us to artists such as Peter Blake, Jann Haworth, Richard Hamilton and Andy Warhol. It's not that I didn't want to pick up the camera – I was just living a life so fast-paced and thrilling it was impossible to fit everything into one day, much less reflect on its significance. I had a day job, too – songs to write, shows to play. On the following pages are photographs from precious moments of downtime where I had the chance to pick up my camera. The negatives are lost, so I have only six original contact sheets to tell the rest of the story.

After we landed in London following that first U.S. visit, we went straight back to work on *A Hard Day's Night*. The film captures the frantic kinetic energy sparked by Beatlemania and was finished quickly. We had just days to learn our lines and how to act, let alone how to hold our own against seasoned actors like Wilfrid Brambell and Victor Spinetti.

After a few months of filming, recording and TV appearances, we embarked upon our first world tour and went back to the U.S. We got to see much more of the country. The trip in February had changed our lives, but it was brief and confined to three cities. This time we travelled across the country, visiting places you might not go as a tourist. We'd notice little things that seemed remarkable to us, like the names of the players in the locker rooms of huge sports arenas. We had come from a land of Fletchers and Williams; here the players' names were Kowalski and Hernandez – a wonderful symbol of immigration working.

Most of these photographs are from that second U.S. visit, taking in the glamour of Las Vegas, the iconic Hollywood Bowl and our first stops in Canada. Also included are some from our first trip to Australia.

We travelled in a troupe. You can see some of the support acts in these photos. You can also see the all-too-familiar sight of the camera lens pointed at us. As much as the world enjoyed gazing at us, we loved returning their gaze. It's still daunting to imagine how many eyes were in that storm.

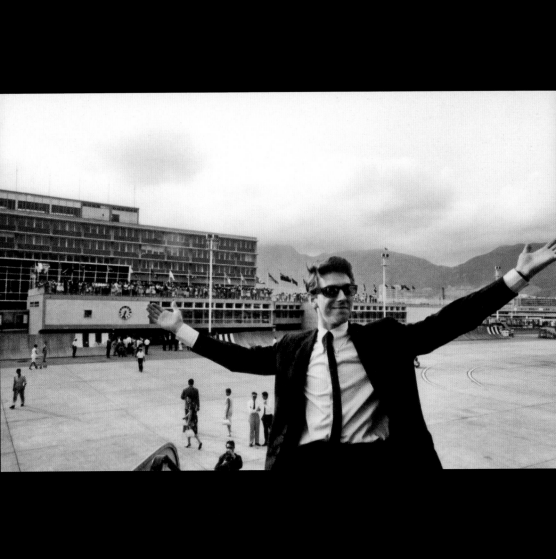

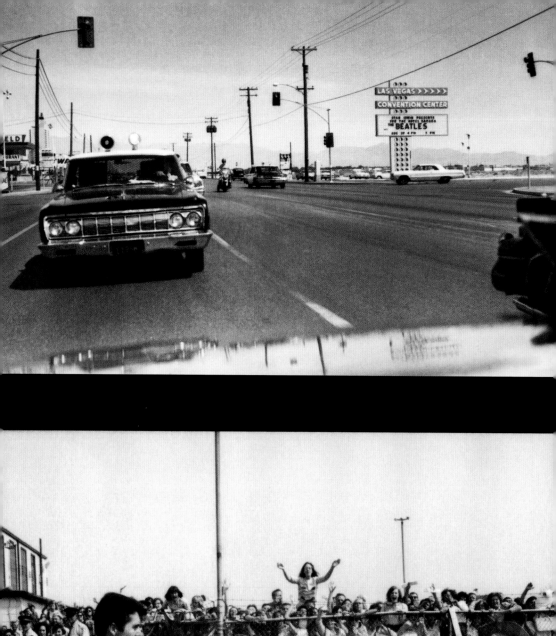
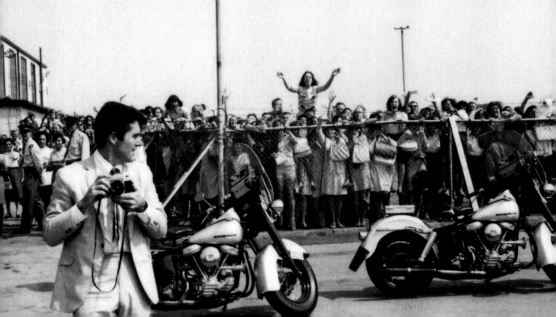

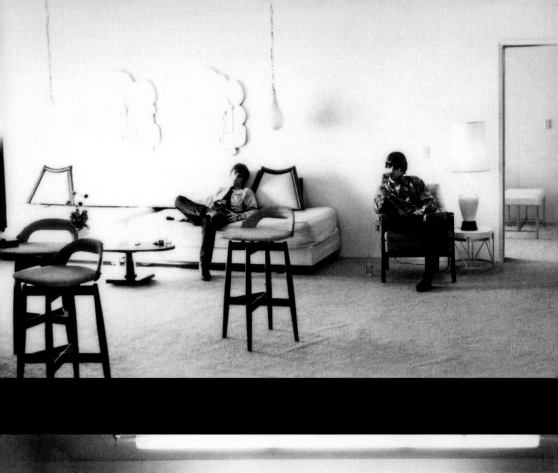
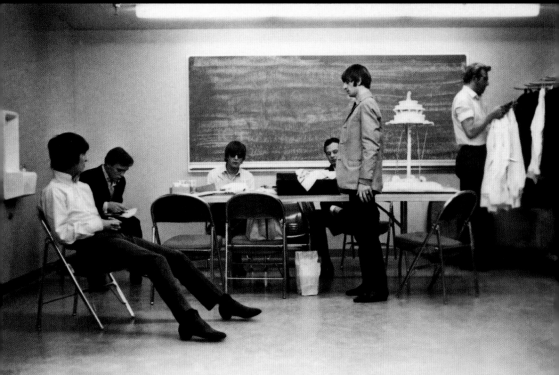

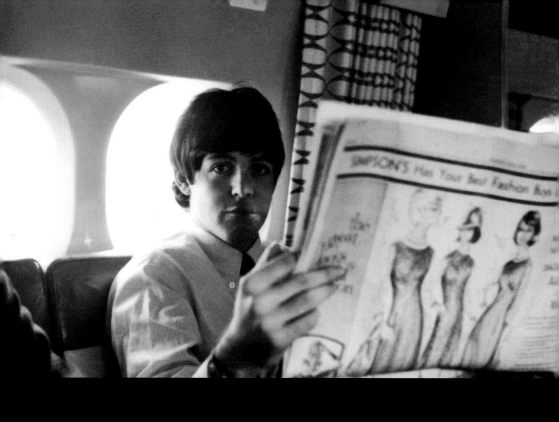

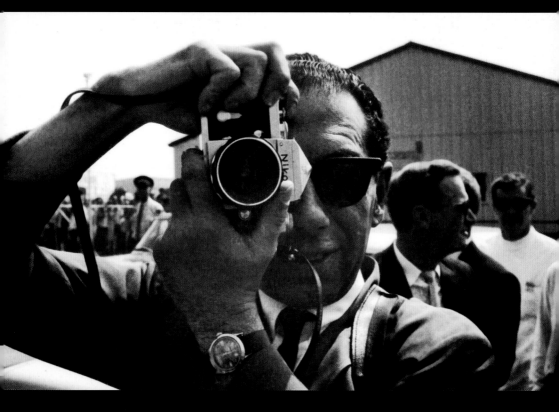

More eyes of the storm, Toronto, September 1964

Clarence 'Frogman' Henry, who opened for us on the North American tour, August/September 1964.

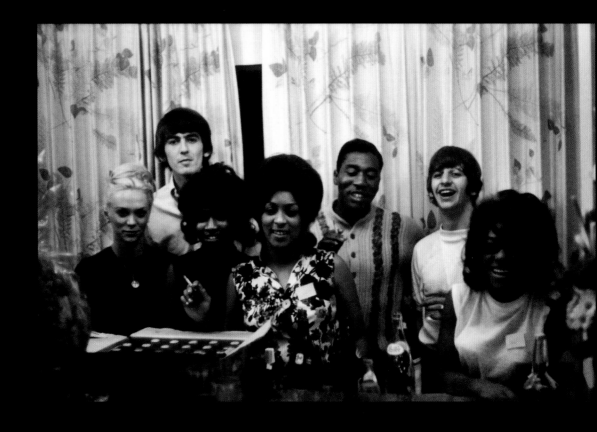

Travelling and backstage with The Exciters and Jackie DeShannon, August/September 1964.

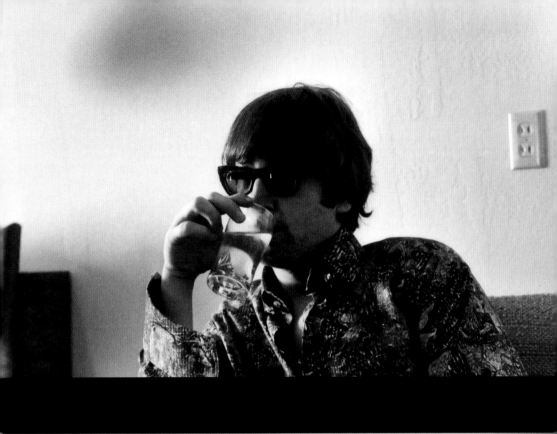
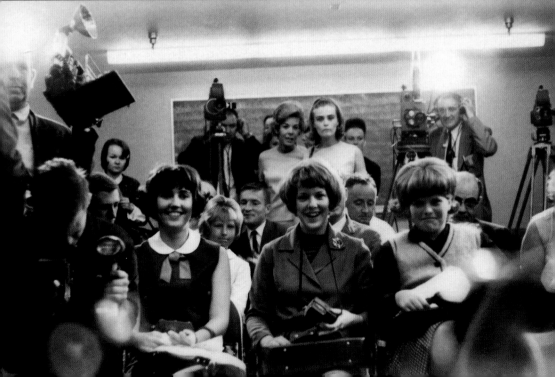

Another Lens
Rosie Broadley

It's a huge tapestry, and the more I look back on my life and think, my God, I feel like a sort of ancient mariner who's been to all these ports and seen all these amazing things.

Paul McCartney

The photographs in this book offer a uniquely personal perspective on a period that has become pop culture folklore: The Beatles' first transatlantic visit. In Paul McCartney's own words, his camera became the 'eyes of the storm', looking out at Beatlemania in full swing. From the moment he acquired a camera in the autumn of 1963, McCartney documented his life with The Beatles, as well as the journey they took from their home city of Liverpool, through London, Paris, across the Atlantic Ocean to New York, then Washington, culminating in Miami Beach in February 1964. He says of that time: 'Now there was the opportunity to do all this stuff we'd been dreaming of, we could actually take pictures ourselves . . . Everywhere I went I just took pictures.'[1] These photographs consist of portraits of the other Beatles, their entourage, street scenes, cityscapes, images of fans and the photographers who trailed in their wake.

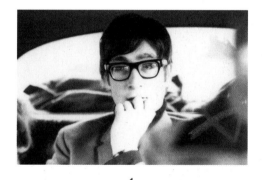

1

McCartney's photographs are redolent of the places through which they travelled and speak to his engagement with a variety of cultural influences, including the cinema. The black-and-white pictures taken in theatre dressing rooms evoke postwar Britain, as epitomised in the kitchen-sink dramas of the period. His Paris street scenes are like stills from a New Wave movie. And finally, a Technicolor American dream comes alive in McCartney's vibrant pictures taken in Florida, which are joyful and full of wonder, showing The Beatles by the pool, on a speedboat, flushed with the success of their performances on *The Ed Sullivan Show.*

As the weeks passed, McCartney's portraits of his fellow Beatles evolved as they responded to what was happening. Images taken in the U.K. are mostly interior scenes, and the group appear sullen. John Lennon wears the thick-rimmed glasses he wore only in private and bites his finger anxiously (fig. 1). In America the group appear transformed: John leaps into a swimming pool with childlike glee, George laughs and Ringo plays it cool in dark glasses.

McCartney's pictures document the in-between times when The Beatles were not performing or recording music, as well as those rare moments when they were alone. These are often images that, in his own words, 'nobody else could capture.'[2] They also bring into focus an extended cast of characters usually overlooked in other visual records of The Beatles, including roadies Mal Evans and Neil Aspinall, the chauffeur Bill Corbett, who drove their Austin Princess, and Freda Kelly, the young woman tasked with managing their daily sacks of fan mail (fig. 2). Touring enabled McCartney to spend more time with people and to get to know them better, including The Beatles' manager, Brian Epstein. Looking back on the photographs today, McCartney says of those moments, 'We had all these opportunities: seeing Brian, who we normally just sat and talked business with, but now here he was on tour with us and so we could have a lot of fun . . . play cards together and eat together, so it was more intimate. We became much more used to each other.'[3] His affectionate portraits of Epstein, who tragically died of an overdose in 1967, aged just thirty-two, are particularly poignant. In one sequence, Epstein laughed in delight as he realised McCartney was snapping his picture (fig. 3).

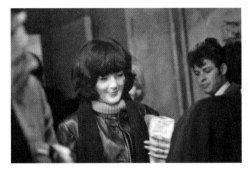

2

McCartney sometimes handed his camera to Epstein, Mal Evans or Neil Aspinall. This means that we are able to catch a glimpse of him performing onstage, photographed from the wings, or participating in a photo shoot, smiles at the ready. They were hustled into formation by Terence Spencer, the photographer who covered The Beatles' 1963 Christmas shows in London for *Life* magazine (fig. 4).[4] In another photo shoot in Paris, this one organised by the photographer Dezo Hoffman, McCartney captures the group gamely dressing up in French uniforms. Ringo, wearing a Napoleon hat, gives McCartney a sardonic look (fig. 5). These posed portraits, intended for publication in magazines and promotional material, are the antithesis of McCartney's candid photographs.

3

By 1963, The Beatles were facing cameras everywhere they looked, and at that point the camera itself becomes a motif in McCartney's photographs. In Paris and New York, he turns his lens on the photographers themselves, crowded into the foreground and jostling for a shot. Despite the apparent intensity of these situations, when all lenses are trained on McCartney, there is also playfulness — the photographers seem delighted that McCartney has noticed them and is taking their picture. As McCartney recalls, 'That was the lovely thing . . . we were definitely not stand-offish, so people got the idea that you could mess around with us, you could have fun with us and we would have fun with them.' At this point The Beatles were enjoying the attention; 'it was only in later years that would start to pale a bit.'[5]

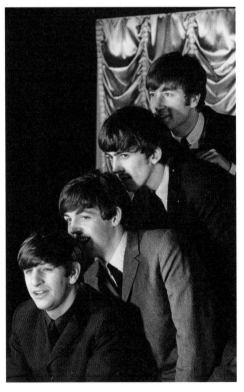

As well as McCartney, the other Beatles also held cameras. One colour photograph taken in Florida shows John making a portrait of his wife Cynthia as she sits in the sunshine. Although Cynthia is in the foreground of McCartney's picture, John is its focus (fig. 6). There is an intimacy to these images that

4

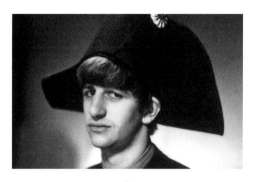

5

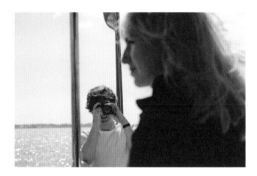

6

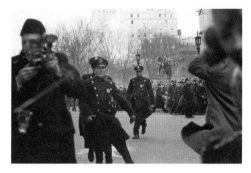

7

McCartney today recognises as particularly potent: 'It's a Beatle taking a Beatle... there's something a little bit incestuous that I like.'[6] Michael Braun, the American journalist, describes the lively scene that ensued after the band heard that 'I Want To Hold Your Hand' was No. 1 in the United States, and they all reached for their own cameras: 'John had bought a 35mm camera, and now they all had them, and were hopping around taking pictures of each other and drinking champagne.'[7] Ringo Starr is the only member of The Beatles whose photographs from the period have been published, and these convey a mutual appreciation for all that was amusing and surprising. As they were being driven through Washington, they simultaneously photographed a seedy cinema promoting 'Christine Keeler Goes Nudist' under the banner 'Art'. The band were surprised to see that Keeler, too, had become famous in the States.[8]

Numerous photographers, filmmakers and journalists were deployed by newspapers and media outlets to cover The Beatles in Paris and America. While most had only fleeting interactions with the band, at press conferences and photo calls, some were invited by Epstein to join the entourage, such as Michael Braun or Albert and David Maysles, who made the documentary *What's Happening! The Beatles in the U.S.A.*[9] They worked alongside one another, and their output inevitably overlapped; events and anecdotes echo and are amplified across the different mediums.

THE NEW SPIRIT IN PHOTOGRAPHY

'We were informed by the stuff we'd seen ... we were starting to see really interesting photographs ... Culturally, things were popping.'

The playfulness and spontaneity of McCartney's pictures are characteristic of an emerging spirit in photography, made possible by new technologies and driven by youthful practitioners. For these photographs, McCartney used a 35mm Pentax SLR (single-lens reflex), one of a new generation of point-and-shoot cameras introduced in the late 1950s. This innovation in technology allowed for the development of a 'snapshot' aesthetic that embraced imperfections. One early exponent, Tony Armstrong-Jones (later Lord Snowdon), described this new approach to image making in 1958: 'They had to be taken fast. It's no good saying "hold it" to a moment of real life. Like trying to hold a breath, you find you've lost it.'[10] The photographs McCartney took from a moving car, as The Beatles swept up to the Plaza Hotel in New York, share this sensibility. They capture the full urgency of the moment, as kids run down the middle of the street and police officers surge towards their approaching vehicle (fig. 7).

Thanks to The Beatles' success, they were able to buy the latest gadgets and were getting to grips with these new 35mm cameras at the same time as some of

the art's best-known practitioners. David Bailey, who became the quintessential 1960s British photographer, had acquired his first 35mm SLR only in 1961.[11] Like The Beatles themselves, many of the new photographers working in Britain were young and working-class, and there are clear parallels in their attitude and style. While cultural commentators obsessed over The Beatles' haircuts, suits and boots, they were also intrigued by this new breed of – predominantly male – photographer. In March 1963 the *Observer* unpicked the 'look' of a typical photojournalist: 'Studiously casual . . . Italian wool jackets, jeans and denim shirts . . . and carrying their black 35mm cameras as unobtrusively as pistols.'[12] When it came to his own photography, it seemed natural for McCartney to align himself with this dynamic movement.

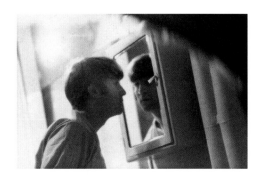

8

By the end of 1963, The Beatles had been photographed by several up-and-coming British photojournalists, including Jane Bown for the *Observer* and Philip Jones Griffiths. Both photographed the band during a U.K. tour, picturing them backstage as they smoked, snoozed and drank tea served in cups and saucers. Jones Griffiths even caught Ringo signing autographs in his underpants. Such images were intended to be authentic and, as such, were the antithesis of the finely tuned pop portrait the band usually posed for. They provided a template for McCartney's own pictures taken in Liverpool and London at around the same time, which evoke claustrophobic dressing rooms and a sense of camaraderie between those represented (fig. 8).

McCartney's down-to-earth approach resonates with related cultural movements in Britain, such as gritty realism in theatre and literature and the Free Cinema movement, all of which prioritised working-class perspectives. He described the period in which The Beatles stayed in various lodgings in London, before they relocated to the capital, with a reference to a 1960 novel set in a London boarding house: 'You could read Lynne Reid Banks's *The L-Shaped Room* and totally associate. "This is what I'm doing! This is about me."'[13] McCartney's capacity to evoke the spirit of a place in his photographs, and to adapt his style to achieve a particular atmosphere, is also evident in his photographs taken in Paris. This series of pictures embodies an aesthetic reminiscent of contemporary French cinema. McCartney and Lennon's favourite film star was, naturally, Brigitte Bardot.[14] They were aware of the New Wave, which had gained momentum by 1959, with filmmakers sometimes shooting on the streets with a hand-held camera. The sequence of John and George standing in a doorway plays out like an ambiguous scene by directors such as Jean-Luc Godard and François Truffaut, in which the protagonists dressed in black exchange loaded glances (fig. 9). When photographing from the window of their Austin Princess, brought over from London to Paris especially for this trip, McCartney captures the pavement cafés and the cool detachment of the young people who catch his eye. Unlike fans in the United Kingdom and the States, they were not screaming, just staring.

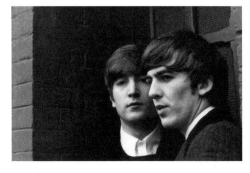

9

For McCartney, and most of The Beatles' entourage, this trip to the United States was their first transatlantic flight; only George had been to America before.[15] In America, McCartney manages to photograph something of the zeitgeist. He notices a young girl framed by the window of the car he sits in. Her headscarf catches the sunlight like a halo, and her self-possession is in contrast to the adults teeming behind her. This image, in which McCartney shares a momentary connection with a stranger, echoes the approach of U.S. photojournalists such as William Klein, who photographed people on the streets of New York in the mid-1950s. McCartney was drawn to ordinary people and workers in particular. Seeing an airport worker playing air guitar as The Beatles arrived in Miami, he captured it on camera (fig. 10). He says of this image: 'Anyone else might have thought, Oh well, there's just a guy who's come to fix the aeroplane or get it ready for take-off . . . Being from the working classes, I'd relate to them. I definitely do relate to work because my family and I did that. We all did menial work, so I know a bit about what's inside the heads of those people, because I was one too.'[16]

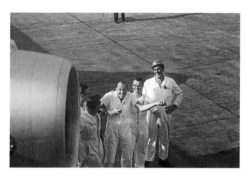

10

McCARTNEY'S PHOTOGRAPHIC INFLUENCES

'I was definitely looking for interesting shots, angles, lighting, compositions.'

McCartney's photographs were born out of a desire to record his own experience at this time, and perhaps as a way to pause time, which was passing too quickly. They also, in part, stemmed from a fascination with photography and the visual arts that extends back to his childhood and his family's first camera, a Kodak Brownie. As a child, he had noticed the work of the great Canadian photographer Yousuf Karsh, whose portrait of Winston Churchill in full 'bulldog' mode is one of the most celebrated portraits of the era. In addition to his passion for music, McCartney was excited by the transformations in visual culture that were taking place in Britain in the 1950s: 'It was after the war,' he says, 'so things were brightening up and you were being more exposed to good art and good photography.'[17]

McCartney's keen perception of the importance of the band's image, and its photographic potential, was sharpened during The Beatles' time in Hamburg, particularly under the influence of Astrid Kirchherr and Jürgen Vollmer. These young German photographers became friends with The Beatles in 1960 after seeing them perform at the Kaiserkeller club on the Große Freiheit Street in the seedy St Pauli neighbourhood of the city. Their photographs capture them, then a five-piece band, as moody rock and rollers, wearing leathers and with quiffed hair. As McCartney later acknowledged, the 'sense of style and excellent photographic skills' of Jürgen Vollmer had a profound effect on The Beatles.[18] Kirchherr said that she had 'fallen in love with their attitude and their faces; theirs was the look

I wanted to photograph.'[19] In 1962, at The Beatles' request, she was commissioned to take pictures to be used in press advertisements for the group's first EMI single, 'Love Me Do'. The photographs show them wearing suits but still unsmiling – an attitude in contrast to the usual cheery and colourful images used to promote pop artists. McCartney was struck by Kirchherr's use of light: 'She'd invite us to her house, where she'd take portraits, and so you learn by seeing.'[20] Her influence remained strong into 1964: in one of McCartney's Paris street scenes, Kirchherr's stylish photographs, chosen to appeal to a Parisian crowd, have been printed on posters and pasted all over an advertisement hoarding (fig. 11).

In Hamburg, McCartney had purchased a camera for his younger brother Mike. The letter that accompanied the gift demonstrates his excitement at the possibilities it presented: 'I've bought you a Rollei Magic camera, the same as Astrid's . . . You can ENLARGE the photos and the subject looks FAB GEAR'[21] – in the Liverpool vernacular, this was the highest praise. When McCartney returned to the family home in Forthlin Road, he and Mike collaborated on a series of striking portraits, described by Mike as 'image building', in which they experimented with light, poses and settings. Mike recalled that 'before The Beatles really happened . . . the boys all practised being famous. They'd come up to me and say, "Make us look like Elvis." In those days, they were desperate for fame and I'd take their photos because I was desperate for willing models . . . I would get Paul to sit for hours while I experimented with techniques.'[22] Mike photographed his elder brother reading the *Observer* (see p. 13), one of the first newspapers to publish the work of the new photojournalists, and in which McCartney would have seen early examples of this developing style. Through his brother, McCartney was also becoming familiar with the rudiments of the photographic process. Mike processed his film rolls in the family bathroom, hanging fresh prints to dry on a line strung across his bedroom. This passion for the camera developed into a photography career, alongside his musical success as a member of the group The Scaffold.

11

PHOTOGRAPHERS ON TOUR

'People became our friends, like part of your family, so, in the same way that you would behave with your family at breakfast, we could just ignore them and do our own thing. That was very special. One of them happened to be the manager of The Beatles and this other guy is a famous photographer, but it didn't matter.'

Rightly sensing that The Beatles' trip to Paris in January 1964 and to America the following month would present great opportunities for publicity, Epstein had invited several photographers to accompany the band, and to document every step. McCartney recalls that The Beatles were initially reluctant: 'People would ask

to accompany you for three days of a tour and at first you'd go, "Three days? Why? Can't he just take a picture?" They'd say, "No, he's doing a photojournalism thing" and so you'd go, "Oh, okay" and then you'd get to quite like him.'[23] However, it meant that there were very few private spaces for The Beatles themselves. Their expansive suites in luxury hotels – the George V in Paris, the Plaza in New York and the Deauville in Miami Beach – doubled as meeting rooms, offices, post rooms and photography studios. The photographers Dezo Hoffman, Harry Benson and Robert Freeman all appear in McCartney's photographs. By observing their practice, he was able to develop his own.

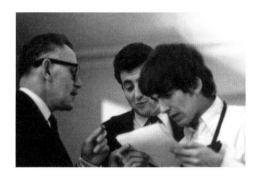

12

The Slovakian-born veteran press photographer Dezo Hoffman features in several of McCartney's photographs, wearing black-framed glasses. In one image, McCartney captures Dezo discussing a photograph with George and fellow photographer Harry Benson (fig. 12). Born in 1912, he belonged to an older generation than the photojournalists but nonetheless was an early influence on McCartney. Hoffman knew The Beatles from their formative days, when their image was distinctly less polished. His first assignment was at Abbey Road Studios in North London on 4 September 1962, when Ringo was new to the band and George sported a startling black eye, acquired in a brawl. (Hoffman explained: 'There'd been a fight in Liverpool about Pete Best's replacement by Ringo.')[24] In March 1963 Hoffman photographed The Beatles doing domestic chores at Forthlin Road – a quaint scenario set up for the weekly music paper *Record Mirror*. In an approach described as 'quasi-documentary',[25] Hoffman preferred to engineer a storyline rather than let a situation unfold. He had a strong sense of what he wanted to achieve, a vision grounded in the everyday: 'I never went for anything arty with them. This is the sort of image I wanted to project.'[26]

On another occasion, Hoffman lent McCartney and Harrison his Rolleiflex camera to make self-portraits in a mirror: 'I tried to teach them photography without flash, and these were a little shaky and out of focus.'[27] In those pictures, McCartney rehearses the self-portraits he made later with his more advanced Pentax, in which he scrutinises his own reflection, cigarette dangling. McCartney was eager for innovation, and confided to Michael Braun: 'Your tastes change in everything . . . I remember at the beginning of this year we thought Dezo was the greatest photographer in the world.'[28] Although they were outgrowing Hoffman's approach and seeking greater creative input, their interaction with him encouraged them to explore photography in more depth.

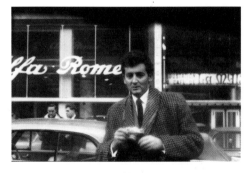

13

Another photographer on the tour was the Glaswegian Harry Benson, later known for his work for *Life* magazine (fig. 13). In 1964, Benson was working for the widely read *Daily Express* newspaper when he was diverted by his editor from an assignment covering the military mutiny in Uganda and sent to photograph The Beatles in Paris. Benson initially refused: 'I considered myself a serious journalist . . . I knew who The Beatles were . . . I wasn't interested in running around with them.' His was a quick conversion: 'I went to my car to get an extension for my

flash and, when I got back, they were playing "All My Loving". It was sensational. I thought: "Christ, this is it – the breakthrough."'[29]

In the George V Hotel in Paris, Benson took pictures of The Beatles signing autographs and composing: despite a gruelling schedule of two daily performances at the Olympia Theatre, they wrote many of the songs for *A Hard Day's Night* during their three-week stay in Paris. Benson also made the famous picture of The Beatles having a pillow fight in their pyjamas, taken on the night they were celebrating their No. 1 spot in the U.S. charts: 'The whole session took around fifteen minutes, and I must have gone through five rolls of film. I went back to my room, taped up the bathroom, and turned it into a darkroom. I had my enlarger and washed the prints. At around 6 a.m. I transmitted them back to London from my bedroom.'[30] Benson had the task of sending a picture to London every day via wireless telegraph. For McCartney, Benson's resourcefulness recalled his brother's use of the family bathroom as a makeshift darkroom. The pillow fight had been Benson's idea, and as McCartney remembers, they were always cooperative: 'You were aware that Harry Benson had to deliver a photo a day, so you would try and help him, so if he wanted a pillow fight, he got a pillow fight.'[31] Like Hoffman's photographs, Benson's pictures were stage-managed in a way that McCartney's were not.

14

British photographer Robert Freeman is the most frequent presence in McCartney's photos: deep in conversation with the band or larking about in the water in Miami (fig. 14). The four men admired his photographs, and his knowledge of the burgeoning London art scene greatly interested McCartney. Freeman was closer in age to The Beatles and was inspired by the work of the Swiss-born American photographer Robert Frank, whom he had already met in New York. In the summer of 1963, Freeman had sent Brian Epstein examples of his work, including black-and-white pictures of jazz musicians such as John Coltrane. 'A few days later, Brian phoned me to say that they all liked the photographs,' he remembered. 'He suggested that I meet them in Bournemouth.'[32] It was in this seaside resort that Freeman took the iconic photo for the front cover of *With The Beatles* (used for *Meet The Beatles!* in the States), which he approached as an extension of his jazz photography.

The chic composure of this photograph – with their faces partially in shadow – belies the less-than-glamorous circumstances in which it was made. Freeman posed The Beatles in the dining room of the Palace Court Hotel: 'The large windows let in a bright sidelight and the dark maroon velvet curtains were pulled round as a backdrop,' he recalled.[33] Ringo had to kneel on a stool in order to achieve the correct position. Freeman's fresh aesthetic and inventiveness appealed to McCartney: 'When Bob Freeman first took photographs of The Beatles, we treated him like any other photographer. It was when he returned with the results that we began to look at him in a different light.'[34] This approach was an obvious inspiration for McCartney, most notably in his portraits of his girlfriend, the actress Jane Asher, which achieved a similar effect (fig. 15).

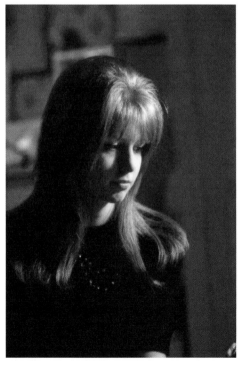

15

McCartney's portraits of Asher represent a fledgling love story at the heart of this collection of photographs. A well-known actress and teen TV celebrity, Asher had first met The Beatles when she was photographed for *Radio Times* magazine at the Royal Albert Hall concert *Swinging Sound '63*. When Epstein relocated the whole band to London later the same year, McCartney moved in with the Asher family and was given a room in the attic of their smart house in Wimpole Street. The photographs taken in the privacy of Asher's home are remarkable for their stillness and intimacy. For once, McCartney holds the only camera in the room. In one portrait, McCartney captures Asher in the mirror as she backcombs her hair. The mirror was a frequent compositional device in McCartney's pictures backstage, but in this case the outcome is more resolved. McCartney was warmly welcomed by the Asher family, and the house became a refuge from Beatlemania for several years, and the place where McCartney and John Lennon met to work on new songs, including 'I Want To Hold Your Hand'.

At this point McCartney had embarked on a crash course in culture. He later recalled, 'I often felt the other guys were sort of partying whereas I was learning a lot.'[35] Like the Ashers, Freeman was helpful in introducing McCartney to a wider cultural milieu. In addition to his photography, he had worked at the pioneering Institute of Contemporary Arts, organising exhibitions and lectures. He introduced The Beatles to a number of up-and-coming artists, including the pop artist Joe Tilson, whose diary entries in September 1963 include 'tea with Beatles and the photographer Robert Freeman and a Beatles concert in Luton.'[36] The Beatles, and McCartney in particular, became embedded in London's counter-culture, which encouraged the cross-pollination of art, music, technology and elements of popular culture including commercial design. When leading British artist Richard Hamilton asked The Beatles for a few personal photographs to incorporate onto the poster he was designing for *The Beatles* ('The White Album') in 1968, McCartney shared a handful of contact sheets from this collection of pictures.

CONTACT SHEETS AND THE MOVING IMAGE

'We liked cinéma vérité – the idea of capturing stuff on the go.
It fitted with who we were and what we were doing. Just photograph
or film people and they'll forget you're there.'

McCartney's photographic archive consists of hundreds of images preserved as negatives and contact sheets. Rarely used by photographers now, a contact sheet was a crucial tool connected to the use of the 35mm camera. Strips of negative film were printed on a single sheet of photographic paper so that all the images on a single roll of film – numbering thirty-six on a standard roll – could be viewed at once, enabling the photographer to look at the events in sequence. McCartney

photographs Ringo perusing a contact sheet as he and Epstein sit in their suite at the George V Hotel. In his use of contact sheets, McCartney emulates a professional approach to photography, and he marked the shots he wished to develop as individual prints with a chinagraph pencil. Unlike the choices made by a professional, however, these were not intended for publication at the time. Only a small number of prints were ever made for close friends and family. Returning to the contact sheets today, McCartney has revised some choices: 'There are others that I think may be even better, looking at it from now.'[37] The contact sheets encapsulate the passage of time and animate the faces of individuals in dialogue with McCartney as he photographs.

The sequential nature of the contact sheets recalls the cinema and, in this context, The Beatles' first film, *A Hard Day's Night*, made in February and March 1964, shortly after they returned from their first trip to the United States. Filmed in black and white, *A Hard Day's Night* was influenced by the emerging documentary film movement of the late 1950s and early 1960s. It has a fast-paced, episodic quality that capitalises on The Beatles' youthful energy and shared sense of humour. Epstein had invited the film's director, Richard Lester, and the screenwriter, Alun Owen, to stay in rooms adjacent to The Beatles' suite at the George V Hotel in January 1964, when the band had a residency at the Olympia theatre. For the script, Owen quoted directly from The Beatles' famous press conferences in which they parried with journalists apparently obsessed with their hairstyles.

As Lester recalls, 'The film was writing itself as we went. We watched how they went from the car to the hotel, and the hotel to the Olympia and back ... We wrote a script to ask them to do the things they knew.'[38] He directed them running from fans, travelling on a train and cornered by photographers, who snap away relentlessly. For John Lennon it was a 'comic-strip version of what was going on ... The pressure was far heavier than that depicted by the film,' and that pressure is more tangible in McCartney's photos.[39]

A prototype for *A Hard Day's Night* was the documentary made by Albert and David Maysles, commissioned for the British TV company Granada.[40] The Maysleses were pioneers of the 'fly on the wall' documentary style known as direct cinema, closely linked to French cinéma vérité and to photojournalism, in which filmmakers aimed to be as unobtrusive as possible while filming real-life scenarios. For McCartney, they were a welcome addition to the party: 'They were mates and we were very much attracted to them because they were artistic ... So when they said, "Oh, just ignore us," we were like "Wow ... what a great way to make a film."'[41] The Maysleses had designed and built their own camera and sound equipment, each item engineered so that it was compact and mobile and enabled them to work in confined spaces. Albert Maysles observed: 'Paul and George were fascinated by the way we were making the film, the technology, the way we could be so quick on our feet.'[42]

16

17

The Maysleses discovered that The Beatles could never truly forget that they were there: 'Posing for the camera from time to time just came from a practice that they had acquired in England before coming to America – "do this, do that" – so they had the habit of playing for the camera.'[43] Surrounded by lenses even in their hotel, The Beatles were performing most of the time, even when the expectation was that they were being their 'authentic' selves. The Maysleses' film shows Freeman photographing McCartney as he reads aloud from the newspaper. On the train from New York to Washington, the Maysleses caught Ringo and George playing up to the captive audience of photographers and journalists, but McCartney sits apart: 'I'm not in a laughing mood,' he says.[44] For McCartney, taking photographs was a form of communication, requiring energy he didn't have at that moment. His photographs from this leg of the journey are mainly views snapped from the window of the train, rather than his fellow passengers.

The Maysleses left The Beatles after their performance for *The Ed Sullivan Show* at the glamorous Deauville Hotel. This was their last scheduled show on their trip (the final New York *Ed Sullivan Show* had been prerecorded). Glancing up at the brilliant blue skies, McCartney decided to switch to colour film. These photographs have a wide-screen quality that conveys expansive vistas and the sunshine of Miami. They had travelled through blizzards in New York and Washington just days before, as though jumping through several seasons in a few weeks. McCartney's pictures show The Beatles and their entourage unwinding in the warm sun (fig. 16). Most of the pictures were taken outside, on boats and by the swimming pool, and are closer in spirit to holiday snaps. Like the rest of the party, photographer Dezo Hoffman switched his winter clothes for swimming trunks, later recalling: 'Miami was a remarkable experience. We had a whole floor in the Deauville Hotel, and we also borrowed a villa off a millionaire. [The Beatles] enjoyed it so much, you can see in the pictures there's not one miserable face. It was as if they'd been born into it, they were so nonchalant.'[45] This is the day that John Loengard, a photographer for *Life* magazine, took his iconic portrait of The Beatles, heads bobbing in the water. In over a decade of working for *Life,* he regarded this photograph of the British musicians as his 'most American' picture: a sentiment that reflects not only how much the American public welcomed The Beatles into their own hearts but also the impact America had on The Beatles.[46]

In Loengard's recollection, the weather was not particularly warm, but this is not borne out by McCartney's glorious photos – and for The Beatles, used to the North of England, it was sufficiently warm to swim outdoors. This experience was in contrast to McCartney's childhood in postwar Britain, where even on holiday he would wear his school uniform: 'We didn't have hang-out clothes like American kids had, like shorts and T-shirts.'[47] In Miami Beach, everyone is wearing the towelling shirts provided by the hotel with their swimming shorts: the ultimate 'hang-out' clothes. Even Epstein, usually scrupulously dapper, joined the sartorial fun (fig. 17).

For McCartney, taking pictures was driven by the same creative impulse as songwriting: 'It was what was happening, it was what was going on at the time and it was very exciting, so taking pictures of it, writing songs about it, talking about it, giving interviews about it, it was all good stuff.'[48] As such, the experience of looking back at these old pictures is analogous to McCartney's recent project to revisit the lyrics of his songs, a process he compared to looking at 'an old snapshot album that's been kept up in a dusty attic. Someone brings it down, and suddenly you're faced with page after page of memories.'[49] His photographs show us what it was like to look through his eyes while The Beatles conquered the world: a lens extended to the people with whom he shared the experience. They speak to his understanding of photography, his interest in technology and his responsiveness to contemporary culture. His viewpoint remains remarkably fresh: 'We were fascinated by what we were doing and what was happening to us and it's something I've never really lost… I've never lost that sense of wonder.'[50]

Rosie Broadley, Senior Curator, 20th Century Collections
National Portrait Gallery, London

Timeline

1963 October

13 Oct
Around 15 million people in the U.K. tune in to see The Beatles top the bill on the ITV programme *Val Parnell's Sunday Night at the London Palladium.*

14 Oct
'Beatlemania' is first coined by the British press to describe the mayhem outside the Palladium.

17 Oct
'I Want To Hold Your Hand' and 'This Boy' are recorded along with 'The Beatles Christmas Record' – an exclusive flexi disc for fan club members.

23 Oct
The Beatles fly to Sweden for their first international tour.

31 Oct
Thousands of screaming fans at London Airport welcome The Beatles on their return from Sweden. Ed Sullivan witnesses the excitement first-hand.

1963 November

1 Nov
The Beatles begin their U.K. autumn tour in Cheltenham.

4 Nov
The Beatles play *The Royal Variety Performance* at the Prince of Wales Theatre, London. The broadcast is watched by 21 million viewers, and the band meet the Queen Mother and Princess Margaret.

18 Nov
The Beatles are seen on American television for the first time during NBC's *Huntley-Brinkley Report.*

22 Nov
With The Beatles, the band's second album, is released and goes on to replace *Please Please Me* at the top of charts in the U.K. It stays there for 21 weeks. The band are playing at the Globe in Stockton-on-Tees, as part of their autumn tour, when they hear that President Kennedy has been assassinated.

1963 December

7 Dec
The Beatles appear on BBC TV's *Juke Box Jury* and, later that evening, *It's The Beatles.* They are watched by an estimated U.K. audience of over 22 million viewers.

21–22 Dec
The Beatles perform previews of *The Beatles Christmas Show* at Bradford's Gaumont Cinema and Liverpool's Empire Theatre.

24 Dec
The Beatles begin a 16-night run of *The Beatles Christmas Show* at the Finsbury Park Astoria in London.

1964 January

11 Jan
The Beatles Christmas Show ends its run at the Finsbury Park Astoria in London.

12 Jan
The Beatles' second appearance on *Sunday Night at the London Palladium.*

14 Jan
John, Paul and George fly to Paris.

15 Jan
The Beatles play a warm-up show at the Cinéma Cyrano in Versailles. When they return to their suite at the George V Hotel, they hear that 'I Want To Hold Your Hand' will be No. 1 in the U.S.

16 Jan
The Beatles play their first show of a three-week season at l'Olympia in Paris. They perform two shows a day across 18 days as part of a nine-act bill. The group have two days off, 21 and 28 January.

29 Jan
'Can't Buy Me Love' is recorded at Pathé Marconi Studios. During the session they also record 'Komm, gib mir deine Hand' and 'Sie liebt dich' for release in West Germany.

1964
February

1964
March

1964
April

4 Feb
The Beatles play their last
show at l'Olympia, Paris.

5 Feb
The Beatles return to the U.K.

7 Feb
The Beatles land at JFK
Airport, New York. They stay
at the Plaza Hotel.

8 Feb
John, Paul and Ringo attend
a press call in Central Park,
followed by rehearsals for
The Ed Sullivan Show. As
George has tonsillitis, he
remains at the hotel.

9 Feb
The Beatles' first appearance
on *The Ed Sullivan Show*
is watched by 73 million
viewers – the highest-ever TV
audience figure to date.

11 Feb
The Beatles arrive in
Washington, D.C. by train to
perform their first U.S. concert
at the Coliseum. Afterwards,
they attend a party at the
British embassy.

12 Feb
The Beatles return to
New York for two shows at
Carnegie Hall.

13 Feb
The Beatles fly to Miami.
They stay at the Deauville
Hotel, Miami Beach.

14 Feb
Life magazine photo shoot
in the morning. In the
afternoon, a rehearsal for
The Ed Sullivan Show.

15 Feb
Additional rehearsals for their
second performance on
The Ed Sullivan Show and
Meet The Beatles! hits No.1 on
the *Billboard* album chart and
stays there for 11 consecutive
weeks.

16 Feb
The Beatles make their second
appearance on *The Ed Sullivan
Show*, live from the
Deauville Hotel.

17–20 Feb
The Beatles enjoy a few days
off in Miami. On 18 February
they meet Cassius Clay,
who is training for his World
Heavyweight Championship
fight with Sonny Liston.

22 Feb
The Beatles return to the U.K.

25 Feb
The Beatles return to Abbey
Road Studios on George's
21st birthday to record
songs for their film *A Hard
Day's Night*.

29 Feb
Introducing... The Beatles
reaches its peak position of
No.2 in the U.S. album chart.
It was kept from being No.1 for
9 weeks by *Meet The Beatles!*

Throughout March
The Beatles film scenes for
A Hard Day's Night
at Twickenham Film Studios
and on location.

19 Mar
The Beatles receive their
Variety Club 'Show Business
Personality of 1963' awards
from prime minister Harold
Wilson at the Dorchester
Hotel, London.

23 Mar
The Duke of Edinburgh
presents The Beatles with
two awards during a live TV
broadcast, *The Carl-Alan
Awards*, from the Empire
Ballroom, London.

Throughout April
The Beatles continue filming
A Hard Day's Night at
Twickenham Film Studios
and around London.

4 Apr
The Beatles hold 12 places on
the *Billboard* singles chart in
the U.S., including the top
5 places (No.1 'Can't Buy Me
Love', No.2 'Twist And Shout',
No.3 'She Loves You', No.4
'I Want To Hold Your Hand',
and No.5 'Please Please Me').

26 Apr
The group play live at the *NME*
Poll-Winners' All-Star Concert
at the Empire Pool, Wembley.

1964 May

2 May
The Beatles go on holiday and *The Beatles' Second Album* replaces *Meet The Beatles!* at No.1 in the U.S. *Billboard* album chart.

6 May
The TV show *Around The Beatles* is broadcast in the U.K. It will air in the U.S. on 15 November 1964.

31 May
The Pops Alive! concert – two shows at the Prince of Wales Theatre, London.

1964 June

3 Jun
Ringo is taken ill on the eve of The Beatles' world tour.

4 Jun
The Beatles' 27-day world tour begins in Denmark with Jimmie Nicol playing drums.

12 Jun
The group are greeted by over 100,000 fans lining the six-mile-long route from the airport in Adelaide, Australia, to the town.

15 Jun
Ringo rejoins the group in Melbourne, Australia.

18 Jun
Paul turns 22.

26 Jun
The soundtrack album *A Hard Day's Night* is released in the U.S. and spends 14 weeks at No. 1 on the *Billboard* album chart.

1964 July

2 Jul
The Beatles return to the U.K.

6 Jul
The world film premiere of *A Hard Day's Night* is held at the London Pavilion.

10 Jul
A Hard Days Night, The Beatles' third album is released in the U.K. When the band return to Liverpool for the northern premiere of the film, 150,000 people crowd the streets to welcome them home.

23 Jul
The Night of a Hundred Stars, a charity revue at the London Palladium, features The Beatles winched above the stage in a ballet sketch called 'I'm Flying'.

28 and 29 Jul
The Beatles make a second visit to Sweden, where they perform four times over two nights.

1964 August

11 Aug
The Beatles begin sessions for their next album at Studio Two in Abbey Road.

16 Aug
The Beatles perform at the Opera House, Blackpool. Support acts include The Kinks and The High Numbers, who would soon change their name to The Who.

19 Aug
The Beatles, play the first concert of a 26-date North American tour at the Cow Palace, San Francisco. The tour includes two dates in Canada and one charity concert in New York City.

28 Aug
After the New York show at the Forest Hills Tennis Stadium, The Beatles meet Bob Dylan for the first time.

1964 September

20 Sep
The final U.S. concert in 1964 is *An Evening with The Beatles* at the Paramount Theatre, New York.

21 Sep
The Beatles return to the U.K.

1964 October

2 and 3 Oct
Rehearsal and recording of the American TV show *Shindig!*, Granville Studio, London. The Beatles perform live in front of an audience of their fan club members.

9 Oct
The Beatles' 27-date autumn U.K. tour starts on John's 24th birthday at the Gaumont Cinema, Bradford. They play two shows per night at each venue.

1964 November

10 Nov
The final night of the autumn tour, Colston Hall, Bristol.

1964 December

21–23 Dec
Rehearsals for *Another Beatles Christmas Show*, Hammersmith Odeon, London.

24 Dec
Another Beatles Christmas Show begins at the Hammersmith Odeon, London. They perform a total of 38 shows over 20 nights.

Notes

BEATLELAND: THE WORLD IN 1964

1 'Beatles First Time on American TV!', *The Huntley-Brinkley Report*, NBC News, 18 November 1963, https://www.youtube.com/watch?v=SY9PoR7-XGA.

2 Bill Crandall, 'CBS News Reports on the Beatles in 1963', CBS News, 21 January 2014, https://www.cbsnews.com/news/cbs-news-reports-on-the-beatles-in-1963/.

3 'The Beatles on CBS News', 21 November 1963, https://www.youtube.com/watch?v=z-sI-e-eJwQ.

4 On the sixties starting in 1964, see especially Jon Margolis, *The Last Innocent Year: America in 1964 – the Beginning of the "Sixties"* (New York: William Morrow, 1999), whose thesis is echoed by many commentators in *1964: American Experience*, written and directed by Steven Ives (PBS 2014), notably Robert Caro and Rick Perlstein.

5 'JFK Assassination: Cronkite Informs a Shocked Nation', https://www.youtube.com/watch?v=6PXORQE5-CY.

6 'Reporting JFK's Assassination: A BBC Correspondent's Notes', 18 November 2012, https://www.bbc.com/news/magazine-24954509.

7 'How the Kennedy Assassination Caught the BBC on the Hop', 18 November 2003, https://www.independent.co.uk/news/media/how-the-kennedy-assassination-caught-the-bbc-on-the-hop-78973.html.

8 Paul McCartney, interview with the author, 20 May 2022.

9 Bruce Spizer, '50 Years Ago: Tales of Triumph and Tragedy – The Beatles Kennedy Connection', 21 November 2013, https://www.beatle.net/50-years-ago-tales-of-triumph-and-tragedy-the-beatles-kennedy-connection/.

10 Burgess quoted in 'How the Kennedy Assassination Caught the BBC on the Hop'.

11 Steven D. Stark, *Meet the Beatles: A Cultural History of the Band That Shook Youth, Gender, and the World* (New York: HarperCollins, 2005), 91.

12 Quoted in Sam Lebovic, '"Here, There, and Everywhere": The Beatles, America, and Cultural Globalization, 1964–1968', *Journal of American Studies* 51, no. 1 (February 2017): 48.

13 'Singers: The New Madness', *Time*, 15 November 1963, https://content.time.com/time/subscriber/article/0,33009,873176,00.html.

14 'Beatles Interview: AP & CBS News, Plaza Hotel 2/10/1964', The Beatles Ultimate Experience, http://www.beatlesinterviews.org/db1964.0210cbs.beatles.html.

15 Louis Menand, *The Free World: Art and Thought in the Cold War* (New York: Farrar, Straus and Giroux, 2021), 327.

16 Quoted in Stark, *Meet the Beatles*, 6.

17 Jonathan Gould, *Can't Buy Me Love: The Beatles, Britain, and America* (New York: Harmony Books, 207), 167.

18 Frederick Lewis, 'Britons Succumb to "Beatlemania"', *New York Times*, 1 December 1963.

19 *The Beatles: Eight Days a Week – The Touring Years*, directed by Ron Howard, written by Mark Monroe (Capitol, 2016), DVD.

20 *The Beatles: Eight Days a Week*, 1:30.

21 Lebovic, '"Here, There, and Everywhere"', 50.

22 Kenneth L. Campbell, *The Beatles and the 1960s: Reception, Revolution and Social Change* (London: Bloomsbury Academic, 2021), 55.

23 Stark, *Meet the Beatles*, 13.

24 Stark, *Meet the Beatles*, 139.

25 'Beatles Press Conference: Indianapolis, Indiana 9/3/1964', The Beatles Ultimate Experience, http://www.beatlesinterviews.org/db1964.0903.beatles.html.

26 Philip Larkin, *Poems*, selected by Martin Amis (London: Faber & Faber, 2011).

27 *The Beatles: Eight Days a Week*, 7:20.

28 Peter Atkinson, 'The Beatles and the Broadcasting of British Cultural Revolution, 1958–63', in *Fifty Years with the Beatles*, ed.

Tim Hill (Croxley Green: Atlantic Publishing, 2013), 18–22.

29 *The Beatles: Eight Days a Week*, about 8:00.

30 Eric Torkelson Weber, *The Beatles and the Historians: An Analysis of Writings About the Fab Four* (Jefferson, NC: McFarland, 2016), 18.

31 'Peter's Cook's The Establishment Club', Darkest London, 11 March 2013, https://darkestlondon.com/2013/03/11/peter-cooks-the-establishment-club/.

32 See Jill Lepore, 'The Man in the Box: Fifty Years of *Doctor Who*', *New Yorker*, 11 November 2013.

33 Quoted in Peter Hennessy, *Winds of Change: Britain in the Early Sixties* (London: Allen Lane, 2019), 317.

34 'Beatles Interview: AP & CBS News, Plaza Hotel 2/10/1964', The Beatles Ultimate Experience, http://www.beatlesinterviews.org/db1964.0210cbs.beatles.html.

35 Campbell, *The Beatles and the 1960s*, 44.

36 Gould, *Can't Buy Me Love*, 155.

37 'CBS News: Cronkite Introduces the Beatles', https://www.youtube.com/watch?v=BIezOS6M5_k and Randy Lewis, 'The Beatles, JFK and Nov. 22, 1963', *Los Angeles Times*, 22 November 2013, https://www.latimes.com/entertainment/music/posts/la-et-ms-beatles-kennedy-assassination-nov-22-1963-20131122-story.html.

38 'Beatles Interview: Washington Coliseum 2/11/1964', The Beatles Ultimate Experience, http://www.beatlesinterviews.org/db1964.0211.beatles.html.

39 'Beatles Interview: Carroll James, Washington Coliseum 2/11/1964', The Beatles Ultimate Experience, http://www.beatlesinterviews.org/db1964.0211cj.beatles.html.

40 Quoted in Stark, *Meet the Beatles*, 24.

41 'Beatles Press Conference: Sydney Australia 6/11/1964', The Beatles Ultimate Experience, http://www.beatlesinterviews.org/db1964.0611.beatles.html.

42 Ian MacDonald, *Revolution in the Head:*

The Beatles' Records and the Sixties (New York: Holt, 1994), 2.

43 'Colonialism Is Doomed' (speech delivered before the General Assembly of the United Nations on 11 December 1964), Che Guevara Internet Archive, https://www.marxists.org/archive/guevara/1964/12/11-alt.htm.

44 Jennifer Crwys-Williams, ed., *In the Words of Nelson Mandela* (Parktown, South Africa: Penguin Books, 1997), 35.

45 Bradford E. Loker, *History with the Beatles* (Indianapolis: Dog Ear, 2009), 84–86.

46 Gould, *Can't Buy Me Love*, 8.

47 Even the Kennedy assassination, as McCartney said: 'It was scary but in all truthfulness we were in our own heads.' *The Beatles: Eight Days a Week,* about 11:00.

48 *The Beatles: Eight Days a Week,* about 12:00. Paul: 'Half of my thinking on that was that when we went over, people were going to make fun of us or were going to toss hard questions at us and so the answer was, always the fallback was Well, but we're number one in your country.'

49 'The BEATLES Are Coming: Teaser Stickers and 1964 Promotional Campaign', Mitch McGeary's Songs, Pictures and Stories of the Beatles website, http://www.rarebeatles.com/photopg2/comstk.htm.

50 Gareth L. Pawlowski, *How They Became the Beatles: A Definitive History of the Early Years, 1960–1964* (London: Macdonald, 1990), 175. Gould, *Can't Buy Me Love*, 211–12.

51 *What's Happening! The Beatles in the U.S.A.*, TV movie, directed by Albert Maysles and David Maysles (Maysles Films, 1964), about 8:00.

52 Stark, *Meet the Beatles*, 10.

53 John McMillian, *Beatles vs. Stones* (New York: Simon & Schuster, 2013), 3.

54 'Beatles Press Conference & Interview: Jacksonville 9/11/1964', The Beatles Ultimate Experience, http://www.beatlesinterviews.org/db1964.0911.beatles.html.

55 Quoted in Stark, *Meet the Beatles*, 15.

56 *Federal Role in Urban Affairs: Hearings Before the Subcommittee on Executive Reorganization of the Committee on Government Operations*, U.S. Senate, 89th Cong., 2nd Sess. (29–30 August 1966), Part 5 (Washington, DC: US Government Printing Office, 1966), 1361–62.

57 Quoted in Weber, *The Beatles and the Historians*, 21.

58 Gould, *Can't Buy Me Love*, 229.

59 'Beatles Interview: Carnegie Hall, 2/12/1964', The Beatles Ultimate Experience, http://www.beatlesinterviews.org/db1964.0212.beatles.html.

60 Quoted in Stark, *Meet the Beatles*, 149.

61 *1964: American Experience*, 42:50.

62 'Beatles Press Conference: New York City 8/28/1964', The Beatles Ultimate Experience, http://www.beatlesinterviews.org/db1964.0828.beatles.html.

63 *The Beatles: Eight Days a Week*, about 3:30.

64 Stark, *Meet the Beatles*, 3–4.

65 Kaitlyn Tiffany, 'Why Fangirls Scream', *Atlantic*, 30 May 2022, https://www.theatlantic.com/technology/archive/2022/05/justin-bieber-beatles-one-direction-screaming-fan/629845/.

66 David Dempsey, 'Why the Girls Scream, Weep, Flip', *New York Times*, 23 February 1964, https://timesmachine.nytimes.com/timesmachine/1964/02/23/290257132.pdf?pdf_redirect=true&ip=0.

67 Latif Shiraz Nasser, 'Spasms of the Soul: The Tanganyika Laughter Epidemic in the Age of Independence' (PhD diss., Harvard University, 2014).

68 'Beatles Press Conference: Detroit 9/6/1964', The Beatles Ultimate Experience, http://www.beatlesinterviews.org/db1964.0906.beatles.html.

69 Harris Faigel, '"The Wandering Womb": Mass Hysteria in School Girls', *Clinical Pediatrics* 7 (July 1968): 377–78.

70 Menand, *The Free World*, 319.

71 Andrew Boyd, 'No. 2640: The Singing Nun', Engines of Our Ingenuity, https://www.uh.edu/engines/epi2640.htm.

72 'Johnny Hallyday "Kili Watch" on *The Ed Sullivan Show*', https://www.youtube.com/watch?v=r1ID-7SVqv8.

73 Quoted in Charles Gower Price, 'Sources of American Styles in the Music of the Beatles', *American Music* 15, no. 2 (Summer 1997).

74 Gould, *Can't Buy Me Love*, 6.

75 *What's Happening!*, about 39:00.

76 Quoted in Jon Margolis, *The Last Innocent Year*, xi.

77 'Beatles Press Conference: Washington Coliseum 2/11/1964', The Beatles Ultimate Experience, http://www.beatlesinterviews.org/db1964.0211pc.beatles.html.

78 *1964: American Experience*, 2014.

79 *The Beatles: Eight Days a Week*, about 23:00.

80 'Malcolm X Comments on Civil Rights Bill, 1964', Special Collections and University Archives, University of Maryland Libraries, College Park, https://www.youtube.com/watch?v=8MH49Aw83U4.

81 Campbell, *The Beatles and the 1960s*, 63.

82 Quoted in Menand, *The Free World*.

83 As quoted in Lerone Bennett Jr, 'Stokely Carmichael, Architect of Black Power', *Ebony*, September 1966 (and reproduced on a poster in the NAACP archives from a 1966 rally in Atlanta in which protesters were trying to get Carmichael out of jail).

84 Brian Ward, *Just My Soul Responding: Rhythm and Blues, Black Consciousness, and Race Relations* (Berkeley: University of California Press, 1998), 330.

85 Gareth L. Pawlowski, *How They Became the Beatles*, 177.

86 *1964: American Experience*, 2014.

87 'Beatles Press Conference: Washington Coliseum 2/11/1964', The Beatles Ultimate Experience, http://www.beatlesinterviews.org/db1964.0211pc.beatles.html.

88 *The Beatles: Eight Days a Week*, about 34:00.

89 United States Senate, 'Civil Rights Act of 1964', https://www.senate.gov/artandhistory/history/civil_rights/cloture_finalpassage.htm.

90 Gould, *Can't Buy Me Love*, 249–50.

91 'Beatles Press Conference: New York City 8/28/1964', The Beatles Ultimate Experience, http://www.beatlesinterviews.org/db1964.0828.beatles.html.

92 Erika White, 'Make America Beatley Again! Inside the "Ringo for President" Campaign of 1964', *Rebeat*, http://www.rebeatmag.com/make-america-beatley-again-the-ringo-for-president-campaign-of-1964/.

93 'Beatles Press Conference: Los Angeles 8/23/1964', The Beatles Ultimate Experience, http://www.beatlesinterviews.org/db1964.0823.beatles.html.

94 'Fannie Lou Hamer: Testimony at the Democratic National Convention 1964', *The American Yawp Reader*, https://www.americanyawp.com/reader/27-the-sixties/fannie-lou-hamer-testimony-at-the-democratic-national-convention-1964/.

95 Andy Gill, *Bob Dylan: The Stories Behind the Songs, 1962–68* (London: Welbeck, 2021), 64.

96 Robert Cohen and Reginald E. Zelnik, eds., *The Free Speech Movement: Reflections on Berkeley in the 1960s* (Berkeley: University of California Press, 2002), 119.

97 'Beatles Press Conference: American Arrival 2/7/1964', The Beatles Ultimate Experience, http://www.beatlesinterviews.org/db1964.0207.beatles.html.

98 'Beatles Press Conference & Interview: Denver 8/26/1964', The Beatles Ultimate Experience, http://www.beatlesinterviews.org/db1964.0826.beatles.html.

99 Michael Ray Fitzgerald, 'Much Ado About Nada: Beatles Brouhaha at the Gator Bowl', *The Jitney*, 25 September 2021.

100 Quoted in Stark, *Meet the Beatles*, 142.

101 'Beatles Interview: North-East Newsview 10/15/1964', The Beatles Ultimate Experience, http://www.beatlesinterviews.org/db1964.1016.beatles.html.

102 Quoted in Gould, *Can't Buy Me Love*, 271.

103 David Edgerton, *The Rise and Fall of the British Nation: A Twentieth-Century History* (London: Allen Lane, 2018), 282.

104 Margolis, *The Last Innocent Year*, viii. Margolis is also the scholar who argues that the sixties began in 1964 and that 1964 began on 22 November 1962 (viii).

105 Dinky Romilly to Joan Baez, 9 July 1965, Student Non-violent Coordinating Committee Files on the Beatles, Martin Luther King, Jr. Center for Nonviolent Social Change, Inc., Atlanta, Georgia.

106 Quoted in Lebovic, '"Here, There, and Everywhere"', 61.

ANOTHER LENS

1 Paul McCartney, interview with the author, 5 July 2022.

2 McCartney, interview with the author.

3 McCartney, interview with the author.

4 Terence Spencer, *It Was Thirty Years Ago Today* (New York: Henry Holt, 1994), 146.

5 McCartney, interview with the author.

6 McCartney, interview with the author.

7 Michael Braun, *Love Me Do! The Beatles' Progress* (Greymalkin Media, 2019), 96.

8 Ringo Starr, *Photograph* (Guildford, Surrey: Genesis, 2015), 132.

9 The original title. Revised for DVD release as *The Beatles: The First U.S. Visit* (Capitol: 1991).

10 Tony Armstrong-Jones, *London* (London: Weidenfeld & Nicolson, 1958), 7.

11 Martin Harrison, *Young Meteors: British Photojournalism 1957–1965* (London: Jonathan Cape, 1998), 97.

12 Harrison, *Young Meteors*, 7.

13 Barry Miles, *Paul McCartney: Many Years from Now* (New York: Henry Holt, 1998), 100.

14 Miles, *Paul McCartney*, 69.

15 The first commercial non-stop transatlantic jet flight had only taken place in 1958.

16 McCartney, interview with the author.

17 McCartney, interview with the author.

18 From the foreword by McCartney in Jürgen Vollmer, *From Hamburg to Hollywood* (Guildford, Surrey: Genesis, 1997).

19 Kenneth L. Campbell, *The Beatles and the 1960s: Reception, Revolution and Social Change* (London: Bloomsbury, 2022), 34.

20 McCartney, interview with the author.

21 Michael McCartney, *Remember: The Recollections and Photographs of Michael McCartney* (London: Merehurst, 1992), 27.

22 Michael McCartney, *Remember*, 28.

23 McCartney, interview with the author.

24 Dezo Hoffman, *With The Beatles: The Historic Photographs of Dezo Hoffman*, ed. Pearce Marchbank (London: Omnibus, 1982), 7.

25 Terence Pepper and Jon Savage, *Beatles to Bowie: The 60s Exposed* (London: National Portrait Gallery, 2009), 14.

26 Pepper and Savage, *Beatles to Bowie*, 32.

27 Hoffman, *With The Beatles*, 30.

28 Braun, *Love Me Do!*, 37.

29 Karin Andreasson, 'Harry Benson's Best Photograph: The Beatles Pillow-Fighting' (interview), *Guardian*, 12 February 2014, https://www.theguardian.com/artanddesign/2014/feb/12/harry-benson-best-photograph-beatles-pillow-fight.

30 Harry Benson, *The Beatles: On the Road 1964–1966* (Germany: Taschen, 2017), 10.

31 McCartney, interview with the author.

32 Robert Freeman, *Yesterday: Photographs of The Beatles by Robert Freeman*, with a foreword by Paul McCartney (London: Weidenfeld and Nicolson, 1983), 7.

33 Freeman, *Yesterday*, 8.

34 Freeman, *Yesterday*, 5.

35 Miles, *Paul McCartney*, 116.

36 Lisa Tickner, *London's New Art Scene: Art and Culture in the 1960s* (New Haven: Yale University Press, 2020), 21.

37 McCartney, interview with the author.

38 Michael Bonner, 'The Making of *A Hard Day's Night*: "The Fans Had Got Hacksaws . . . "', *Uncut*, 5 October 2015; originally published in September 2014, https://www.uncut.co.uk/features/the-making-of-a-hard-days-night-the-fans-had-got-hacksaws-71060/

39 Kenneth L. Campbell, *The Beatles and the 1960s: Reception, Revolution and Social Change* (London: Bloomsbury, 2022), 79.

40 It was commissioned for Granada's TV news show *Scene at Six Thirty*, on which it was shown in instalments. See also Derek Granger, 'Letter: Albert Maysles' Beatles Films Were an Enduring Relic of Their Fabled Early Years', *Guardian*, 17 March 2015, https://www.theguardian.com/film/2015/mar/17/albert-maysles-obituary-letter.

41 McCartney, interview with the author.

42 Albert Maysles, commentary, *The Beatles: The First U.S. Visit* (Capitol, 2004), DVD.

43 Maysles commentary, *The Beatles*.

44 *The Beatles: The First U.S. Visit* (Capitol, 2004), DVD.

45 Hoffman, *With The Beatles*, 98.

46 Richard Sandomir, 'John Loengard, *Life* Photographer and Chronicler, Dies at 85', *New York Times*, 30 May 2020; updated 2 June 2020, https://www.nytimes.com/2020/05/30/arts/john-loengard-dead.html.

47 Paul McCartney, interview with Jill Lepore, 20 May 2022.

48 McCartney, interview with the author.

49 Paul McCartney, *The Lyrics: 1956 to the Present* (London: Penguin / Allen Lane; New York: Liveright, 2021), xiv.

50 McCartney, interview with author.

Acknowledgements

Special thanks to Nancy, my kids and my loving family.
Also to Bob Weil, Stuart Proffitt, Nicholas Cullinan,
Rosie Broadley, Jill Lepore, Lee Eastman and Richard Ewbank.

MPL

Alex Parker
Aoife Corbett
Ben Chappell
Issy Bingham
Louise Morris
Maddy Evans
Mark Levy
Miranda Langford
Nancy Jeffries
Nansong Lue
Richard Miller
Ross Martin
Samantha Townsend
Samantha Woodgate
Sarah Brown
Steve Ithell
And everyone at MPL

LIVERIGHT/W.W. NORTON

Anna Oler
Bonnie Thompson
Clio Hamilton
Cordelia Calvert
Don Rifkin
Elisabeth Kerr
Elizabeth Clementson
Haley Bracken
Joe Lops
Julia Reidhead
Nick Curley
Peter Miller
Pete Simon
Rebecca Homiski
Steve Attardo
Steven Pace

ALLEN LANE/PENGUIN PRESS

Alice Skinner
Ingrid Matts
Isabel Blake
Jim Stoddart
Katy Banyard
Liz Parsons
Rebecca Lee
Sam Voulters
Thi Dinh

NATIONAL PORTRAIT GALLERY, LONDON

Andrea Easey
Andy Horn
Andrew Smith
Anna Starling
Denise Vogelsang
Ed Simpson
Emily Summerscale
Fran Laws
Georgia Smith
Jessica Rutterford-Nice
Jude Simmons
Juno Rae
Kara Green
Melanie Pilbrow
Poppy Andrews
Rosie Wilson
Sarah Tinsley
And everyone at the
National Portrait Gallery

BOOK AND COVER DESIGN

Stefi Orazi Studio

PHOTO RESTORATION

Altaimage London

ADDITIONAL THANKS

Kevin Howlett
Steve Martin
Stuart Bell

NATIONAL
PORTRAIT
GALLERY

Credits